D1517562

From Bonaventure to Bellini

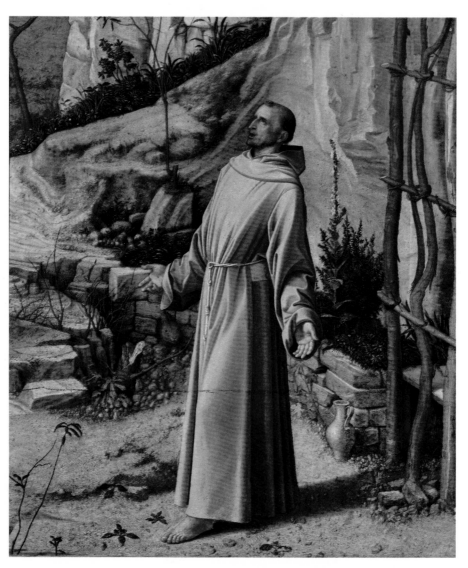

Frontispiece: Giovanni Bellini, San Francesco nel deserto,
detail: St. Francis.

From Bonaventure
to Bellini

AN ESSAY IN FRANCISCAN EXEGESIS

by John V. Fleming

PRINCETON UNIVERSITY PRESS
PRINCETON, NEW JERSEY

Publication of this book has been aided by a grant from the
Paul Mellon Fund of Princeton University Press

This book has been composed in Linotype Janson

Clothbound editions of Princeton University Press books
are printed on acid-free paper, and binding materials are chosen for strength
and durability

Printed in the United States of America by Princeton
University Press, Princeton, New Jersey

The Princeton Essays on the Arts is a series of short-length books in the fine arts and aesthetics and includes interdisciplinary essays as well as original contributions in a single field. Works in the series draw in substance upon the visual arts, music, literature, aesthetics, drama, film, and other theatrical arts, and are illustrated as appropriate. The series includes the following volumes, published simultaneously in hardcover and paperback editions:

1. Guy Sircello, A NEW THEORY OF BEAUTY
2. Rab Hatfield, BOTTICELLI'S UFFIZI "ADORATION": *A Study in Pictorial Content*
3. Rensselaer W. Lee, NAMES ON TREES: *Ariosto into Art*
4. Alfred Brendel, MUSICAL THOUGHTS AND AFTERTHOUGHTS
5. Robert Fagles, I, VINCENT: *Poems from the Pictures of Van Gogh*
6. Jonathan Brown, IMAGES AND IDEAS IN SEVENTEENTH-CENTURY SPANISH PAINTING
7. Walter Cahn, MASTERPIECES: *Chapters on the History of an Idea*
8. Roger Scruton, THE AESTHETICS OF ARCHITECTURE
9. Peter Kivy, THE CORDED SHELL: *Reflections on Musical Expression*
10. James H. Rubin, REALISM AND SOCIAL VISION IN COURBET AND PROUDHON
11. Mary Ann Caws, THE EYE IN THE TEXT: *Essays on Perception, Mannerist to Modern*
12. Egbert Haverkamp-Begmann, REMBRANDT: *The Nightwatch*
13. Morris Eaves, WILLIAM BLAKE'S THEORY OF ART
14. John V. Fleming, FROM BONAVENTURE TO BELLINI: *An Essay in Franciscan Exegesis*

for Robbie and Betty

T

Contents

List of Illustrations — xi

List of Abbreviations and Short Titles — xv

Acknowledgments — xvii

ONE Problems and Principles — 3

TWO The Desert, Moses, Elijah — 32

THREE The Feast of Tabernacles — 75

FOUR The Scribe of the *Tau* — 99

FIVE The Angel of the Sixth Seal — 129

EPILOGUE San Francesco nel deserto — 158

Index — 165

List of Illustrations

Frontispiece: Giovanni Bellini, *San Francesco nel deserto*,
ca. 1485, detail: St. Francis. Copyright the Frick Collection,
New York. ii

1. Bellini, *San Francesco nel deserto*. Copyright the
Frick Collection, New York. 2

2. Bellini, *San Francesco*, detail: the *onager*. Copyright the
Frick Collection, New York. 39

3. Bellini, *San Francesco*, detail: the bittern (*nycticorax?*).
Copyright the Frick Collection, New York. 39

4. Bellini, *San Francesco*, detail: the grey heron (*pelicanus
solitudinis*). Copyright the Frick Collection, New York. 43

5. Line drawing of the Fontaine de Vaucluse by Francis
Petrarch. Paris, Bibliothèque nationale, MS latin 6802,
f. 143r. 43

6. Bellini, *San Francesco*, detail: the rabbit in the rocks.
Copyright the Frick Collection, New York. 45

7. Bellini, *San Francesco*, detail: the shepherd with his flock.
Copyright the Frick Collection, New York. 50

8. School of Dirk Bouts, Moses at the burning bush.
Copyright the Philadelphia Museum of Art. 52

9. Moses at the burning bush. Woodcut illustration in the
Koberger Bible (Strassburg, 1483), after the Quentell
Bible (Cologne, 1479). 52

10. Bellini, *San Francesco*, detail: the swaying tree.
Copyright the Frick Collection, New York. 53

11. Moses at the burning bush (detail from four-part
narrative sequence). London, British Library, Add.
MS 27210 ("The Golden Haggadah"), f. 10v. 54

12. Bellini, *San Francesco*, detail: the walking stick and
sandals. Copyright the Frick Collection, New York. 55

13. The Golden Calf and Moses on the mountain. Wood-
cut illustration in the Koberger Bible (Strassburg, 1483),
after the Quentell Bible (Cologne, 1479). 61

14. Bellini, *San Francesco*, detail: stone or ceramic lip of
spring's mouth. Copyright the Frick Collection, New York. 61

15. Bellini, *San Francesco*, detail: Francis and his desert
garden. Copyright the Frick Collection, New York. 68

16. Elijah and the Angel (sixteenth-century). Liège,
Diocesan Museum. 71

17. Panel of retable with scenes from the life of St. Ann.
Detail: Carmelites salute members of the Holy Family.
Frankfurt-am-Main, Historisches Museum. 72

18. Bellini, *San Francesco*, detail: the tabernacle (*sukkāh*).
Copyright the Frick Collection, New York. 79

19. Bellini, *San Francesco*, detail: the lectern. Copyright
the Frick Collection, New York. 87

20. Bellini, *San Francesco*, detail: chapel bell. Copyright
the Frick Collection, New York. 88

21. Moses refreshes the twelve tribes. Dura-Europos
Synagogue. From Erwin R. Goodenough, *Jewish Symbolism
in the Greco-Roman Period*, Bollingen Series 37, Vol. 11,
Symbolism in the Dura Synagogue. Copyright 1964
Princeton University Press. Photograph by Fred Anderegg. 91

22. Bellini, *San Francesco*, detail showing paper under
Francis' belt. Copyright the Frick Collection, New York. 101

23. Bellini, *San Francesco*, detail: the *chartula*. Copyright
the Frick Collection, New York. 106

24. Autograph of Francis of Assisi. Assisi, Sacro Convento. 110

25. Fourteenth-century copy of the *signum tau cum capite*
in the autograph. Assisi, Biblioteca communale MS 344. 111

26. Plaque from a Mosan cross: Aaron marking the *tau*.
London, Victoria and Albert Museum. 118

27. The brazen serpent. Woodcut by Tobias Stimmer for
Neue künstliche Figurer biblischer Historien (Basel, 1576). 118

28. Detail of the St.-Bertin cross: Elijah and the widow of Zarephath. Saint-Omer, Hotel de Sandelin. 122

29. Detail of the St.-Bertin cross: the man in linen (*homo similis Aaron*) marks the penitents on their foreheads. 124

30. Enamel plaque: the *similis Aaron*, writer of the *tau*. Paris, The Louvre. 125

31. St. Anthony Abbot. Woodcut from the *Feldtbuch der Wundtartzney* (Strassburg, 1517). 127

32. Bellini, *San Francesco*, detail: the fig stump. Copyright the Frick Collection, New York. 147

33. Bellini, *San Francesco*, detail: sapling growing from rock behind Francis. Copyright the Frick Collection, New York. 149

34. Bellini, *San Francesco*, detail: grafting knot. 151

List of Abbreviations
and Frequently Cited Short Titles

AFH	*Archivum Franciscanum historicum*
ASI	*Archivio storico italiano*
Bonaventure	*Doctoris Seraphici S. Bonaventurae S.R.E. episcopi cardinalis Opera Omnia*, ed. PP. Collegii a S. Bonaventura (cited by volume and page)
CC	*Corpus Christianorum*
CF	*Collectanea Franciscana*
Documents	*Saint François d'Assise. Documents, écrits et premières biographies*, ed. T. Desbonnets and D. Vorreux
Fleming	John V. Fleming, *An Introduction to the Franciscan Literature of the Middle Ages*
Fletcher	J. M. Fletcher, "The Provenance of Bellini's Frick 'St. Francis,'" *Burlington Magazine* 94 (1972): 206-214
FS	*Franziskanische Studien*
Gemelli	*I Fioretti di S. Francesco e le considerazioni sulle stimmate*, ed. Agostino Gemelli
Legendae	*Legendae S. Francisci Assisiensis saeculis xiii et xiv conscriptae* (*Analecta Franciscana*, x)
Liber Conformitatum	Barthelmy of Pisa, *De Conformitate vitae beati Francisci ad vitam Domini Iesu auctore fr. Bartholomaeo de Pisa*
Meditatio Pauperis	*Meditatio Pauperis in solitudine auctore anonymo saec, xiii*, ed. F. M. Delorme
Meiss	Millard Meiss, *Giovanni Bellini's St. Francis in the Frick Collection*
MF	*Miscellanea Franciscana*

NRT	*Nouvelle Revue théologique*
Opuscula	*Opuscula Sancti Patris Francisci Assisiensis*, ed. Caietanus Esser
PG	Migne, *Patrologia graeca*
PL	Migne, *Patrologia latina*
Ratzinger	Joseph Ratzinger, *Die Geschichtstheologie des heiligen Bonaventura*
Reeves	Marjorie Reeves, *The Influence of Prophecy in the Later Middle Ages. A Study in Joachimism*
Smart	Alastair Smart, "The *Speculum Perfectionis* and Bellini's Frick *St. Francis*," *Apollo* 97 (1973): 470-476
Ubertino	Ubertino da Casale, *Arbor vitae crucifixae Iesu*
ZkTh	*Zeitschrift für katholische Theologie*

Biblical citations are based in the Latin text published by R. Weber, *Biblia Sacra iuxta vulgatam versionem* (Stuttgart, 2nd ed., 1975), 2 vols. The English generally follows the Douay rendering of the Vulgate, but particularly felicitous or familiar phrases from the Authorized Version have frequently been retained, and other English translations have been used from time to time.

Acknowledgments

Two subjects that have long teased my interest—the allegorical language of medieval poems and pictures and the cultural history of the Franciscan movement—have conspired to force the issue of this brief study. I have surrendered to the duress of Bellini's panel with reluctance, and I have presumed to write about it at all only because of the encouragement and active support of many friends and colleagues to whom I now wish to express my sincere gratitude.

It has been my singular good fortune for the last decade and more to have been surrounded by a diverse group of brilliant medievalists in many fields, colleagues who have agreed on practically nothing except the most important things, such as the nature of collegiality in the scholarly calling. Without their encouragement, discouragement, stimulation, irritation, correction, and collaboration, I should never have undertaken such a study in the first place and should certainly never have brought it to conclusion. I owe continuing thanks to my great teacher, D. W. Robertson, Jr., and to my friends Robert Hollander, Michael Curschmann, Marjorie Reeves, and Karlfried and Ricarda Froehlich. I have benefited in very specific ways from the encouragement and the instruction of my friend and former colleague Rona Goffen of Duke University, from conversations with my colleagues Marilyn Lavin and John Shearman, and from the advice of two generous, learned, and anonymous readers for the press. Three particular friends—my colleagues Rosalie Green and Gail Gibson and my brother-in-law John Newman—read and commented on the manuscript in helpful ways that have significantly strengthened my book. I shall not pretend by implication that they necessarily approve of its results. I regret that I came to this study too late to discuss matters of common interest with the late Millard Meiss. Although I offer certain criticisms of his discussion of Bellini's *St. Francis*, it will be obvious that I never would have conceived my study without the stimulation of his elegant monograph.

Several institutions can claim my thanks. The first of them must be my own, Princeton University, which encourages scholarly re-

search by collegial example, material support, and the provision of superb facilities—some, like the Index of Christian Art and the Marquand Library, fabulous in their intellectual riches. To Mary Schmidt, the librarian of Marquand, to the capable and diligent staffs of the Firestone Library and the Speer Library of Princeton Theological Seminary, and to Ms. Bernice Davidson and Mr. Edgar Munhall of the Frick Collection, I express my warm thanks.

Several audiences helped me formulate my ideas by inviting me to lecture on various aspects of my research, and I want to mention especially the Medieval Club of New York, the Department of Comparative Literature at Dartmouth, and the graduate students of the Department of Art and Archaeology at Princeton. Though I was the ostensible teacher on these occasions, it was invariably I who learned the most from them. I gratefully acknowledge the permission granted by individuals and institutions cited in the photographic credits to reproduce illustrations for this book. The actual procurement of photographs was eased by the administration of Les Editions Franciscaines in Paris; by two scholars at the Courtauld Institute of the University of London: John Newman, already mentioned in another context, and George Zarnecki; and by Professor Philippe Verdier.

My children have contributed significantly if indirectly to the completion of this book: Richard by keeping me fit on the squash court, Katy by lifting my heart with her vivacious enthusiasm, and Luke by taking long summer naps. My greatest debt, as always, is to my wonderful wife Joan.

Princeton
Michaelmas, 1981

From Bonaventure to Bellini

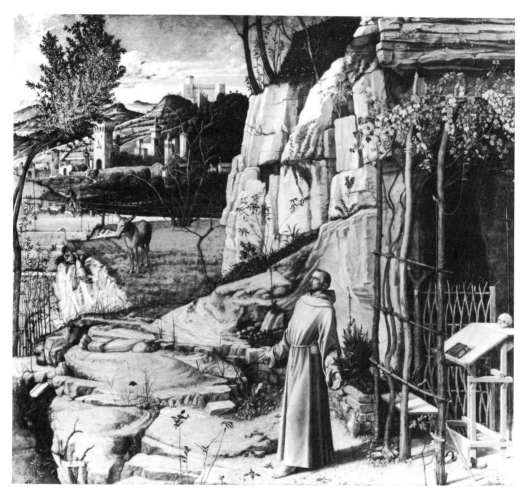

1. Bellini, San Francesco nel deserto.

Problems and Principles

S*ors audaces juvat*: thus the Vergilian motto to the thirty-ninth emblem of Sambucus, a disquieting image of Ajax and Hector, their powerful swords raised high for a moment's hostile pause as they square off for their fierce and fatal duel. A fair translation, one that at any rate captures something of the singular doubtfulness of the thought, might be "Fortune abets the foolhardy." I hope so. The literary historian who would pretend to offer instruction in art history on a subject that has long attracted the focused attention of distinguished luminaries of that discipline must be mindful both of his own audacity and of the more pessimistic possibilities of that raised and gleaming steel.

I cannot claim that this book has been dictated by Fortune but must confess that it is an accident. Its readers alone can judge whether the accident be a happy or a deplorable one; the author, its efficient cause, can hope only to give some account of how it came about. Some years ago, at a time when I was beginning a study of the Franciscan literature of the thirteenth and fourteenth centuries, a friend presented to me as a gift Millard Meiss' monograph *Giovanni Bellini's St. Francis in the Frick Collection*.[1] This was, and is, a lovely book, executed with all the skill and beauty that characterize our press' publications in the visual arts. I knew little of Bellini, and I had never before laid eyes on the haunting and brilliant

[1] Millard Meiss, *Giovanni Bellini's St. Francis in the Frick Collection* (New York, 1964); first published as "Giovanni Bellini's *St. Francis*," *Saggi e memorie di storia dell'arte* 3 (1963): 9-30.

painting that was Meiss' subject (fig. 1). I must confess that I first looked at all of the photographic illustrations—the full-color frontispiece with the busy furniture of a large panel still distinct and articulate even when reduced to the confines of an octavo page, then the larger and yet more precise black-and-white details. From the Franciscan texts with which I was familiar I could summon no immediate clue to the picture's narrative subject. Certainly, it seemed to me, that subject was *not* the Stigmatization. But I thought I did see, in a conspicuous detail in the middle distance, an obvious indication of the painting's general spiritual import.

Only then did I read Professor Meiss' elegant and plausible essay about the painting. According to his analysis, the subject of the painting *was* the Stigmatization of St. Francis on Mt. Alverna, though I could forgive myself for not having recognized it, for, according to Meiss, Bellini, turning his back on the clichés of iconographic tradition, had invented a unique and deeply personal statement of the Stigmatization, a "stigmatization by light." Meiss did establish a number of possible connections between Franciscan texts and details in the painting, but he stressed Bellini's iconographic independence and originality, and he took an agnostic position toward the iconological potential of the busy and sometimes distracting details with which Bellini had decorated his eremitic landscape. The significant detail that I had seen, or thought I had seen, was a donkey; or rather it was an *onager*, to use the biblical word for a biblical thing, a wild ass, let free to wander in the wilderness and barren land, scorning the multitude of the city and searching round about the mountains of his pastures. Concerning this beast Professor Meiss wrote thus: "The ass is possibly the one that carried the saint up Mount Alverna"; and although he admitted that it was conceivable that the animal might have an emblematic religious meaning, he did not think it probable. Even in granting the possibility, in fact, Meiss seemed to imply that the search for such meaning would be hopeless amidst the thick underbrush of the medieval symbolic forest. "In medieval thought the ass, for instance, can symbolize, in addition to many evil qualities, the people whom Christ leads to the heavenly kingdom."[2]

[2] Meiss, p. 23.

And so, I knew, it could. Had not Francis himself, intending no compliment, addressed his own body as *frater asinus*? Was it any more justifiable to see in this inoffensive animal a spiritual *onager* than it would be to see in him Brother Ass?[3] Surely it was safer to see "just" a donkey, as esthetically satisfying as a great painter could make him, and perhaps a narrative allusion to the larger subject of the panel and perhaps a monument to Bellini's attested visual whimsy and his compositional idiosyncrasy, than to see a Panofskian "icon." That day I read no further.

I have come back to Bellini's St. Francis only because I feel compelled to do so by what I shall call Bonaventure's St. Francis. The more deeply I have studied the classical repertory of thirteenth- and fourteenth-century Franciscan texts, the more inescapably I have been led to the conclusion that the Bellini painting is a profound and studied expression of a medieval meaning of Francis and that it draws upon, and gives brilliant visual raiment to, a cherished and privileged metaphoric vocabulary of medieval Franciscanism, itself brilliant in its literary expression. It is a painting full of ideas, ideas much in vogue among serious Christians of the later Middle Ages and almost universally ignored by modern art history. The purpose of my own study is to give some account of these ideas—that is to say, in some fashion to "explain" the painting.

The methods of explication to be used are for the most part traditional, and they involve the frequent and sometimes detailed discussion of visual motifs in terms of written texts that can help to illuminate them. Yet this is not a "study in iconology" *tout court*. I should prefer that the reader see it more accurately, in the first instance, as an essay on visual and verbal art alike. Though one important aim is to demonstrate positive relationships between specific aspects of Bellini's pictorial content and certain literary texts, the more profound and difficult intention is to suggest some of the ways in which fundamental Franciscan ideas, ideas often by nature more poetic and pictorial than discursive, could find powerful expression in word and image. Since all of the major themes of Bellini's painting, without the least exception, are of specific bibli-

[3] See, for example, Bonaventure's *Legenda Major*, v, 4; *Legendae*, p. 578.

cal origin, I should also claim for my work the genre of scriptural exegesis. That is also, of course, the genre of the painting itself.

It is now many years since Rensselaer Lee was able to write, in his magisterial essay on poetry and painting, that "no sympathetic student of the Renaissance will quarrel with the view already expressed in the fifteenth century by Alberti that the painter will do well to know the poets and historians who will supply him with subjects of universal interest, and to associate with poets and learned men of his own day who may provide interesting ideas."[4] Certainly art historians have not been wholly reluctant to give to Giovanni Bellini the mantle of a "learned painter," though eddies of controversy swirl around the very phrase. At least since the publication of Edgar Wind's essay on the *Feast of the Gods*, we have seen one face of Bellini with new eyes, and various of his works have been examined, with results of varying satisfaction, along "Panofskian" lines.

Yet any iconographic analysis of the Bellini painting that intends to make serious claims for an allegorical and religious content must overcome two assumptions by now so hoary as to have passed the unguarded frontier separating simple prejudice from established authority. The first is that what Bellini and most other Renaissance artists were interested in, really interested in, was the world of scientifically or emotionally observed nature. The second is that Giovanni Bellini was a maverick genius whose boundless mind was not to be constrained by petty prisons of any sort, least of all those of traditional religious iconography. Nineteenth-century Romantic criticism can claim the paternity of the first of these, but Bellini himself is at least partly responsible for the second. Neither assumption can be disproved—or proved, either—on the purely theoretical level; but they can and should be confronted and denied.

The tradition classically represented by Berenson maintains that the ostensibly religious subject matter of so many of Bellini's paintings was merely a convention if not a studied pretext that provided the artist with the opportunity to exercise his real artistic interests, the execution of splendid landscapes and finely finished *realia* of

⁴ R. W. Lee, *Ut Pictura Poesis: The Humanistic Theory of Painting* (New York, 1967), p. 41.

all sorts and the bravura performance of astonishing technical feats. For such critics, justly awed by the painterly achievement, questions of traditional iconographic control seem in poor taste. We are witnessing the radical secularization of traditional categories of Christian art as they surrender to the more personal and expressive demands of a Renaissance artist.

For critics of a certain viewpoint, the word "medieval" is naughty, and the suggestion that, for instance, Bellini might have had medieval inspiration in painting a Madonna must be advanced apologetically.[5] By implication, his sources *should* be pagan and cabbalistic, not scriptural and patristic. According to one such critic, indeed, traditional Christian spirituality can be, in and of itself, a "denial of the Renaissance."[6] The misleading implication is that we need not expect any serious attempt at continuity between Bellini's Franciscan landscape and Franciscan tradition, for that tradition is medieval. *Where* is this scene supposed to take place? "St Francis' exaltation is not the hermit's tortured isolation, but joyous emotion in a domesticated world," writes one critic. "He is far from La Verna, the rugged site of the stigmatization, and has ascended instead to the Venetian hinterland where the green fields and neat rows of plane trees give way to the more irregular configurations of the Dolomite foothills."[7]

One wonders whether the mere historical dubiety of such an opinion would not forbid it to the pages of, say, the *Guide bleu*; yet it passes without challenge into the fane of art history. Who am I to gainsay it? To be sure, the mountain of the Stigmatization is, in Franciscan tradition, never a mere geographical location, a pretty place accidentally made famous by its associations with the most stupendous miracle of medieval Christianity. It was, rather, a "holy place," prepared by God from the foundations of the

[5] David Cast, "The Stork and the Serpent: A New Interpretation of the *Madonna of the Meadow* by Bellini," *The Art Quarterly* 32 (1969): 252.

[6] Charles D. Cuttler, "The Lisbon *Temptation of St. Anthony* by Jerome Bosch," *Art Bulletin* 39 (1957): 126. See, however, Rona Goffen, "Icon and Vision: Giovanni Bellini's Half-Length Madonnas," *Art Bulletin* 57 (1975): 487-518, for a convincing demonstration of Bellini's "medievalism."

[7] A. Richard Turner, *The Vision of Landscape in Renaissance Italy* (Princeton, 1966), p. 60.

world for its special purpose in providential history.[8] In the first of the *Considerazioni sulle stimmate*, we learn the details of its donation to Francis by Count Orlando da Chiusi di Casentino. There the count describes it as *uno monte devotissimo*; and Francis accepts the gift contingent upon its being suitable for prayer and penitence—*atto a orazione e a fare penitenzia*.[9] To discover whether this be the case, he sends two of his brothers to scout out the terrain—an action that, as Gaudenzio Melani has pointed out, consciously recalls the reconnaissance of Canaan ordered by Moses (Numbers 13).[10] In other words, in Franciscan tradition, Mount Alverna was a divinely given "promised land." I cannot prove that a romantic sensibility did not decide that the Dolomite foothills were, on the whole, even better, any more than I can prove that the Naples *Transfiguration* is set on Mount Ventoux. The one is no less likely than the other; but it is no *more* likely either.

Bellini, who usually worked on commission or at least with a definite "public" in mind, probably produced this work for a Franciscan layman. Marcantonio Michiel, in 1525, said that the painting had been done for a certain "Zuan Michiele," and it is possible that J. M. Fletcher has correctly identified this man as a respected and prominent Venetian who eventually held public office.[11] Meiss concluded that "Messer Zuan, even if he did not welcome so personal a religious conception, would very probably have permitted the painter greater iconographic freedom than any official body."[12] But Messer Zuan did, apparently, want a picture of St.

[8] "Mons iste Alvernae a Deo fuit beato Francisco preparatus, ut in ipso stigmatizaretur." Barthelmy of Pisa, *De Conformitate vitae beati Francisci ad vitam Domini Iesu*, ed. Quaracchi Fathers [*Analecta Franciscana*, iv-v] (Quaracchi, 1906-1912), II, 387.

[9] *I Fioretti di S. Francesco e le considerazioni sulle stimmate*, ed. Agostino Gemelli (Milan, 1970), p. 229.

[10] Gaudenzio Melani, *Nel crudo sasso: San Francesco alla Verna* (La Verna, 1965), p. 16.

[11] J. M. Fletcher, "The Provenance of Bellini's Frick 'St. Francis,' " *Burlington Magazine* 114 (1972): 206-214. I shall refer to this article repeatedly, without, however, addressing its central iconographic claim. Let me simply say that I find in it no credible evidence that there was once a seraph in the Frick painting.

[12] Meiss, p. 32. The curious notion that the Christian clergy are, at any historical moment, more "religious" than the Christian laity has no basis in

Francis in the desert. That anyone with a votive interest in St. Francis would have issued an iconographic indulgence to rewrite the most sacred moment of the Franciscan legend by moving it from the holy desert of Alverna to the Dolomite foothills is, to say nothing more, doubtful.

The second assumption—to wit, that Bellini was characteristically independent and unconventional in his attitude toward the subjects of his paintings and toward iconographic tradition—has been drawn from Bellini's own famous statement, reported by Bembo, the purchasing agent for Isabella d'Este, concerning his long delay in fulfilling her commission.[13] The old man is reported to have said that he preferred to work without predetermined goals (*signati termini*) and that it was his practice "ever to wander at will through the pictures" (*sempre vagare a sua voglia nelle pitture*).

This statement has proved rather mischievous, in my opinion, and the *vagare* business in particular has provided critics with a spurious warrant to suggest that Bellini's paintings typically reject the constraints of traditional iconographic categories in order to indulge and exult in the expression of unique, personal, imaginative formulations.[14] There are other possible interpretations, however. I take it that what Bellini said—in the context of explaining why he had not done something that he did not want to do—was that he liked to pick his own subjects and that in treating them he liked to impose his will on their thematic development. This is perhaps a confident, even an imperious claim, but it is hardly the manifesto of a romantic revolutionary. In fact, as far as the Frick *St. Francis* is concerned, Bellini presents us with few iconographic oddities, though we can ourselves invent them if we think of the scene as a "stigmatization by light" (Meiss) or a travel poster (Turner). Bel-

history even though it is an apparent axiom of medieval and Renaissance studies.

[13] The documents reporting the history of this commission have been repeatedly published and discussed. For recent bibliography, see Felton Gibbons, "Further Thoughts on the Allendale Nativity," *Studies in the History of Art* 7 (1978): 23f.

[14] See, for example, Fletcher, p. 124; Millard Meiss, *The Painter's Choice* (New York, 1976), p. ix.

lini has not chosen to depict St. Francis in a Dominican habit, for example, just for the *vagare* of it all. Nor has he pastured an otter or a polar bear in his middle ground, though in fact their presence there could hardly surprise a naturalist more than that of his bittern and "grey heron," two aquatic birds that would be about as comfortable on this arid mountain as a walrus in a cotton patch.

My own assumptions are quite different. I find that Bellini brings to the religious subject of his painting a sustained, sympathetic, and informed interest. My further assumption is that in treating this subject matter Bellini is guided less by personal whimsy than he is by "interesting ideas" (to hark back to Rensselaer Lee) and by "the poets and historians who will supply him with subjects of universal interest." Since the subject that Bellini has chosen, or accepted, is Francis, it would seem to follow that the learned men to whom we might look in questioning and experimental mood are the poets and historians of Franciscanism. This is an assumption without novelty or impudence, but it has thus far been inadequate to the task of explaining the painting, and it even has been rejected in theory.

"While I am not trying to detract from the originality of the Frick St. Francis I do not feel the key to that originality will be found in Franciscan texts, or as Alastair Smart has recently suggested, in the *Speculum Perfectiones*" writes J. M. Fletcher; "nor am I confident that the clues which will lead to the final identification of the subject will be revealed by a careful cataloguing of animal or vegetable details or the attribution of a dogmatic fixed symbolic meaning to separate botanical fragments."[15] If this intuition is correct, my own enterprise is of course doomed from the start, for, though I shall eschew dogmatic botany whenever possible, I am indeed convinced that it is in Franciscan texts that we shall find the "clues" to the painting's subject. If the Bible might be useful in identifying the subject of a biblical painting like the *Transfiguration* and the *Fasti* might be a useful aid in identifying the subject of an Ovidian painting like *The Feast of the Gods*, it seems to me a not unuseful working hypothesis to think that Franciscan texts might be helpful in identifying the subject of what everyone agrees is a Franciscan painting.

[15] Fletcher, p. 212.

It is nonetheless true that such recourse as has so far been made to early Franciscan literature in an attempt to explain the painting has been disappointing in its results; but this fact, in my opinion, speaks to an inadequacy of philological preparation rather than a flaw in method. To express this opinion thus baldly may seem to pick a quarrel with two art historians who have taught us all, and me especially, a good deal about the art history of medieval Franciscanism—I refer of course to Millard Meiss and Alastair Smart —but such is not my intention. The critical review of their arguments that follows has several goals: to distinguish between baby and bathwater, to advance certain modest claims on behalf of literary study, and to propose a few general principles of Franciscan iconography of possibly general utility. But its final aim is to lay the groundwork of an argument to demonstrate what these scholars have already taught us—that Bellini's painting *is* about Francis of Assisi.

Let me begin with Meiss' argument. Meiss wanted to see in Bellini's painting a unique "stigmatization by light," and he sought to explain the absence of any visual emphasis on the act of wounding in terms of a supposed "recapture of an old, largely forgotten, religious conception." Thus, he claims, early verbal and pictorial treatments of the stigmatization stressed Francis' spiritual communion with God rather than his physical analogy with the incarnate and crucified Christ: "From about the mid-thirteenth century on up to Bellini's time religious texts and paintings that dealt with the Stigmatization stressed increasingly the imprinting of the wounds on the body of St. Francis . . . and in the texts there was a related development until in the late (c. 1390) Franciscan treatise, *Liber de Conformitate Vitae b. Patris Francisci ad Vitam Nostri Jesu Christi* by Bartolommeo of Pisa, the visionary Christ actually printed the wound with his own hands. Such conceptions, however, were foreign to the period immediately following the death of the saint."[16]

Meiss' only documentation of this substantial claim are his own words published in another book and a "passage . . . quoted" in something called *L'Alcoran des Cordeliers* published in Amsterdam in 1784.[17] A literary historian must find this a curious mode of

[16] Meiss, p. 33.

[17] Meiss, p. 49, notes 120 and 121.

argumentation. The *Liber Conformitatum* of Barthelmy of Pisa—
the only primary Franciscan source cited by Meiss, and then cited
only for the purpose of saying that it does not reflect primitive
Franciscan tradition—is neither an unimportant nor an obscure
book. Paul Sabatier did "not hesitate . . . to see in it the most im-
portant work which has ever been made on the life of St. Fran-
cis."[18] It has been published numerous times, and the Quaracchi
Fathers produced a splendid critical edition of it more than a half
century before Meiss wrote.[19] *Der Barfuser Muenche Eulenspiegel
und Alcoran*, cited by Meiss in an eighteenth-century French trans-
lation, is on the other hand a tendentious, abusive, and highly
satirical "version" of the *Liber Conformitatum* made by the Ger-
man Protestant Erasmus Alber in 1544. It is an engaging and deeply
facetious work that tells us a great deal about the attitudes of
Protestant humanism toward certain traditions of Roman Cathol-
icism; but as a means of discovering what medieval Franciscans
thought about Francis, it can hardly claim authority.[20]

Meiss' conclusion—that the emphasis on the physical reality of
the stigmata wounds was a late development—is no more authori-
tative than the evidence from which it is drawn. Indeed, in my
view, the "history" of the stigmata is almost precisely the opposite
of that suggested by Meiss. The miracle of the stigmata was re-
garded by Francis' contemporaries—including the pope who can-
onized him—as an absolutely new and unparalleled sign, which
pointed to a unique spiritual meaning in the *poverello*'s life and
work. The strategy of the early texts was, accordingly, to estab-
lish and defend the literal historicity of the event within the frame-
work of a poetic and scriptural historical vision. Such an emphasis
is marked in the *vitae* of Thomas of Celano; in the *Legenda Major*
of Bonaventure, a work structured according to theological themes
rather than narrative sequence, it becomes a commanding energy.[21]

[18] *Life of St. Francis of Assisi* (New York, 1894), p. 422.
[19] Bibliographical citation in note 8 *supra*; see further, John V. Fleming,
An Introduction to the Franciscan Literature of the Middle Ages (Chicago,
1977), pp. 68ff.
[20] See J. Lindeboom, "De satyren naar aanlieding van het 'Liber Con-
formitatum,'" *Mededeelingen der Nederlandsche Wetenschappen, Afdeel-
ing Letterkunde*, n.s., VII (1944): vi.
[21] See Fleming, p. 41.

Although "the period immediately following the death of the saint" offers scant evidence of any kind, what there is argues against Meiss rather than for him. The encyclical obituary of Elias of Cortona, written in the period immediately following Francis' death, insists both on the literal details of the miracle (the size, shape, and color of the wounds) and upon its particular divine signification.[22] That the wounds were printed characters is a trope already to be found in the antiphon *Celorum candor splenduit*, perhaps the oldest poem on the subject of the Stigmatization, probably written on the occasion of the canonization in 1226.[23] Since, as Bonaventure makes clear, the "seraph" of the Stigmatization was in fact Christ in angelic form, it is probable that Franciscans believed from the earliest times that "the visionary Christ actually printed the wounds with his own hands."[24] Ubertino da Casale has a whole chapter in his fifth book on "Jesus seraph alatus."[25]

Pictorial evidence is distinctly more problematical, but it too argues against Meiss. Thirteenth-century treatments of the reception of the stigmata in general submit to the expectations of a rather literal reading of the text of the *Legenda Major*. Articulate lines of force between the seraph and Francis emphasize the "imprinting" of the wounds. In the fourteenth century, one begins to find a rather wider spectrum of iconographic conception, just as—in such written sources as the sermons of Francis of Meyronnes or the *Considerazioni sulle stimmate*—one finds an increasing independence of the purely narrative tradition.[26] In fact, it is the independence and variety of fifteenth- and sixteenth-century renditions of the scene that have led scholars to believe that Bellini's painting may well be a "traditional" stigmatization in spite of its want of a seraph, or a kneeling Francis, or Brother Leo, and so

[22] "Epistola encyclica de transitu S. Francisci," *Legendae*, pp. 526-527: "Nam manus eius et pedes quasi puncturas clavorum habuerunt, ex utraque parte confixas, reservantes cicatrices et clavorum nigredinem ostendentes. Latus vero eius lanceatum apparuit et saepe sanguinem evaporavit."

[23] "Sacer Franciscus claruit, / Cui Seraph apparuit, / Signans eum charactere / In volis, plantis, latere . . . ," *Legendae*, p. 388.

[24] *Legenda Major*, xiii, 6; *Legendae*, p. 616.

[25] *Arbor vitae crucifixae Jesu* (Venice, 1485), V, iv.

[26] "Trois Sermons de François de Meyronnes sur la Stigmatisation de Saint François," *La France Franciscaine* 10 (1927): 371-397.

forth. But insofar as it is possible to define a specific movement in either pictorial or literary treatment, it is a movement away from, rather than toward, a conception of "writing." Barthelmy of Pisa, whose views Millard Meiss seemed to regard as novel and original, is in fact merely the greatest collector and editor of what may be regarded as the classical Franciscan literary tradition of the thirteenth and fourteenth centuries.

Thus Meiss' central argument, at least insofar as it rests upon relevant primary texts, is distinctly compromised. I am further convinced that it has been marshalled in support of a mistaken iconographic identification. Though Meiss neither intended nor claimed for his essay the character of a deep iconographic study, it has been so read by numerous other scholars largely because of its captivating suggestion of a novel subject, a painless stigmatization by light. Meiss' search for a "tradition" for such a subject, even an "ancient tradition," perhaps accounts for his inaccurate characterization of early Franciscan texts and pictures. We shall follow a safer path to abandon altogether the notion that the subject of the painting is the Stigmatization, for, in my view, it is not.

Alastair Smart's article—the subject of the skeptical remarks by J. M. Fletcher that I have already quoted—avoids Meiss' principal error by moving away from the assumption that the painting is a stigmatization.[27] He is comfortable with an interpretation that can accommodate visual allusions both to the event of the stigmatization and to the themes of the *Cantico di frate sole*. His attempt to find a written source or analogue for this thematic collocation in classic Franciscan literature is much more sophisticated than was Meiss', and it seems at first highly promising. His specific argument, on the other hand, I find problematical and, finally, unconvincing.

Smart thinks that Bellini's painting illustrates the general sense of a chapter of the *Speculum Perfectionis* entitled, "On [Francis'] especial love for water, rocks, wood, and flowers." This chapter, the one-hundred-and-eighteenth, near the end of the *Speculum*, is followed by one entitled, "How he praised the sun and fire above all other creatures," which in turn is followed by the text of the

[27] Alastair Smart, "The *Speculum Perfectionis* and Bellini's Frick *St. Francis*," *Apollo* 97 (1973): 470-476.

Cantico. Although neither here nor elsewhere in the *Speculum* is there an explicit history of the miracle of stigmatization, Smart sees general allusions to it in continuous passages. Furthermore, he argues that the passage explains a number of specific distinctive features of the iconography—among them, the details of the rocky landscape, the spring of water, the lopped-off tree, the flower garden, and the discarded sandals.

"The *Speculum*," he writes, "was first printed at Venice in 1504, but it had come into prominence in the second half of the fifteenth century during the renewed struggle between the Observants and the Conventuals which followed the Great Schism."[28] Before looking more closely at the specific text that Smart adduces, it is necessary to raise two preliminary objections. The first concerns a certain bibliographic confusion. The *Speculum Perfectionis* was, as a matter of fact, first printed in Paris, in 1898. Its "discovery" and triumphant publication by Paul Sabatier is probably the most famous episode in the history of Franciscan scholarship. The book that Smart must surely have in mind, published in Venice in 1504, is called the *Speculum vitae beati Francisci et Sociorum eius.*[29] This *Speculum vitae*, a product of the medieval twilight, is a rather confused and confusing anthology of biographical anecdotes, legislative stipulations, and miracles, gathered together from a fairly wide spectrum of early Franciscan texts. I have found no evidence at all that this book, or any manuscript that it reproduces, enjoyed any prominence whatsoever until the nineteenth century. On the contrary, it enjoyed a splendid obscurity until Sabatier thought he found in its disordered pages garbled evidence of the most ancient biography of Francis of Assisi, hidden like "a diamond in its gangue."

Since practically all of the *Speculum Perfectionis*, including chapter 118, was anthologized, in however disordered and confusing a form, in the *Speculum vitae*, it may seem little more than a bibliographical quibble to challenge Smart's statement. There is, however, a much more fundamental objection to his suggestion

[28] Smart, p. 470.
[29] See *Saint François d'Assise: Documents, écrits et premières biographies,* ed. Théophile Desbonnets and Damien Vorreux (Paris, 1968), p. 1,483, for clear bibliographical information about the two works.

that the *Speculum Perfectionis* is a source of Bellini's painting in
the Frick Collection. In the repertory of Franciscan biography
of the thirteenth and fourteenth centuries there are, as it were,
canonical books and apocryphal books. The official biography par
excellence is Bonaventure's *Legenda Major*, a copy of which was
by capitular action supposed to be in every Franciscan house in
Europe.[30] Manuscript evidence would suggest that this injunction
was taken seriously. But the first "official" lives of Francis, those
by Thomas of Celano, written before the middle of the thirteenth
century, also continued to have wide circulation. The *Speculum
Perfectionis* is one of many unofficial and peripheral texts that
grew out of the poverty context. It is a relatively late text, prob-
ably belonging to the pontificate of John XXII—heady days for
the Franciscan Order. In fact, it may be justly regarded as a lit-
erary forgery composed and used by a small group of so-called
Spiritual Franciscans whose ideas were repeatedly disowned by
various popes and Chapters General. It is nonetheless true, as
Smart says, that the *Speculum Perfectionis* did have readers among
the Observants of the fifteenth century as it had among the Spir-
ituals of the fourteenth. But it was an "underground" document
and a polemical one. It is not impossible that Bellini would have
known it, but I regard it a priori as distinctly unlikely; and if the
painter actually was inspired by its "great chapter" describing
Francis' love of nature, I dare say he got it from somewhere else.
Smart seems to be unaware that this section of the *Speculum Per-
fectionis* has been borrowed, more or less verbatim, from a much
more ancient and respectable text, the *Vita secunda* of Thomas of
Celano.[31]

The discovery of bibliographical and textual naiveté does not,
of course, directly address the question of the validity of Smart's
iconographical identifications, for it is possible to adduce a proper
text from an improper source. My own discussion by no means
proves that his specific suggestions concerning rocks, stubs, san-
dals, and "patches" are wrong, but it should pointedly raise a
principle of iconographical study too often lost sight of. The com-

[30] Fleming, p. 45.
[31] *Vita secunda*, II, cxxiv, 165; *Legendae*, pp. 225-226; see also *Legenda Ma-
jor*, ix, 1; *Legenda perusina*, 51; and the *Vita prima*, 80.

merce between the literary text and the painted surface must always be, even in the case of a servile and self-denying draughtsman, rather complicated, for the artist must always make decisions, studied or impetuous, about the literary details that he will pick out and emphasize, the degree to which he is willing to follow an existing pictorial model, and so forth. The fact of the artist's direct and unmediated knowledge of a "source text" in any form is but rarely positively demonstrable, and even when it is, the successful demonstration of a literary influence on any particular pictorial representation must involve a number of aspects of probable argument and must take into account a number of factors not easily quantified, such as tone, mood, and irony.

The problems raised are most acute, perhaps, with regard to allegorical imagery. Showing that a hawk or a handsaw had a special "meaning" for St. Bernard is hardly sufficient to demonstrate that it had one for Botticelli. Of the numerous factors that must be considered, however, one of the most fundamental remains the "simple" question of accessibility. Botticelli *could* have been reading Bernard; he *could not* have been reading Francis Bacon. I suspect that some of the excessive reaction to "Panofskian" interpretation that we are currently witnessing stems from scholarly disbelief that major works of Renaissance art are consciously built of esoteric, not to say arcane, images that can be explicated only by reference to a highly privileged literature.

"Esoteric" may not be the *mot juste* to describe the position of the *Speculum Perfectionis* among the Franciscan literary texts that may have had an impact on Bellini or his patrons, but it comes close to the mark. *If* Bellini was inspired by the passage adduced by Smart—and I think that he was not, in any direct sense—it is much more likely that it would have come to him through the pages of Thomas of Celano than through those of the *Speculum Perfectionis*. The student of Franciscan iconography enjoys a considerable advantage in collating visual constructs with probable literary sources, but it is not an advantage that art historians have yet learned to exploit. The peculiar history of the Franciscan Order makes it possible to discern a reasonably reliable typology of literary sources dealing with the life of Francis in terms of their likely availability to painters and poets.

Whether Francis' immediate friends and associates, and in particular his confessor Friar Leo, left any extended biographical writings is a matter of considerable dispute. One of the first witnesses to claim that Leo *had* written such works, Dante's contemporary Ubertino da Casale, implies that they were by his time no longer extant. Certainly the first known and extant *vitae* are those of Thomas of Celano, dating from 1228 and 1244. That there were others, probably many and probably often of a controversial nature, is suggested by the draconian action taken by the Chapter General of 1260. In 1244 the Minister General, Crescentius of Jesi, published an advertisement asking for uncirculated materials concerning the life of the founder. It is probable that the response was generous (including Thomas of Celano's *Vita secunda*) but divisive in effect, for in 1260 the Chapter General issued the decree that all extant biographical materials be destroyed and replaced by a single official *vita* to be written by master Bonaventura of Bagnoreggio.

Hence it is that preeminent among Franciscan literary sources must always be the *Legenda Major* of Bonaventure, the official biography for the order, a work that enjoyed an authoritative monopoly in the late Middle Ages and that was further and powerfully recommended by the comprehensiveness of its contents, the lucidity of its style, and the brilliance of its organization. This last feature is of particular importance. The *Legenda Major* has certain special literary qualities that could make it particularly useful to painters who might seek to relate narrative themes to a larger emblematic significance, for its own heuristic principles are not historical and chronological, but allegorical and theological. In Bonaventure's work the tendency to subordinate the biographical data of a single thirteenth-century life to the grand eschatological design of God's working in history—a tendency already distinct in Thomas of Celano—is everywhere triumphant.

Next in order of importance are probably the liturgical office books, including, of course, Bonaventure's own *Legenda Minor*, Julian of Speir's *Officium rhythmicum*, and the most ancient hymns of the Franciscan festivals, such as those written by Gregory IX or Raynaud Cappoccio. The importance of the liturgical texts stems from the fact that it was in these hymns and lectionary

readings that Franciscans throughout Europe found the staple metaphors of Franciscan life.

The *vitae* of Thomas of Celano, perceived as the obvious sources for Bonaventure's work, seem never to have been seriously considered banned works, and they circulated freely throughout the thirteenth and fourteenth centuries. Their controlling influence over major monuments of Franciscan iconography, including much of the painting in San Francesco d'Assisi, is well known.

Finally, there are two vast, synoptic works of the fourteenth century—Barthelmy's *Liber Conformitatum* and the *Arbor Vitae* of Ubertino da Casale—that make special, and largely unheeded claims for the attention of students of Franciscan literature and Franciscan visual art alike.

In the following chapters of this book, I set for myself the iconographical discipline, somewhat arbitrary but nonetheless appropriate, of submitting each of my interpretive claims about Bellini's painting to the pages of St. Bonaventure. Although I shall make wide reference to early Franciscan literature in all its genres mentioned above and more, I shall advance no interpretation with confidence unless, in addition to meeting other appropriate criteria, it can also be confirmed by a text of St. Bonaventure's. The approbation of Bonaventure, in other words, will become the necessary but insufficient condition of allegorical demonstration. I have chosen this discipline neither because I believe that the works of Bonaventure are the only reliable Franciscan sources nor because I attribute to Bellini an unusual familiarity with them or dependence upon them, but in order to emphasize the primacy of Bonaventure's authority in the establishment of Franciscan iconography.

That primacy has both positive and negative implications. It is unquestionable that Bonaventure's authority was paramount in the Franciscan circles of Bellini's immediate intellectual milieu—the Venice of the last quarter of the fifteenth century. The canonization of the Seraphic Doctor by a Franciscan pope in 1482 brought victory to a cause and official sanction to a cult that had been nowhere more vigorously promoted than in Venice. It is a legitimate a priori assumption that anything that Bonaventure had said about Francis would be well known to those people in Venice most interested in commissioning a painting of the founder and

that it would be regarded as particularly authoritative.[32] There is also a negative implication—namely that any painter would be unlikely to offer an iconographic suggestion at clear variance with the *Legenda Major*. For example, the suggestion that Bellini is presenting a moment of stigmatization without the visible seraph described in detail by Bonaventure (*Legenda Major*, I, xiii, 3), while not impossible, is distinctly a *lectio difficilior*. Giovanni Bellini is a painter, above all in this painting, who paints things as they really are. Francis has no halo, for men do not "really" have them. But the seraph of the Stigmatization was real, the realest thing that ever was, in fact, the Wisdom of the divine Father. No painter who wanted to imagine the Stigmatization as it really happened would leave out its realest element.

If some general perception of the profile of antique Franciscan literature is undoubtedly a useful prolegomenon to the analysis of antique Franciscan pictures, no less so is an a priori appreciation of certain distinctive literary features of the principal texts. Two related features of the history of early Franciscanism were a particularly rich source of "pictorial" ideas—Joachimism and the poverty contest, both of which made prominent in certain Franciscan texts what otherwise might be considered local and arcane in the context of late medieval intellectual history generally. Finally, a more fundamental, indeed radical, feature of most early Franciscan texts, the profound biblicism of their vocabularies and literary energies, has wide-ranging implications for the study of all Franciscan art, implications that have not, I think, been fully grasped by inquiring scholars.

The prophetic and apocalyptic habits of mind prevalent in the spiritual and political thought, the poetic expressions, and the visual art of the late twelfth and thirteenth centuries exercised a defining control on the early historiography of the Order of Friars Minor. Marjorie Reeves, whose remarkable researches have demonstrated the profundity of the influence of the ideas of Joachim of Fiore in the later Middle Ages, has taught us as well the crucial role that

[32] I should point out what seems to me an excellent application of the principle of Bonaventure's "iconographic priority." Smart (p. 470) uses the witness of the *Legenda Major* to challenge a suggestion made by Meiss (p. 26) drawn from the *Considerazioni sulle stimmate*.

Franciscan visionaries played in their dissemination and adaptation.[33]

The reign of Antichrist, the angelic pope, the radical *renovatio* of the sacred and secular orders, the Second Coming of Christ—such were the apocalyptic events that commanded the excited expectations of thinking men in those times. It is difficult, indeed, to credit the extent to which such esoteric preoccupations imposed themselves upon the secular world. The theoreticians of thirteenth-century apocalypse were, to be sure, mostly visionary religious whose interest in the "prophetic" future was closely connected with a commitment to a radically reformed Church guided by a severe asceticism; but much of literate Europe bobbed in their wake. We read of the excited conversation between Richard the Lion-Hearted (hardly a church mouse) and Joachim himself at Messina in Sicily in 1191/92, when the Calabrian abbot expounded to the English king and his lay and clerical courtiers the meaning of the seven-headed dragon.[34] There are in the *Cronicà* of Salimbene of Adam—a fairly good representative of the middlebrow clerisy of the thirteenth century—repeated and often amusing episodes illustrative of the vivacity of Joachim's ideas for Salimbene and his friends. He reports, for example, the indignation of the Franciscan Joachite Hugh of Digne upon meeting a doubting Dominican, Brother Peter of Apuleia. Had Peter actually read Joachim? "I have read him, and read him well" was the answer. "I think you read him the way a woman reads a psalter," fumed Hugh, "who by the time she gets to the end can't remember what she read at the beginning!"[35] Salimbene himself abandoned Joachim only in the face of the empirical uneventfulness of the "apocalyptic" year 1260. The episode of Brother Gerard of Borgo San

[33] Marjorie Reeves, *The Influence of Prophecy in the Later Middle Ages: A Study in Joachimism* (Oxford, 1969). In addition to this major study, there is now available from the same author a somewhat more introductory and popular treatment, *Joachim of Fiore and the Prophetic Future* (London, 1976). On the Franciscans, see Reeves, *The Influence of Prophecy*, pp. 175ff.

[34] Reeves, pp. 7-8.

[35] Salimbene de Adam, *Cronicà*, ed. Giuseppe Scalia (Bari, 1966), pp. 344-345: " 'Legi et bene legi.' Cui frater Ugo dixit: 'Credo quod sic legisti sicut una mulier legit psalterium, que, quando est in fine, ignorat et non recordatur quid legerit in principio.' "

Donnino, author of the inflammatory "Introductorius" to *The Everlasting Gospel*, commanded sufficient public interest to claim a place in Jean de Meun's *Roman de la Rose*, perhaps the most widely read vernacular poem of the later Middle Ages.[36]

For Joachim, prophecy meant not clairvoyant prognostication but the "spiritual" understanding of the Scriptures, the fruit of arduous reading and contemplation of the Bible.[37] Like other aspects of his thought, the concept of *intelligentia spiritualis* was radically Trinitarian in nature. Spiritual understanding flows from the concordant mastery of the Old and New Testaments, just as the Spirit "proceeds from the Father and the Son," in the words of the Western creed. For some of Joachim's later votaries, though never for Joachim himself, this analysis would lead to the hypothesis of a third and definitive testament, an "everlasting gospel," which would be to the "age of the Son" what the "age of the Son" had been to the "age of the Father." Likewise trinitarian is his division of human history into three periods or *status*, characterized respectively by the three "orders"—married men, clerks, and monks. But trinity could be thought of both in terms of threeness and in terms of the harmonic relationship between two and one—as Augustine had thought of it in one of his deepest books, *De Trinitate*. "Joachim, then, founded his interpretation of history upon a belief that it reflected the nature of the Godhead. . . . Joachim's mystical experiences and his historical studies are fused together and this gives a peculiar quality to his work, at once spiritual and exalted and, on the other hand, concrete, framed by earthly events."[38] Reeves might be describing the peculiar quality of the Frick *St. Francis* as well.

We shall do well to admit the "alterity" of such prophetic modes of thought, for the conviction of historical purposefulness characteristic of many medieval thinkers is largely inaccessible to us today. Though prelapsarian Marxism once offered our century the

[36] *Roman de la Rose*, ed. F. Lecoy (Paris, 1965-1970), II, 108ff. (lines 11, 761ff.).

[37] I follow Reeves, pp. 16ff. Joachim's sense of "prophecy" is very close to Bonaventure's sense of "revelation": the plenary understanding of the spiritual sense of Scripture.

[38] Reeves, pp. 20-21.

excitement of an invitation to specific and definable historical participation, we now live, most of us, in a spiritually humiliated universe that offers no possibility for the individual will either to embrace or to contest an overarching but comprehensible historical design. Hence, the modes of thought characteristic of Peter Damian or Innocent III—let alone Joachim of Fiore or Angelo Clareno—may strike us as highly artificial and postured when they were in fact entirely coherent and organic. Spiritually minded men at the turn of the twelfth and thirteenth centuries "naturally" viewed the large events of their day—Islamic power, the vicissitudes of the Crusades, the phenomenon of Frederick III, the flowering of the carnal church on the one hand and of the "heretics" on the other, the ubiquitous thirst for an authentic evangelical life —in terms of scriptural, historical expectations.

The "natural" connections between the nascent Franciscan movement and what we may loosely call "Joachimism" were many and varied, but one of the strongest bonds was poverty. The defining feature of primitive Franciscanism was the doctrine of evangelical poverty, but evangelical poverty proved to be a concept open to various and controversial interpretation. Certainly one of the most dynamic forces in the order's history in the period between the death of Francis and the end of the fourteenth century was the continuing contest between alternative and discordant visions of poverty. The history of this debate is easy neither to summarize nor to characterize in brief compass. It is too often presented—and never more sharply than in primitive Franciscan documents themselves—as a simple contest of heroes and villains, of those who would be true to the unmediated law of Christ as dictated through the Franciscan rule and Francis' *Testamentum* and those backsliders and summer soldiers who sought to accommodate the vision of Franciscan life to the compromised expectations of a carnal church and the laws of men. It was, of course, far more complex; but its importance for the history of European art and literature is indeed often nearer its surface than its center.

The poverty debate, though centered in the Franciscan Order, reverberated throughout Europe.[39] It was a prominent topic in

[39] The most recent general study of Franciscan poverty is by M. D. Lambert, *Franciscan Poverty* (London, 1961). There are a number of relevant

papal politics between Gregory IX and John XXII, and it was avidly followed, and joined, in the secular realm as well. Its themes commanded not merely theoretical discussion of Christian perfection throughout Europe but also the very practical and often undignified struggle between friars and secular clergy in the parishes of every land. We see Jean de Meun and Geoffrey Chaucer toying with its issues in witty and wicked ways for an obviously *au courant* lay audience. The poverty contest made the Franciscan rule a document in the public domain, and its scriptural images of ascetic renunciation, its scrips and staves and sandals, became the materials of a powerful and polemical iconography.

In particular, ideas of poverty and prophecy often went together in the thirteenth and fourteenth centuries; and a prophetic vision of history, often of an explicitly Joachimist stamp, characterized the *fraticelli* and a number of the more conspicuous figures in the tradition of Spiritual Franciscanism, including John of Parma, Hugh of Digne, Angelo Clareno, Olivi, and Ubertino da Casale. There were numerous attempts to read the advent of Francis of Assisi into the scheme of the three *status*, and not all of them were so dangerous or so embarrassing as that of *The Everlasting Gospel*. It would be certainly wrong to describe such ideas, in and of themselves, as heretical. Although Bonaventure was, in a strict sense, an anti-Joachimist, his whole attitude toward history, and in particular his explicit desire to see the meaning of Francis of Assisi within an apocalyptic framework, permanently established the legitimacy within Franciscanism of a "prophetic" historical view that was, indeed, commonplace.

The statement of Bellini's painting is Joachimist in this general and entirely orthodox sense, and it exploits ideas, themes, and images—such as the ecclesiological significance of Aaron and Moses or the Angel of the Sixth Seal—that had long before Bellini's time become the common fare of Franciscan Joachites. It is a pity that the whole question of Joachimist iconography in European painting of the Middle Ages and the Renaissance—particularly in the Netherlands and in the Italian Quattrocento—still awaits systematic study, for it is probable that such investigation would

articles in the collection of M. Mollat, *Etudes sur l'histoire de la pauvreté*, 2 vols. (Paris, 1974).

offer a useful comparative context against which Bellini's achievement could be more intelligently assessed.[40] It might also pay tardy homage to Joachim's own career as a Venetian artist. Above the sacristy doors in San Marco are twin medallions of Francis and Dominic, widely credited in legendary history to have been painted by Joachim himself in the twelfth century in prophetic anticipation of the advent of the "raven" and the "dove," the two new orders of angelic renovation within the Church.[41]

From one point of view, Joachimism is merely a peculiarly biblical view of human history in which human time and divine time could be reconciled and in which current events could be seen as the reflex and afterlife of biblical events. This mode of thought was one fundamentally shared by Francis and his followers; and a kind of radical biblicism, though by no means unique to the Franciscan Order, is the invariable characteristic of Franciscan history and art. Francis himself lived as though the road to Cortona came first to Capernaum, and his own words and those used of him by others were first the words of the prophets and the evangelists. A classic Franciscan text, the *Sacrum Commercium* for example, is built phrase by phrase with biblical words, just—as I hope to show—as a classic Franciscan painting is built image by image of biblical things.[42]

It is not to be expected that a single example can serve the complexity of this Franciscan biblicism, but one of Francis' most delightful and charmingly spontaneous actions might come close. At Eastertide, at Greccio, Francis played a marvellous lark on the brothers. He snuck out of the room when they were not looking, put on the costume of a beggar, and returned to beg at their door.[43] Both the action itself and its treatment in early biography are full of wonderful instruction.

We see, in the first place, something of Francis' habitual, natural,

[40] See, however, Donald Weinstein, *Savonarola and Florence* (Princeton, 1970), pp. 334ff. and cited bibliography.

[41] See Camillo Botto, *La Basilica di San Marco*, III (Venice, 1888): 371; Guido Bondatti, *Gioachinismo e francescanesimo nel dugento* (Santa Maria degli Angeli, 1924), p. 150.

[42] See Fleming, p. 81.

[43] *Vita secunda*, xxxi, 61; *Legendae*, pp. 167-168. The passages discussed are all included in this chapter.

and spontaneous theatricality, what one critic has nicely called his "instinct for pantomime, that Italian sense of mimickry and imitation which renders dramatic every little no less than every great event or dialogue."[44] Francis was a player, an actor; his remark that the Friars Minor were "God's troubadours" has been so often sentimentalized or trivialized that we are in danger of forgetting just how seriously it was meant. In the little story of the Easter meal at Greccio, we see no mere casual witticism but an attempt to create and exploit mimetic illusion. Francis creeps out of the room "stealthily, on tip-toe" (*furtim et pedententim*), in order to surprise the friars. He costumes himself with stage properties, a poor man's hat and a walking stick. He speaks in what must be an assumed stage voice, for the friars do not recognize him until he comes through the door. There is, in short, a good amount of the contrived deception of the theater about the whole episode. At the same time, however, the scene is richly informed by extrinsic suggestions that would have been obvious both to Francis and to his "audience." The whole episode is, in fact, a slightly modified rendition of the twelfth-century liturgical play on the Easter meal at Emmaus, the *Ordo Peregrinorum*, in which Christ, dressed with a pilgrim's hat and staff, comes unrecognized to his disciples to be made known to them "in the breaking of the bread."[45] In other words, Francis, though he is "playing" Christ, does so from the script of a theatrical "role" familiar from his contemporary dramatic repertory.

That Thomas of Celano is aware of every bit of this, and more, must be evident from the terms in which he presents the episode in his biography. After reciting the story, he comments, "Similem hunc fuisse peregrino illi, qui solus erat in Ierusalem eodem die, facti series probat. Cor nihilominus ardens in discipulis, dum loqueretur, effecit" ("Thus was he like that pilgrim who was alone that day at Jerusalem, as the rest of the story shows, for his words no less inflamed the hearts of his disciples"); this sentence not merely points with explicitness to Luke 24 but actually paraphrases its lan-

[44] Hilarin Felder, *Der Christusritter aus Assisi* (Zürich, 1941), p. 115.

[45] See Karl Young, *The Drama of the Medieval Church* (Oxford, 1933), I, 688. I owe this general perception to a conversation with my friend Julia Holloway.

guage. He addresses the problem of the actor's deception with the single word *verus*: "Clamat verus pauper ad ostium" ("The true poor man calls at the door"). Francis is no mere feigned poor pilgrim, dressed like Tristan in a cockle-hat; he is a *real* pauper. The implication, in fact, is that it is the "paupers" within, gathered around their festive table, who are the fakers.

Yet what is to me most interesting in Thomas' narration is the kind of thoroughgoing if subliminal theological copyediting it has undergone. The author very clearly sees and understands the larger biblical themes of the story as they apply to the Order of Friars Minor. The story is, in effect, a dramatic exemplification of the sixth chapter of the *Regula bullata*, "Quod nihil approprient sibi fratres, et de eleemosyna petenda et de fratribus infirmis," which is at once an injunction to poverty, a prescription of the spirit in which begging should be undertaken, and finally, a stipulation of how sick friars should be treated. All of these elements, of course, are highlighted in Thomas' story. But so also is the biblical metaphor of pilgrimage around which the chapter is built: "Et *tamquam peregrini et advenae* in hoc saeculo, in paupertate et humilitate Domino famulantes, vadant pro eleemosyna confidenter; nec oportet eos verecundari, quia Dominus pro nobis se fecit pauperem in hoc mundo." The phrase "pilgrims and strangers" is a citation of I Peter 2:11, "Dearly beloved, I beseech you as strangers and pilgrims, abstain from fleshly lusts, which war against the spirit," which is itself an allusion to Psalm 38:13.

Yet what might be called the "allegory" of Francis' little play, its historical connections with the Emmaus story in Luke, merely ministers to a tropological intention. The whole point of Francis' play-acting is to make a moral point, not to sound a hollow typological resonance. Francis is an imitator of Christ not because of a false voice or a funny hat, but because he *represents*, in the medieval sense of that word, the humility and the poverty of a friar minor. Thus far Thomas of Celano is merely drawing out of the episode some of the implications that spring from Francis' mental habit of thinking of the order as a pilgrimage, an extension of the Exodus. But now he goes further, revealing a more complex set of scriptural associations. Francis, stranger and pilgrim, begs at the door; the friars at table invite him in. They see him, and the jig is up. Imagine,

says Thomas of Celano, the surprise of the *burghers*: "Sed quantum stuporem credis peregrinum civibus intulisse?" Why are the friars called "burghers"? The answer is that, quite clearly, Thomas of Celano wishes to introduce the reproach from Hebrews 13. Jesus suffered "without the gate"—that is, as an exile. We should do likewise. "Let us go forth therefore unto him without the camp, bearing his reproach. For here we have no continuing city, but we seek one to come" (Heb. 13:13-14). This passage "naturally" occurs to him because of its parallels with Francis' own thought in the rule and because it is introduced with the injunction, "Be not forgetful to entertain strangers: for thereby some have entertained angels unawares" (Heb. 13:2). And of course, Francis *is* an angel—the Angel of the Sixth Seal.

Since I believe that the controlling vision of Bellini's painting is one that unites an understanding of Franciscan biography with a special understanding of the Scriptures, and in particular the history of the Exodus, much of my iconographic analysis will depend upon certain recurrent typological correspondences. It is worth making the point from the start that there is nothing novel or unusual in the *fact* that Bellini examines a thirteenth-century life in an Old Testament landscape. His painting is a hagiographical construct —in form and pigment, to be sure, rather than in cadences and phrases—and it reveals a number of the structural conventions of its genre.

Medieval saints' lives are, as a whole, about as derivative and formulaic as the international popular tale or the jokes about travelling salesmen. In them, stock characters, situations, dialogues, appear and reappear. Yet the familiarity of the holy man, instantly recognizable to readers of the classics of early Christian biography and of the Bible, is an affirmation of authenticity rather than an invitation to skepticism. This approbation of apparent plagiarism finds its classical statement in the literature of monastic hagiography in the *Dialogues* of Gregory the Great. In the lives of the latter-day saints of Italy, the mighty wonders of the Old Testament "monks"— Moses, Elijah, Elisha—echo and reëcho. If Moses struck water from the flinty rock, so did Benedict. If the iron swam for Elisha, so did it swim for Benedict. Gregory does not find this disturbing; on the

contrary, he finds it entirely just and congruent that the virtue that manifested its power in the miracles recorded in the Scriptures manifests it still in the lives of modern holy men who are its heirs. Of Benedict, Gregory writes, "This man was filled with the spirit of *all* just men."[46] The biblicism of late medieval hagiography is no less radical. How, indeed, could it be otherwise? The God of Bernard and of Dominic and of Francis is none other than the God of Abraham and of Isaac and of Jacob. He who sustained the vineyards and valleys of Judah sustains those also of Umbria and of Burgundy.

It would be a mistake, however, to view the typological motifs that command early Franciscan biography as entirely or even primarily the imposed and retrospective inventions of posterior analysis. It is true that for, say, Bonaventure Francis was a second Moses and that for the whole tradition summarized by Barthelmy of Pisa he was a second Christ; but there is also a profound sense in which, quite clearly, Francis had seen himself in such terms too. That is, early Franciscan writers do not impose a biblicism on their materials; they find it waiting to be drawn out. To put this in another way, the kind of resonances that early Franciscan writers find between Francis and Christ are markedly similar to those found by the evangelists between Jesus and the prophets. The fundamental justice of patristic exegesis, as many New Testament scholars now recognize, is that it is a mode of reading "in the same spirit as the author writ." The spiritual connections between the Mount of the Transfiguration and Mount Sinai were *discovered* by Jerome and Augustine, not *fabricated* by them. The congruences themselves are a radical part of the gospel narrative.

I think that it is imperative to bear such principles in mind as we approach the Bellini painting, even if at first blush they seem to complicate rather than to ease our task. That is, before we can say with confidence that any particular element in the Bellini strikes a resonance with Franciscan tradition we may be asked to address the deeper question of the biblical resonances of "Franciscan tradition." There is a donkey in the painting. Meiss thinks it possibly, Smart

[46] "Vir iste spiritu iustorum omnium plenus fuit" (*Dialogus ii*, 8). On the whole subject, see the excellent article of B. de Gaiffier, "Miracles bibliques et vies des saints," *NRT* 88 (1966): 376-385.

certainly, alludes to an episode in the literary history of the Stigmatization.[47] Francis, exhausted from illness and ascetic vigil, needed to be carried up the height of Mount Alverna; his disciples accordingly borrowed a beast from a peasant. The episode is, in fact, an obvious thematic echo of Jesus' *descent* from the Mount of Olives (Matt. 21:1; and parallels). Though my own view is that Bellini's is a "donkey" of another iconographic color, it would in any event be insufficient to try to explain the image in terms of the passage in the *Considerazioni* without also considering its literary affiliations with the gospel of Palm Sunday, for the one event is completed only by the other.

I think that we shall be seriously distracted from a deep understanding of the painting as long as we hope to find in it a precise narrative—"St. Francis receiving the stigmata," "St. Francis composing the *Cantico*," or the current favorite, "St. Francis composing the *Cantico* while receiving the stigmata."[48] It is, to be sure, full of narrative and historical *allusions*, but it is not itself a "story" bound by space and time. Let me attempt to construct an analogy between the Bellini painting and a classic work of Franciscan literature—perhaps *the* classic work of Franciscan literature—a book that one learned man of the fifteenth century said was worth all the books that had ever been written in the history of writing. In the prologue to the *Itinerarium Mentis in Deum*, St. Bonaventure tells us, "I ascended to Mount Alverna as to a quiet place, with the desire of seeking spiritual peace; and staying there, while I meditated on the ascent of the mind to God, amongst other things there occurred that miracle which happened in the same place to the blessed Francis himself, the vision namely of the winged Seraph in the likeness of the Crucified."[49] Bonaventure gives us a "narrative situation," so to speak. I cannot believe, however, that anyone would think he could make an adequate description of the subject of the *Itinerarium Mentis* in "narrative" terms. The subject of the *Itinerarium Mentis*,

[47] Meiss, p. 23; Smart, p. 472.

[48] Giles Robertson, *Giovanni Bellini* (Oxford, 1968), p. 77: "We see here not only the representation of the stigmatisation but at the same time an illustration of the Hymn to the Sun in the Laudes Creaturarum."

[49] *Itinerarium Mentis in Deum*, prologue, 2; *Opera*, V, 295; trans. de Vinck, *The Works of Bonaventure*, I, p. 6.

that is, is emphatically *not* "Bonaventure's ascent of Alverna" or "Bonaventure sees the Seraph." The actual subject of Bonaventure's great book is much better suggested by the title that he himself actually gave it—*Speculatio pauperis in deserto*, or "The Meditation of the Poor Man in the Desert." Likewise, the best title given to the Bellini painting is that given by Marcantonio Michiel in 1525: *San Francesco nel deserto*. The similarity of the two titles is not coincidental.

The Desert, Moses, Elijah

Though critics disagree as to the subject matter of *San Francesco nel deserto*, nearly all agree upon its setting. The rocky escarpment upon which St. Francis stands represents Mount Alverna. In fact, as Meiss and others have rightly pointed out, the mountain that Bellini depicts here so authentically suggests the actual geological formations of the real mountain that it seems likely that Bellini drew upon his own or others' direct visual experience.[1] Under these circumstances, it is somewhat idle to ask whether Bellini has imposed on this wild landscape a "symbolic" meaning. There was no need for him to do so, since God Himself had marked the mountain of the Stigmatization with outward and visible signs that pointed to its hidden mystery. At the consummation of Christ's Passion, "the veil of the temple was rent in two from the top even to the bottom, and the earth quaked, and *the rocks were rent*" (Matt. 27:51). That these rocks were those of Alverna Barthelmy of Pisa is unequivocal.[2] Like the "things" of Scripture, this Italian mountain had not merely being but *meaning*. Its height meant *mentalis elevatio*, its purity the purity of the stigmatized, its remoteness the remoteness of ascetic withdrawal. Any painter who sought to be realistic would perforce aim to capture these real qualities.

Alverna, though a mountain, is also a desert. Marcantonio Michiele called it a desert, and it is as desert that we shall come to know

[1] Meiss, p. 22.

[2] "Nam tempore passionis, ut patet in Evangelio, *petrae scissae sunt*; quod singulari modo in monte isto apparet." *Liber Conformitatum*, II, 387.

its topography and ecology. The desert of Alverna is, in fact, the first of many scriptural images to claim our attention. There are in the New Testament images of the desert three principal and cognate strands of complex meaning.[3] The desert is, in the first place, the special abode of demons, a place of supernatural dangers. The Gadarene demoniac was "driven by the devil into the deserts" (Luke 8:29); "When an unclean spirit is gone out of a man, he walketh through dry places" (Matt. 12:43). The demonic population of the desert makes of it a special place of testing and temptation; and the principal ascetic image of the gospels, and of all of medieval religious life, is Christ's eremitic fast of forty days. This is the second and more important meaning of the desert for Christians, for every Lent is a desert and every desert a Lent. Though Christ's victory over the "three temptations" of the Tempter gives this ascetic significance of the desert its definitive expression, that significance is attested to as well by all those saints of the old Israel "who lived by faith," those "of whom the world was not worthy; wandering in deserts, in mountains, and in dens, and in caves of the earth" (Heb. 11:38). The third meaning is ecclesiological. The desert is the special arena of the people of God, Israel, the Church; and Paul's powerful typological intuition of the Exodus history (I Cor. 10) plaits into a single stout cord the strands of ancient and modern church history.

It was the "desert church" that seems to have most decisively captured the imagination of Francis and Bellini alike, and we shall have a good deal to say of it in another chapter. In other visions of Christian perfection, it is often the more personal "deserts" of demonic warfare and ascetic penance that become the commanding themes, and thus we find them in the first chapter of the *Considerazioni*.[4] Francis withdraws to the desert mountain of Alverna, "monte molto solitario, e salvatico," with the express aim of prayer and penance (*orazione e fare penitenzia*); and he is almost imme-

[3] I follow the categories of Pierre Bonnard, "La Signification du désert, selon le Nouveau Testament: Essai sur l'interprétation théologique, par l'église primitive, d'un concept historio-géographique," *Hommage et reconnaissance: Recueil de travaux publiés à l'occasion du soixantième anniversaire de Karl Barth* (Neuchâtel, 1946), 9-18.

[4] Gemelli, pp. 228ff.

diately attacked by a large gang of fierce devils (*una grande molti-
tudine di demonj ferocissimi*). Even a casual reading of this episode
of spiritual warfare will reveal the intermediary literary text inter-
posed between these Bible images and their Franciscan expression.
It is the *Vita Antonii*, the most influential work of monastic hagiog-
raphy ever penned, and possibly the most important fiction of late
Antiquity.[5] The *Considerazioni* makes of Francis of Assisi a Desert
Father in the mode of the greatest of all Desert Fathers, Anthony,
the "father of monks."

Thus also Bellini points his eremitical imagery toward the idea of
Francis as a "monk" and by implication toward the Franciscan
renovation of the religious life. Two related phenomena—the im-
portance of religious houses as patrons of art, and the great popu-
larity of such ascetic subjects as Anthony and Jerome—guarantee
a certain deceptive familiarity to the eremitical landscape of Al-
verna, elements of which are readily identifiable in hundreds of
Renaissance paintings, including many of Bellini's own. It is a dan-
gerous familiarity, for too often the art historian succumbs to the
temptation to "explain" the familiar elements as mere visual clichés.
That many of the features of Bellini's Franciscan landscape are tra-
ditional I shall not for a moment deny; but I want to argue, strenu-
ously if necessary, that its traditions sharpen rather than blur the
focus of spiritual meaning.

Animal life, while less fecund in *San Francesco nel deserto* than
in many other paintings of its spiritual genre, is certainly prominent.
The most insistent form in the painting, aside from that of Francis
himself, is some kind of donkey; and there are two remarkable birds
—identified as a grey heron and a bittern—a rabbit, and, in the dis-
tance, a flock of sheep. What do they tell us about Bellini's "mean-
ing"? Meiss' discussion of their iconological possibilities is vague and
inconclusive, but also tolerant and open-minded. Though he does
not firmly deny the possibility of precise allegorical intention, he
suggests that these desert creatures are visual clichés that "seem to
be present as representatives of the wild creatures that accompany
holy hermits and as manifestations of the Quattrocento love of the
natural world."[6] He adduces numerous but imprecise parallels from
a wide range of paintings by Bellini and others—a deer in one Giam-

[5] *Vita Antonii*, VIII, 2; ed. G.J.M. Bartelink (Milan, 1974), p. 24.
[6] Meiss, pp. 22-23.

bono, a bird in another, a donkey in the Niccolini *Crucifixion*, and so forth—but he ends in agnosticism and romantic speculation: "Whether . . . as *specific creatures* they are connected with objects and events in the legend of the saint, and also symbolize more general religious concepts—is, as often, difficult to say. Perhaps we may recognize in the rabbit the leveret that St. Francis protected. The ass is possibly the one that carried the saint up Mount Alverna."[7]

I have a different view. I think that we shall recognize the meaning of Bellini's birds and beasts not by reference to other paintings nor to the vast zoology of Franciscan hagiography, but by recognizing their habitat. Giovanni Bellini's desert is the Tuscan mountain called La Verna, but we must be prepared to discover that its flora and fauna are those of the Levant. That is to say, while the artist's command of animal anatomy and vegetable forms reveals a close empirical observation, his vision of animal ecology would seem to reflect the literary sources of the Scriptures, and his desert wildlife gives visual form to the poetic diction of the Psalms, Isaiah, and Job.

Medieval "orientalism" took varying forms, some of a popular nature, such as the enduring cult of Antony Abbot or the innumerable adaptations and vernacularizations of the *Vitae Patrum*. These mild exoticisms were fostered and encouraged by monastic groups.[8] At no time during the Middle Ages did Latin monasticism totally lose sight of its Eastern origins, and in the renewal of European religious life in the twelfth and thirteenth centuries, a renewal given clearest institutional expression, perhaps, by the rise of mendicancy after the Fourth Lateran Council, the spiritual memory of Nitria and Scete was the conscience of reforming zeal. "As the brethren of Mont-Dieu introduce to our western darkness and French cold the light of the East and that ancient fervor of Egypt for religious observance," writes William of St-Thierry in a passage justly famous, "run to meet them, O my soul!"[9]

[7] Meiss, p. 23.
[8] See Gregorio Penco, "Il Ricordo dell'ascetismo orientale nella tradizione monastica del medio evo europeo," *Studi medievali*, ser. iii, 4 (1963): 571-587.
[9] *Epistola ad fratres de Monte Dei*, I, i; in *The Golden Epistle*, trans. T. Berkeley (Kalamazoo, 1976), p. 9.

The *orientale lumen* was in fact a religious vision in poetic form, a bookish image of ascetic life kept alive by a monastic library of spiritual classics, which made available to a Latin audience the ignorant wisdom of the desert saints. Preeminent among its volumes were the works of John Cassian, a Provençal monk of the fifth century who made his life's work the firsthand study of the asceticism of the Eastern deserts and its practical adaptation in the Latin West. His two most famous books, the *Conferences* and the *Institutes*, are fundamental texts of Western monasticism, and no other single writer, not excepting Benedict himself, who was one of Cassian's earliest and most respectful disciples, wielded a greater influence over the technical vocabulary of medieval religious life or the manner in which medieval monks thought and wrote about the "life of the desert."

The eighteenth "conference," given by Abbot Piamun, is concerned with the "three kinds of monks," here defined as cenobites, anchorites, and Sarabaites.[10] Of these, the Sarabaites are rejected out of hand as reprehensible, and Piamun moves directly to the cenobitic life, the life of monastic community, which for him is that described in the Acts of the Apostles (4:32): "And the multitude of believers had but one heart and one soul: neither did any one say that ought of the things which he possessed was his own, but all things were common unto them." From this form of the perfect life, another, higher still in aspiration, sprang. That was the life of the anchorite, the hermit, a life classically exemplified by Paul and Anthony, but founded long before them by the desert monks of Scripture.[11]

Thus, writes Cassian:

> from the first practice which we have described proceeds a second form of the perfect life. Its followers [*sectatores*] are rightly called anchorites or recluses [*secessores*]. Not content with that victory whereby in the society of men they crushed underfoot

[10] "Conlatio Abbatis Piamun de tribus generibus monachorum," XVIII, iv: "Tria sunt in Aegypto genera monachorum, quorum duo sunt optima, tertium tepidum atque omnimodi euitandum." Jean Cassien, *Conférences*, ed. E. Pichery (Paris, 1959), III [Sources chrétiennes, 64]: 14.

[11] See A. J. Festugière, "Lieux littéraires et thèmes de folklore dans l'hagiographie primitive," *Wiener Studien* 73 (1960): 123-152.

the devil's hidden traps, eager to face the demons in open battle, they fear not to penetrate the vast wastes of the desert. This they do in imitation of John the Baptist, who spent his whole life in the desert, and of Elijah and Elisha and of those whom the Apostle recalls: "They wandered about in sheep-skins, in goat-skins, being in want, distressed, afflicted, of whom the world was not worthy, wandering in deserts, in mountains, and in dens, and in caves of the earth" [Heb. 11:37-38]. Of these the Lord speaks allegorically to Job: "Who has freed the wild ass, and loosed his chains? I have given him the desert for a habitat, and the barren land for a tabernacle. Scorning the multitude of the city, not hearing the querulous voice of a master, he looks about the mountains of his pasture" [Job 39:5-8]. Likewise in the Psalms [6:2] "Let them say so that have been redeemed by the Lord, whom he hath redeemed from the hand of the enemy"; and a little later: "They wandered in a wilderness, in a place without water: they found not the way of a city for their habitation. They were hungry and thirsty: their soul fainted in them. And they cried to the Lord in their tribulation: and he delivered them out of their distress." Jeremiah describes them thus: "Blessed is the man who has taken the yoke upon him from his youth; he shall sit solitary and hold his peace, for he has taken it upon himself" [Thren. 3:27-28]. By their aspirations and deeds they join voice with the Psalmist: "I am become like to a pelican of the wilderness. I have watched, and I have become as a sparrow, all alone on the house top" [Ps. 101:7-8].[12]

[12] Conlatio, XVIII, vi, in *Conférences*, III, 17-18: "Ita ergo processit ex illa qua diximus disciplina aliud perfectionis genus, cuius sectatores anachoretae id est secessores merito nuncupantur, eo quod nequaquam contenti hac uictoria, qua inter homines occultas insidias diaboli calcauerunt, aperto certamine ac manifesto conflictu daemonibus congredi cupientes uastos heremi recessus penetrare non timeant, ad imitationem scilicet Iohannis Baptistae, qui in heremo tota aetate permansit, Heliae quoque et Helisaei atque illorum de quibus apostolus ita memorat: *Circumierunt in melotis et in pellibus caprinis angustiati, adflicti, egentes, quibus dignus non erat mundus, in solitudinibus errantes et montibus et speluncis et in cauernis terrae.* De quibus etiam figuraliter dominus ad Iob: *Quis autem est qui dimisit onagrum liberum, et uincula eius resoluit? Posui habitaculum eius desertum, et tabernacula eius salsuginem: inridens multitudinem ciuitatis, et querellam*

That, in all its poetic divagation, was the copybook definition of a hermit for the monastic Middle Ages.

As we shall see, all of the animals and birds of Alverna are identified in this and other closely related monastic texts; but the most striking in Bellini's "conference" no less than in Abbot Piamun's is the *onager* in the middle distance (fig. 2). This beast is not "the one that carried the saint up Mount Alverna." It has known no shoe nor crop nor brand, nor ever will. This is a wild animal, a native of these parts. His back is turned to the city, and he pays no attention to the animal *exactor*, the shepherd wittily positioned behind him in a fertile plain that is in a different world from his rugged but satisfying mountain pasture. "Who hath set out the wild-ass free, and who hath loosed his bonds? To whom I have given a tabernacle in the wilderness, and his dwellings in the barren land. He scorneth the multitude of the city; he heareth not the cry of the driver. He looketh round about the mountains of his pasture, and seeketh for every green thing."

The word *onager* is a hard one, which invited definition and exegetical comment, and this we find everywhere in medieval Bible dictionaries. The first of these would seem to be the handbook compiled by Eucher of Lyon in the first half of the fifth century, the *Formulae spiritalis intelligentiae*;[13] in the fourteenth century, the Franciscan Alvaro Pelayo would define it with a single word: *heremita*.[14] Of course, it is an image used by Bonaventure.[15] The com-

exactoris non audiens, considerabit montes pascuae suae, et post omne uiride quaerit. In Psalmis quoque: *Dicant nunc qui redempti sunt a domino, quos redemit de manu inimici.* Et post pauca: *Errauerunt in solitudine in inaquoso. Viam ciuitatis habitaculi non inuenerunt, exurientes, et sitientes: anima eorum in ipsis defecit. Et clamauerunt ad dominum cum tribularentur: et de necessitatibus eorum liberauit eos.* Quos etiam Hieremias ita describit: *Beatus qui tulit iugum ab adulescentia sua, sedebit solitarius et tacebit, quia leuauit super se.* Quique illud Psalmistae adfectu et opere concinunt: *Similis factus sum pellicano solitudinis. Vigilaui, et factus sum sicut passer solitarius in tecto.*

[13] *Formulae spiritalis intelligentiae*, iv; in Corpus Scriptorum Ecclesiasticorum Latinorum 31:26.

[14] Alvaro Pais, *Colírio de fé contra as heresias*, ed. Miguel Pinto de Meneses (Lisbon, 1956), II, 294: "*Onager*, heremita. In Iob: 'Quis dimittet onagrum liberum?'"

[15] Bonaventure associates the *onager* with the two principal Franciscan

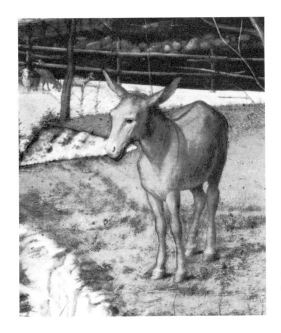

2. *Bellini*, San Frances-
co, *detail: the* onager.

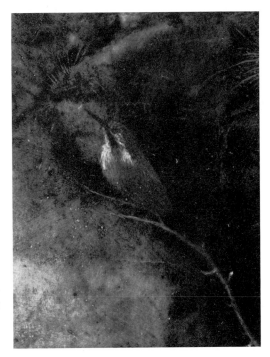

3. *Bellini*, San Frances-
co, *detail: the bittern*
(nycticorax?).

manding dominance of John Cassian in the creation of a verbal
iconography of the ascetic life is so marked that we may regard the
eighteenth "conference" as the *locus classicus* of the image's devel-
opment, but its popularity and authority was absolutely guaranteed
by its prominent use by Gregory in the *Moralia*.[16] Bellini's use of
the *onager* as an emblem of eremitic life is a commonplace, though
in the context of his panel, one of considerable visual originality.[17]

But there was also a more specific and pointed interpretation of
the image, which linked it with other major concerns of early Fran-
ciscan apocalypticism. I refer to Joachim of Fiore's identification of
the *onager* with the "spiritual men" of the third *status*, those men
whom many Franciscan Joachites, and possibly Bonaventure him-
self, saw typified in Francis of Assisi. The prophet writes thus:
"Gaudium ergo onagrorum sunt pascua gregum donec effundatur
super nos spiritus de excelso. Quia tamdiu viri spirituales qui desig-
nantur in onagris gaudent in pascuis scripturarum, quamdiu abun-
dantiam illam spiritus non habent."[18] Joachim here cites not Job, but
the collateral passage in Isaiah 32:14-15: "For the house is forsaken,
the multitude of the city is left, darkness and obscurity are come
upon its dens forever, a joy of wild asses, the pasture of flocks; un-
til the spirit be poured upon us from on high: and the desert shall
be as a charmel, and charmel be counted for a forest." Here also
was the scriptural source of a paradoxical image dear to the ancient
monks of Egypt: "the desert a city!"

In the famous passage in Cassian's history of the monastic life, that
life's highest form, eremitic anchoritism, is betokened not merely
by a desert beast, the *onager*, but also by desert birds. So also on Bel-
lini's Alverna we find the *onager* associated with two marvellously
realized birds. So masterful is Bellini's technique that we can iden-

disciplines: penance (second Epiphany sermon [*Opera*, ix, 153]) and poverty
(fifth Annunciation sermon [*Opera*, ix, 676]).

[16] *Moralia in Job* 30:50.

[17] See Gregorio Penco, "Il Simbolismo animalesco nella letteratura mo-
nastica," *Studia monastica* 6 (1964): 19-20. Penco's richly documented ar-
ticle is a major contribution to the study of ascetic iconography and merits
the attention of art historians.

[18] *Liber Concordie Novi et Veteris Testamenti* (Venice, 1514), f. 133r., as
cited by Reeves, p. 138n.

tify them with certainty as a grey heron and a bittern, as we would name them today. This "naturalism" has won warm and deserved praise: "They are wonderfully observed, especially the bittern, though Bellini of course did not seek the precision of Audubon."[19] The considerable precision he did achieve, however, is enough to tempt us to look for no meaning beyond their richly satisfying forms. It is therefore worth making the point that there are strict limits to Bellini's trustworthiness as a naturalist, for to assign two waterfowl to a desert mountain, even one irrigated by a miraculous trickle, is not ornithological realism.

The Abbot Piamun joined together the *onager* from Job with the birds from Psalm 101, but his citation of the relevant verses was elliptical. There are in the integral text three, not two, examples of desert birds. In addition to the "pelican of the wilderness" and the roof-nesting sparrow, there is also a *nycticorax*, a rare word rendered by the Douay translators as "night-raven." The imprecise history of zoological and botanical terms stymies iconographic exactitude time and again in the analysis of premodern art, and those of the Bible in particular are often especially impenetrable. English-speakers, who cannot agree on what a robin is, are unlikely to share certainty about a dragon (Job 30:29) or a behemoth (Job 40:15). I nonetheless suggest, cautiously, that Bellini's bittern and heron allude, respectively, to the *nycticorax* and the *pelicanus solitudinis*.

The *nycticorax*, whose solitary scriptural appearance is in this verse, seems to be a night bird and a dweller in deserted ruins. The bird is thus cognate with if not entirely identical with the only slightly less mysterious *ericius* or *erinacius* or *herenicius*. The latter is called a "bittern" in the Authorized Version, but it was probably actually a porcupine or a hedgehog. We must return to this philological mystery when we come to scrutinize Bellini's rabbit. The difference between a bittern and a porcupine is only slightly less pronounced than that between a hawk and a handsaw; so we are, to say the least, on uncertain ground. Nonetheless, Bellini probably means by his bittern perched among the rocks against the unilluminated shadow of a crevice (fig. 3) just what King James' translators meant by "bittern": a solitary bird of rocky deserts.

[19] Meiss, p. 11.

The iconological difficulty presented by the *pelicanus solitudinis* is, by contrast, the offspring of the word's lexical familiarity. Unlike the unfamiliar *nycticorax*, a rara avis indeed, a pelican is both well known and highly distinctive. Bellini himself seems to have known our pelican, for he has placed one in the background of his "Madonna with Child."[20] But a pelican is not a heron; so how can his grey heron (fig. 4) be considered a *pelicanus solitudinis*?

The simple answer is that *pelicanus/pelican* are false cognates. A Louisiana pelican is no more like a scriptural pelican than a guitar is like a scriptural *cithara*. A cursory iconographic survey of the well-known emblem of the "Pious Pelican" in the Middle Ages and Renaissance will reveal an entire aviary, birds we would be disposed to call pelicans, egrets, herons, eagles, storks, and swans, not to mention many we would be hard pressed to give a name to at all.[21] In ornithological terms, the "pelican" seems to be any large bird, especially any large water bird. In poetic terms, the pelican is almost any desert bird, so that the *pelicanus* and the *passerus* are treated as equivalents in monastic texts.[22] Whether the "pelican" is identical with Pliny's *onocrotalus* is an issue of patristic debate.[23] What for Jerome is *pelicanus* in Psalm 101 was *onocrotalus* in Leviticus 11:18. And Jerome draws a distinction between a "water onocrotalus" and a "desert onocrotalus."

It is Augustine who underscored for us those associations of the pelican that are most poetically appropriate for Bellini.[24] The peli-

[20] See Rudolph Wittkower, "Eagle and Serpent. A Study in the Migration of Symbols," *Journal of the Warburg Institute* 2 (1939): 322, and plate 53a; reprinted in Wittkower, *Allegory and the Migration of Symbols* (London: Thames & Hudson, 1977), p. 39 and plate 55.

[21] A goodly sample of medieval pelicans are gathered together in the whimsical letters of Roger W. Drury and Samuel S. Drury, *In Pursuit of Pelicans* (Privately Printed, 1931).

[22] Penco, "Il Simbolismo animalesco," p. 21.

[23] See the dauntingly learned remarks of Samuel Bochart, *Hierozoicon sive de Animalibus S. Scripturae*, ed. Rosenmüller (Leipzig, 1796), III, 18.

[24] Augustine's testimony deserves citation, for it is directed to scholars who peep and ornithologize upon their mothers' graves. *In psalmo ci*, vii [vv. 7-8]: "Primo quid sit pelicanus, dicendum est. In ea quippe regione nascitur, ut nobis ignota haec avis est. Nascitur in solitudinibus, maxime Nili fluminis, in Aegypto. Quaelibet sit avis haec, quod de illa Psalmus dicere voluit, hoc intueamur. *Habitat*, inquit, *in solitudine*. Quid quaeris formam

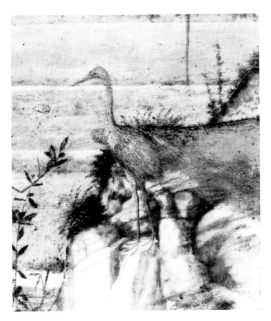

4. *Bellini,* San Frances-
co, *detail: the grey her-
on* (pelicanus solitudi-
nis).

5. *Line drawing of the
Fontaine de Vaucluse
by Francis Petrarch.*

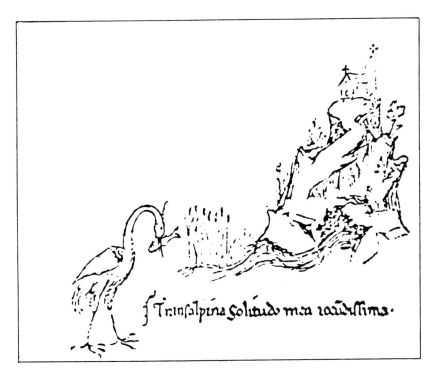

can is a dweller of the Nile, a water bird and an Egyptian bird.
Bellini gives us a wonderful rendition of a large and solitary water
bird, an ancient symbol of the eremitic life or what William of
St-Thierry had called "that ancient fervor of Egypt for religious
observance." Where ornithology and philology alike fail us, we are
safest in seeking Bellini's mind in the poetry of what Jean Leclercq
has nicely called the "monastic bestiary."[25] "Who has freed the
wild ass?"; "I have become like to a pelican of the wilderness."

There is corroboration of the heron's particular identification as
the *pelicanus solitudinis* in a casual drawing by one of the greatest
artists of the early Italian Renaissance. (It is aesthetically unfor-
tunate, but iconographically irrelevant, that he was not a great
visual artist.) Francis Petrarch decorated a leaf of his manuscript of
Pliny with a pen sketch of his rustic haunt at the Fontaine de Vau-
cluse, the source of the Sorgue River. He shows the cliff above the
fountain pool—upon which stood a chapel since destroyed—and a
suggestion of the Sorgue itself (fig. 5). In its waters stands a heron,
a fish in its mouth, and Petrarch has supplied a caption in one of his
unmistakable hands: *transalpina solitudo mea jocundissima*, or "my
most beautiful wilderness beyond the Alps."

Finally, there is the rabbit in the rock (fig. 6), after the *onager*
the most obvious monastic emblem of Bellini's desert. "There are
four very little things of the earth, and they are wiser than the wise.
The ants, a feeble people, which provide themselves food in the
harvest: the rabbit, a weak people, which maketh its bed in the
rock: the locust hath no king, yet they all go out by their bands;
the stellio supporteth itself on hands and dwelleth in king's houses"
(Prov. 30:24-28). The rabbit of the rocks finds a fruitful exegetical
confusion with the mysterious *erinacius* in the cognate text from
Psalm 103:18: "The high hills are a refuge from the harts: the rock
for the irchins [hedgehogs]." This hedgehog from the Septuagint
gets a spirited monastic interpretation in Cassian's tenth "confer-
ence" (Abbot Isaac on prayer) before returning to its less exotic

eius, vocem eius mores eius? Quantum tibi Psalmus dicit, avis est habitans
solitudine."

[25] Jean Leclercq, *Etudes sur le vocabulaire monastique du Moyen Age*
(Rome, 1961), p. 34. His precise phrase is "un Bestiaire symbolique de la vie
monastique."

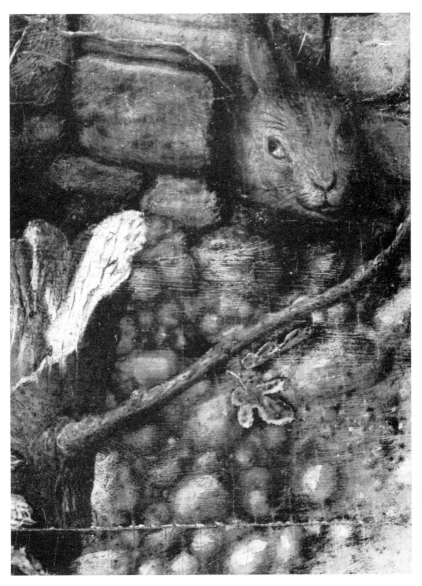

6. *Bellini*, San Francesco, *detail: the rabbit in the rocks.*

form as an occidental rabbit beneath the confident philological scrutiny of St. Jerome. We shall find rock-dwelling rabbits wherever we find hermits, for the rabbits *are* hermits.[26]

It is not my purpose here to survey the whole of the Hieronymite menagerie so thick on the ground in Renaissance ascetic landscapes, but art historians should not dispose of them too hastily as empty clichés or as "manifestations of the Quattrocento love of the natural world." The ass, the lizard, the pelican, the bittern, the rabbit, and the deer—not to mention, of course, the *erinacius*—have the clearest possible warrant as the monks of Holy Writ even before we turn to the abundant animal antitypes in the *Vitae Patrum* or the letter to Eustochium. That they could be used more casually by artists indifferent to or ignorant of their iconological claims seems abundantly clear from a survey of Renaissance deserts, but it will not do to arraign the master for the mediocrities of the apprentice. Bellini's eremitical fauna are wonderfully just. The *poverello* has in this painting only a leafy trellis as a shelter made by hands; but if he had a proper roof, we can be sure that in it there would be a proper nesting sparrow.

With his profound development of the desert theme, Bellini teaches us to look toward Francis as a founder of religious life in what we might call the great tradition of Western asceticism. Francis is here a hermit, a desert father, placed quite centrally within the visual context of a generalized monastic history. The inescapable prominence of the idea of stigmatization, the "unheard of wonder," will make powerful claims for his uniqueness within the economy of that history; but Bellini is also quick to show, as were the Franciscan exegetes whose ideas he shared, that Francis takes his place within a tradition of specific desert heroes in whose spirit and power he lives. To the most important of these associations we must now direct our attention.

As night fell on October 3, 1226, Francis lay naked on the bare earth of the Portiuncula compound and died as he had lived, "a pauper, crucified." Within a short time, perhaps within hours, Elias of Cortona was drafting an announcement of the founder's death to be sent to all of the provinces. This rhetorically artificial and

[26] Penco, "Il Simbolismo animalesco," p. 22.

ornate epistle, "half way to being a bull" as one historian has wittily put it, surrenders any sense of immediate and personal grief to the public purposes of the order as Elias saw them, the advertisement of the stigmata, till then a secret, and the nourishment of the cult. Perhaps in his mind's eye he could already see the great church of San Francesco, the most ironic building in Europe, towering over the hill at Assisi. "Pater et frater noster Franciscus migravit ad Christum," he writes. "Vos, ergo, carissimi fratres, ad quos litterae praesentes pervenerint, Israelitici populi sequentes vestigia, deplorantis Moysen et Aaron inclytos duces suos, viam demus lacrimis, tanti patris solatio destituti."[27] The metaphor is obvious—the Franciscan Order is a new Exodus; but one phrase is rather curious: Francis is both Moses *and* Aaron.

The significance of Francis' identification with Aaron will be the subject of detailed study in a later chapter. Our present task is to consider the meaning of his identification with Moses, and the first difficulty it presents is to distinguish between a specific Franciscan poetry and a general medieval cliché. There can hardly be a medieval saint who is not, in some way or another, compared by his biographers with Moses; certainly there can be no religious *legislator* who is not. One must admit from the start that the "Franciscan" Moses merges into a largely undifferentiated stereotype—"he was filled with the power of *all* just men"—but there are nonetheless a number of distinctive emphases in Franciscan thought, which, when taken together, sketch the profile of a distinctly Franciscan Moses. Many of these features are clear in Francis' own thought and writings; others are made explicit in the clearest possible terms by early Franciscan writers, and particularly in Bonaventure's theology of history.

I shall not repeat the work of a well-documented study by Sophronius Clasen, which adduces many (but still by no means all) of the most prominent primary texts that link Moses and Francis, but I shall attempt to enumerate some of the congruences that seemed most remarkable to early Franciscan writers and that most obviously inform Bellini's vision of Francis.[28] They are that (1) Francis

[27] "Epistola encyclica de transitu S. Francisci," viii; in *Legendae*, p. 527.
[28] Sophronius Clasen, "Franziskus, der neue Moses," *Wissenschaft und Weisheit* 24 (1961): 200-208.

and Moses are both leaders of a pilgrimage, an Exodus from Egypt;
(2) both are exemplary monks and religious founders; (3) both are
lawgivers; (4) both see a divine vision on a mountain; (5) both re-
ceive divinely written communications; and (6) both are associated
with Elijah and Christ in the Transfiguration.

All of these ideas, however unfamiliar they may at first appear,
were true Franciscan commonplaces at the end of the Middle Ages,
and each is relevant to a greater or lesser degree to the Bellini paint-
ing. One principal congruence between Moses and Francis is their
shared role as lawgivers. We see the Mosaic typology clearly at
work in those parts of the legend that describe Francis' spiritual re-
treat to a mountain when actually pondering the rule, but it is no
less important a strand in the history of the reception of the stig-
mata. Moses received a law written in stone, Francis one written in
his flesh. The sixth lesson for the Feast of the Stigmata in the *Roman
Breviary*, a lesson taken from Bonaventure (*Legenda Minor*, vi, 4)
reads in part as follows: "He came down from the mountain bearing
in himself the form of Jesus Crucified, not portrayed upon tables of
stone or wood by the hands of any earthly craftsman, but drawn
upon his flesh by the finger of the living God." The implied typo-
logical link between Alverna and Sinai is too obvious to command
statement, but an analysis of Bonaventure's allusive language in the
broader context of the whole chapter makes it clear that he thinks
of the stigmatized Francis in terms of *two* "mountain" episodes
from the life of Moses: his vision of the burning bush in Exodus 3,
where the mountain is called Horeb, and the reception of the tables
of the Law, when it is called Sinai.

For reasons we shall in time discover, Giovanni Bellini was most
interested in suggesting the relationship between Alverna and
"Horeb," and of the five most obvious Mosaic emblems in the paint-
ing, four make reference to the vision of the burning bush.

> Now Moses fed the sheep of Jethro his father-in-law, the priest
> of Madian: and he drove the flock to the inner parts of the desert,
> and came to the mountain of God, Horeb. And the Lord ap-
> peared to him in a flame of fire out of the midst of the bush: and
> he saw that the bush was on fire and was not burnt. And Moses
> said: I will go to see this great sight, why the bush is not burnt.

And when the Lord saw that he went forward to see, he called to him out of the midst of the bush, and said: Moses, Moses. And he answered: Here I am. And he said, Come not nigh hither. Put off the shoes from thy feet: for the place whereon thou standest is holy ground (Ex. 3:1-5).

The iconographical features of the Bellini painting that make most conspicuous allusion to the Moses of Horeb are the radiant laurel tree, the shepherd with his flock, the rabbit in the rock, and the abandoned sandals. There is, in addition, another and more general Mosaic allusion, to wit the spring of water flowing from the rock. The allusions are of differing sorts, so that both the distant shepherd and the diffident rabbit "are" Moses, but in markedly different ways. Let us look first at the shepherd (fig. 7). He is remote, anonymous, and unimportant; but Meiss, who notices everything, observed him "leaning on his crook and looking intently in the general direction of the saint." He went on to note that there are auxiliary shepherds enow in all sorts of Renaissance religious paintings, albeit none precisely like this one, and he allowed the possibility of an historical allusion: "Could he be one of those shepherds who, according to the legends, were witnesses of the miracle of Monte Alverna?"[29] Fletcher suggests that the shepherd is merely a happy bit of observed experience, a shepherd as Bellini might have seen one from the verandah of his villa in the Veneto.[30]

That Bellini's painting is filled with observed life only a madman would seek to refute, though I shall in a moment argue that he was much more likely to be interested in "nature" that was continuous with the supernatural than in nature that was not. What of the legends of testifying shepherds to which Meiss refers? I know of but one, in the *Actus/Fioretti*. In the *Considerazioni*, there are *mulattieri*, or muleskinners. But whether keepers of sheep or keepers of mules, they have an undoubted typological kinship with the shepherds of St. Luke who witnessed the Nativity. We cannot entertain the children without their parents.

But we shall best see this shepherd, I think, with Franciscan eyes, that is, with an attention poised for possible resonances between the

[29] Meiss, p. 26. [30] Fletcher, p. 212.

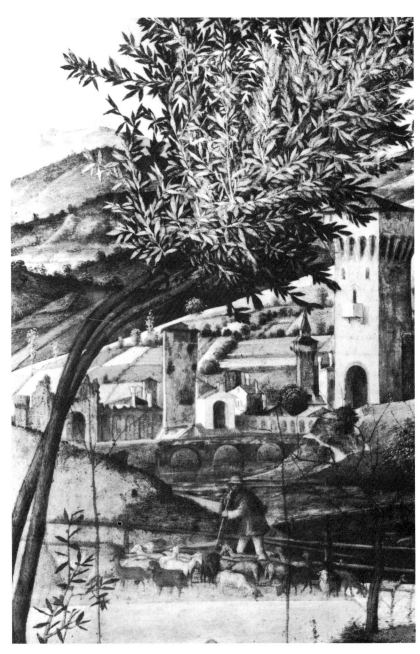

7. *Bellini*, San Francesco, *detail: the shepherd with his flock.*

old Moses and the new: "Now Moses fed the sheep of Jethro . . . and he drove the flock to the inner parts of the desert, and came to the mountain of God, Horeb. And the Lord appeared to him in a flame of fire out of the midst of a bush; and he saw that the bush was on fire and was not burnt." Perhaps this explains the iconographic oddity, as Meiss saw it, of Bellini's shepherd: "Only in the Frick panel does he seem engrossed with a religious event."[31]

Of course, the shepherd "is" a fifteenth-century swain such as might be seen in any pasture in Italy, and he may also be the Lukan shepherd of the *Actus/Fioretti*; but in a no less important way he also "is" the young Moses about to be called by God from the idiocy of rural life to become the deliverer of Israel. One could hardly describe his positioning in the Bellini painting better than with the words of the Authorized Version: Moses came "to the back of the wilderness." Such an iconographic construct is "fanciful" in the best sense, for it involves a witty and original reformulation of a traditional idea, allowing the artist opportunity for purposeful *vagare*. In and of itself, however, such a sprightly flourish is neither of great emblematic import nor of conspicuous utility in convincing literal-minded students of Renaissance painting. Bellini has in effect re-modelled an ancient form from the Byzantine iconography of Moses, a form very common in the illustration of Latin Bibles, which combines in continuous narration an image of Moses as shepherd with one of Moses discalcing before the burning bush (figs. 8 and 9). In *San Francesco nel deserto*, the pastoral figure could hardly be called obvious. Bellini whistles the tune, and we judge the music beautiful whether or not we recognize the composer. With the "burning bush" itself, however, his intention becomes decidedly more assertive. Meiss says that the shepherd stands "looking intently in the general direction of [Francis]," but I reckon he is looking at what Francis looks at, a peculiarly radiant shrub.

This stunning tree at the margin of the painting (fig. 10) has long been regarded as one of its most remarkable features, and Meiss in particular responded to its special claims with eloquent sensitivity. The tree seems to be, as it were, the filter of the light that infuses parts of the panel and seems also, physically, to respond

[31] Meiss, p. 26.

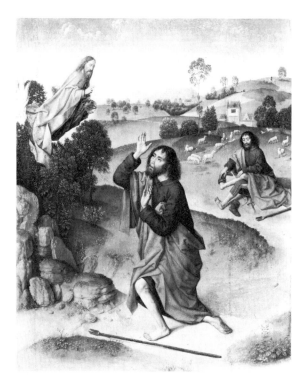

8. *School of Dirk Bouts,
Moses at the burning
bush.*

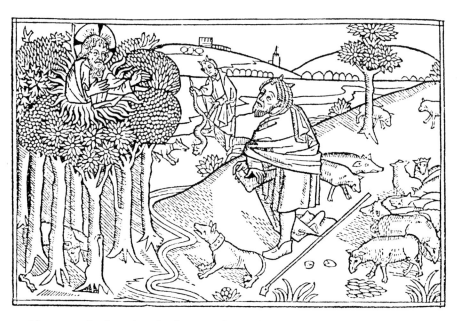

9. *Moses at the burning bush. Woodcut illustration in the Koberger
Bible (Strassburg, 1483).*

10. Bellini, San Francesco, *detail: the swaying tree.*

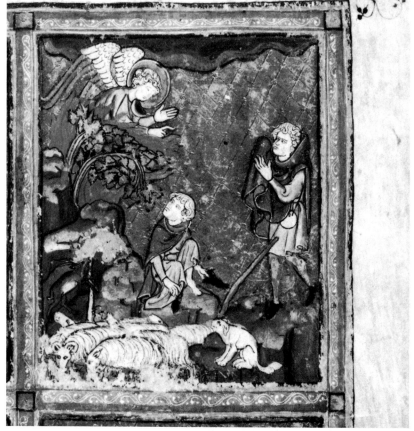

11. *Moses at the burning bush (detail from four-part narrative sequence). From "The Golden Haggadah."*

12. Bellini, San Francesco, *detail: the walking stick and sandals.*

to it: "Its branches, like the radiance above it, curl into an arc, and they seem stirred and pulled towards it, as by a magnetic force."[32] The tree in fact bends *away* from the light, but bend it does. Meiss' feint at an iconography of the laurel tree also deserves citation: "The portrayal of an active tree seems to be rooted in the tradition of the Stigmatization. It is perhaps significant, however, that in Bellini's picture this tree has become a laurel—a *laurus nobilis*, whose very name suggests the values that it symbolized. Inasmuch as the laurel was believed to be resistant to fire, it designated enduring, indestructible virtues. In his *Reductorium morale* Berchorius compared it with a cross, which kept mankind from the fire of eternal damnation."[33]

There Meiss halts, before the abyss of what he calls a "mystery," but one that becomes somewhat less mysterious if we think of the episode of the burning bush. This "bush," the object of repeated and prolonged patristic exegesis, was as often as not thought of in medieval art as a tree (figs. 9 and 11). These trees are sometimes "active," as Meiss puts it; and it is even possible that there is a "tradition" of a swaying tree in medieval Jewish iconography (fig. 11). As far as iconological speculation goes, one must here be tentative. The identification of the bush (tree) of the Horeb vision with the Cross, with spiritual crucifixion, and with ascetic discipline generally is so common that it may be regarded as commonplace; but on the precise meaning of the laurel, Bonaventure's silence must require my own. That Meiss is correct in identifying the tree as a laurel I have no doubt. That Bellini intends by his laurel a lesson in dogmatic botany I have little doubt. There are very few fire-resistant trees or bushes in the desert or, for that matter, in the forest.

The historical allusions to Horeb are completed by a detail on the opposite side of the panel, the discarded sandals (fig. 12). The young Moses, attracted by the "great sight" of the burning bush, drew near to watch. "And when the Lord saw that he went forward to see, he called to him out of the midst of the bush, and said: Moses, Moses. And he answered: Here I am. And he said, Come not nigh hither; put off the shoes from thy feet: for the place whereon thou

[32] Meiss, p. 27.

[33] Meiss, p. 23. Meiss' citation of Berchorius (p. 47, n. 73) should be corrected to read "*II*, 495-496."

standest is holy ground." The general iconological significance of Francis' bare feet has been commented upon several times by earlier critics,[34] but its specific Franciscan significance no doubt informs Bellini's panel. Shoelessness, one of the literal injunctions of Christ's apostolic charge (Matt. 10:10; Luke 10:4), was an important element in Francis' vision of mendicancy, and it was carried over into the *Regula bullata* in negative refraction in a phrase of the second chapter: Those who are forced by necessity may wear shoes. Because the injunction seems to be contradicted by Mark 6:9, the question receives a special attention in the exegetical literature. The classic solution of the Four Masters was that "non calciari vero est forma vitae."[35] In the polemical literature of the poverty contest, the "shoe question," like the "purse question," claims a startling amount of energy and ink.[36] By Bellini's time, discalcement was an effective, if not quite an official, emblem of the Observance. The special significance of the sandals in Bellini's painting is underscored by their visual collation with the walking stick, likewise left behind in the saint's cell, and likewise the object of apostolic proscription. That Moses' barefoot vision on Horeb was formally connected with the barefoot apostolate of Franciscan poverty is attested to by a beautiful passage in Ubertino.[37]

The details of the shepherd at the back of the wilderness, of the laurel tree, and of the discarded sandals point our attention toward the third chapter of Exodus, where the event and the meaning of the Stigmatization find both adumbration and clarifying gloss. But Bellini's panel is an essay in *comparative* theophanies, and another prominent detail emphatically positioned alludes to a second meeting between Yahweh and Moses on the "mountain of God." That

[34] For example, Smart, p. 473: "Discarded shoes or sandals are a common symbol of reverence in fifteenth-century painting, but seem also to be unprecedented in Stigmatization scenes."

[35] See *Peter Olivi's Rule Commentary*, ed. David Flood (Wiesbaden, 1972), p. 133, for a typical discussion. On the "Four Masters," see Fleming, pp. 96ff.

[36] See Fleming, pp. 90ff.

[37] "Iesus desertum incolens," *Arbor vitae crucifixae*, III, iii, f. k ii r° (Turin ed., 1961), 147, where the discussion of the discalced Moses is followed by a lengthy exegesis of the *onager*. Ubertino is probably influenced by Bonaventure, *Apologia Pauperum*, x (*Opera*, viii, 306-307).

detail is the rabbit peeking out from the hole in the rock wall im-
mediately below Francis' wounded right hand (fig. 6).

It may be objected at this point that I have already claimed this
rabbit for the genus *plebs invalida* of the Proverbs, symbol of ere-
mitic life, and that I now threaten the poor creature with a kind of
iconological double jeopardy. I can only answer with the great
Gregory that the Scriptures are a stream in which the lamb may
safely wade and the mighty elephant may freely swim. No one who
has spent but an hour with the exegesis of Augustine or Jerome—or
with those Christian poets like Dante and Geoffrey Chaucer who
wrote for the audience they had created—will think for a moment
that any scriptural image will mean one thing and one thing only.
But is the rabbit a scriptural image in the first place?

There is still among certain art historians a reluctance to admit an
allegorical intention to pictorial images unless they be stridently
assertive or grossly offensive to verisimilar expectation. Thus "an
over-large white bird struggling with a snake in an otherwise calm
setting does demand some investigation while a rabbit peering out
of the crevice in St. Francis' rock may have no point beyond the
pleasure afforded by its simulated self."[38] This is to say, as I under-
stand it, that all thumbs must be sore thumbs. The appalling exegeti-
cal principle behind this is clear. If the literal sense is coherent, there
is no need to search for the spirit. Take the chaff and let the grain
alone, to paraphrase Faussemblant from the *Roman de la Rose*. One
knows quite well what Augustine would have said to the sugges-
tion that the rabbit—which, like every other species of bird and
animal life in the painting, without the slightest exception, *is* a bibli-
cal image—was "just" a rabbit.

Berenson's view of Bellini, at least as far as this painting is con-
cerned, was not merely wrong but corrupting. Religious subject
matter does not provide in this painting an occasion for visual
"realism." Rather, wonderfully real things are the vocabulary of a
privileged but coherent religious language. Nor is it satisfactory to
say, with a recent critic, that the painting combines symbolism and
realism.[39] The real things *are* symbolic. To put this another way,
real things are here the occasion of religious truth.

[38] Fletcher, p. 213.
[39] Colin Eisler, "In Detail: Bellini's Saint Francis," *Portfolio* (April/May
1979), p. 18.

In the commerce between art historians and literary historians, the latter may seem to suffer a substantial trade deficit, so that students of poetry should not be diffident about hawking their wares as best they can. In my view, the discussion of literary allegory by such scholars as D. W. Robertson, Robert Hollander, and Charles Singleton has much to teach us about reading allegorical paintings as well as allegorical poems.[40] The fundamental guarantor of medieval literary reality was the Bible, filled with things so real that none could be realer. God, the divine Maker, was the craftsman of real things: real stones, real trees, real doves. All scriptural truth was grounded in the basis of truth, the literal sense. Allegory, whether pictorial or verbal, must satisfy several intellectual appetites; but its first task is also its most difficult—the creation of a convincing, engaging, and satisfying letter.

Actually, Bellini's rabbit *is* something of a sore thumb, and as a detail of realistic fauna, one would have to judge its simulated self an anatomical compromise if not a downright failure. Its large head implies a body rather too large for its modest hole. Though its proportions are less egregious than those of the grey heron on the cliff side—which, in terms of visual perspective, is more distant from the viewer than the *onager*, yet is nearly the height of that beast—it is nevertheless prominent. To what does its prominence invite us?

In the thirty chapters that separate Moses' first vision of God on Horeb from his second, a great deal has happened. Moses, now the leader of Israel, has brought his people through the Red Sea and the desert; they have been miraculously relieved of the plague of fiery serpents and miraculously fed with manna from heaven. They have fallen into the idolatry of the golden calf and suffered the terrible wrath of God. In Exodus 33:18, Moses sets out to begin anew, and he begs God to "shew me thy glory." God, before replacing the stone tables shattered by Moses in his wrath, answers him thus: "Thou canst not see my face: for man shall not see me and live.

[40] See in particular, Singleton's essay "The Irreducible Dove," *Comparative Literature* 9 (1957): 129-135, and its elaboration as "The Irreducible Vision," in *Illuminated Manuscripts of the Divine Comedy*, by P. Brieger, M. Meiss, and C. S. Singleton (Princeton, 1969), I, 3-29. For a magisterial treatment of the general principles of medieval allegory, see D. W. Robertson's chapter "Allegory, Humanism, and Literary Theory," in his *Preface to Chaucer* (Princeton, 1962), pp. 286-390.

And again he said: Behold there is a place with me, and thou shalt
stand upon the rock. And when my glory shall pass, I will set thee
in a hole of the rock, and protect thee with my right hand, til I pass:
And I will take away my hand, and thou shalt see my back parts:
but my face thou canst not see."

If we have followed at all Bellini's audacious development of his
cognate patterns of eremitic and Mosaic iconography, we cannot
fail to see that in this marvellously witty rabbit the two converge.
The rabbit "is" the religious life, but it "is" no less Moses, the pre-
Christian founder of that life. The feeble folk who make their home
in the rocks are also Moses, hidden in the hole of a rock that he
might view the glory of God. Thus writes Jerome in his important
commentary on Matthew. The text glossed is Matt. 7:25: "[And
the rain fell, and the floods came, and the winds blew, and they beat
upon that house] and it fell not, for it was founded on a rock."

> On this rock the Lord founded his Church; from this rock the
> Apostle Peter takes his name; on this kind of rock are not found
> the tracks of the serpent; of this rock the prophet boldly speaks:
> "He set my feet upon a rock" and in another place, "The rocks
> are a refuge for rabbits or *erenaciis*" . . . Whence it is said of
> Moses at that time when he fled Egypt and was the little rabbit
> of the Lord [*lepusculus Domini*]: "Stand in a hole of the rocks,
> and thou shalt see my back parts."[41]

A learned iconographical essay by J. B. Bauer has traced the lineage
and transmission of this exegetical image with careful demonstration
and ample documentation (fig. 13).[42] It is one of the many em-
blematic beauties that the Latin Church owes to Origen, and for
which it has repaid him so ill.

Moses, then, hides in the rock, but he first stands upon it: "Behold,

[41] "Super hanc petram Dominus fundauit ecclesiam, ab hac petra et apos-
tolus Petrus sortitus est nomen, super huiusmodi petram non inueniuntur
serpentis uestigia, de hac et propheta loquitur confidenter: *Statuit supra
petram pedes meos*, et in alio loco: *Petra refugium* leporibus siue *erenaciis*
. . . Vnde et Moysi dicitur eo tempore quo de Aegypto fugerat et lepusculus
Domini erat: *Sta in foramine petrae, et posteriora mea uidebis.*" *In Matheum*,
i; CC 77 (pt. i, 7): 46-47.

[42] Johannes Baptista Bauer, "Lepusculus Domini: Zum altchristlichen Ha-
sensymbol," *ZkTh* 79 (1957): 457-466.

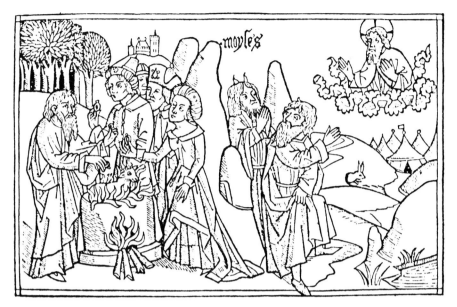

13. *The Golden Calf and Moses on the mountain. Woodcut illustration in the Koberger Bible (Strassburg, 1483).*

14. *Bellini,* San Francesco, *detail: stone or ceramic lip of spring's mouth.*

there is a place with me, and thou shalt stand upon the rock." It is
this rock upon which Christians in all times and places have longed
to stand—

> If I could, I surely would
> Stand on the rock where Moses stood

—and it is there that Francis of Assisi stands in this frozen yet dy-
namic moment of divine contemplation. Bellini has marked this
carapace with a final emblem of Mosaic power, a spring of water
flowing from its dry and flinty heart (fig. 14).

"Amongst all the books of the Pentateuch," wrote Rabanus
Maurus in the ninth century, "the Book of Exodus is deservedly
preeminent; for in it nearly all of the sacraments by which our
present Church is instituted, nourished, and governed, find figura-
tive expression."[43] Of these "signs," none is more potent than the
rock from which Moses struck water (Ex. 17:6): "Behold, I [Jah-
weh] will stand before thee there upon the rock in Horeb; and thou
shalt smite the rock, and there shall come water out of it, that the
people may drink." The allegorical identification of this "rock" did
not need to await the scrutiny of an Ambrose or an Augustine, for
the Apostle Paul himself said that "the rock was Christ" (I Cor.
10:4) in a crucial passage that was the foundation of the medieval
typological understanding of the Exodus.[44]

In early Franciscan biography, the miracle of the fountain of
Horeb finds its application to Francis:

> Another time, while traveling to a hermitage where he planned
> to devote himself to prayer, St. Francis rode an ass belonging to
> a poor laborer, because he was weak. It was summertime and, as
> the owner of the animal followed the saint into the mountains,
> he was exhausted by the long and grueling journey. Fainting
> with thirst, he began to cry out insistently, saying that he would
> die immediately, if he did not get something to drink. Francis dis-

[43] "Praefatio in Exodum," *PL* 108:9; cited by Olivier Rousseau, "Les Mys-
tères del l'Exode d'après les pères," *Bible et vie chrétienne* 9 (1955): 31-42.

[44] See Gustave Martelet, "Sacrements, figures et exhortation en I Cor x,
1-11," *Recherches de Sciences Religieuses* 44 (1956): 323-359, and 515-559;
and the penetrating analysis of A. Feuillet, *Le Christ Sagesse de Dieu d'après
les épitres pauliniennes* (Paris, 1966), pp. 87-111.

mounted there and then and knelt on the ground with his hands stretched out to heaven and there he prayed until he knew that he had been heard. When he had finished, he said to his bene-factor, "Go to that rock and there you will find running water. In his goodness Christ has made it flow from the solid stone just now for you to drink." The man ran to the spot Francis pointed out and he had his fill of water which had been produced from a rock by the power of one man's prayer, a drink which God of-fered him from solid stone."[45]

In the next century, the same story shows up in the first of the *Considerazioni*, where the place of hermitage is named: Alverna. Smart knows of these texts, but rejects them in favor of the *Speculum Perfectionis*: "This cannot be an allusion to the well-known story of the sweating muleteer" because "no trace of the spring remained after the miracle—a circumstance particularly stressed in the *Legenda Major*."[46] This cruel victory of letter over spirit is not entirely un-happy, however, for it leads to a stimulating analysis of an instruc-tive text from the *Speculum Perfectionis*:

> Whenever he washed his hands he used to choose some place where the water that fell would not be trodden by his feet. More-over, when he walked over stones he would walk with great fear and reverence for the love of him who is called The Rock; whence, when he recited that passage in the Psalm, "Thou didst exalt me on a rock," he used to say, out of his great reverence and devotion, "Under the foot of the rock thou hast exalted me."

Smart's discussion of this passage is very illuminating, for it sketches the typological pattern of allegorical scriptural images as they come together in Francis' own mind: the Psalmist's allusions to the his-tory of the Exodus and Paul's sacramental typology of its mysteries. But I find here, too, the firm ground of my disagreement with him, a disagreement not so much broad as deep. It has less to do with the rival candidacies of literary "sources" than with alternative modes of imagining. The "Rock" is indeed present in Bellini's painting, but it is not there *because* of the *Speculum Perfectionis* or any other

[45] *Legenda Major*, vii, 12; *Legendae*, p. 591.
[46] Smart, p. 473.

medieval text; it is there for *the same reason* it is in the *Speculum Perfectionis* (and Thomas of Celano, and the *Legenda Major*, and the *Considerazioni*), and that is because Moses was *in* Francis. To write about Francis, or to paint about him, was also in some measure to write or paint about Moses. As Bonaventure says, almost brusquely, "he drew water from a rock in imitation of Moses."[47]

The typological themes that link Moses and Francis are so insistent in the pages of Thomas of Celano and Bonaventure that they can have escaped no informed reader of early Franciscan biography. Another thematic line taken up by Bellini, somewhat more discretely but nonetheless with effective intention, links Francis with the other Old Testament hermit of the Transfiguration, Elijah. The association was an exegetical inevitability given the unique role assigned to Elijah in both the Old and New Testaments and given the legendary history of Christian monasticism.

Throughout the gospels, the figure of Elijah is associated with the messianic mission of Jesus, since one line of rabbinic teaching held that the coming of the Christ must await the return of Elijah (Matt. 17:10). John the Baptist will appear "in the spirit and power of Elijah" (Luke 1:17), and the uncomprehending repeatedly mistake Jesus for the ancient prophet. Elijah is a prefiguration of Christ, Francis a postfiguration. It was accordingly inevitable that Franciscan mysticism should link the *poverello* with the prophet of fire. Among the boldest and most bizarre miracles reported of Francis by Thomas of Celano in the *Vita Prima*, and thence painted on the walls of the upper church at Assisi, is the manifestation of the spirit of Francis as a fiery orb within a chariot of fire. The allusion to Elijah (IV Kings 6:17), rather abruptly presented by Thomas, received a careful theological development in the pages of Bonaventure. Francis is an alter *Elias*, the leader of the "true Israelites," that is, the leader of the "spiritual men."[48] In the *Legenda Minor*, he is perhaps even more clearly the leader of the Church—*spiritualis*

[47] *Legenda Major*, vii, 13: "omnipotentis Dei famulus sicut in eductione aquae de petra conformis exstitit Moysi." *Legendae*, p. 591.

[48] *Legenda Major*, iv, 4; *Legendae*, p. 573: "ut tamquam veri Israelitae post illum incederent, qui vivorum spiritualium, ut alter Elias, factus fuerat a Deo currus et auriga."

militiae princeps.[49] These ideas are explicitly Joachite, and their relevance to the ecclesiological themes of Bellini's painting will claim our attention in another section.[50]

To speak of Moses and Elijah is to speak of two men but of a single spiritual power, for in the books of Kings, Elijah already clearly appears as an antitype of Moses, a man of sacred mountains, desert pilgrimages, angelic refreshments, and above all, fierce, majestic monotheism.[51] His Mosaic lineage is more insistent still in the New Testament. His special connection with Jesus, a particularly powerful one as we shall see, is established in the revelation of the Transfiguration, a subject to which Giovanni Bellini repeatedly turned his attention. We shall without surprise find these three greatest of prophets—Moses, Elijah, and Jesus—at the center of much Christian ascetic speculation.[52] In the legendary history of mendicant religion, Elijah was to claim a quite particular preeminence.

Among the several literary genres characteristic of the vibrant renewal of religious life in Europe in the eleventh, the twelfth, and the thirteenth centuries—offspring of the canonic and Cistercian reforms, the Fourth Lateran Council, and the efflorescence of the mendicant movements—the formal religious apology, the defense of this or that specific religious institution, is conspicuous. Some exceptional pieces of this genre are well known—the lively polemics of St. Bernard, for example—but no synoptic survey of this extremely important body of texts has to my knowledge ever been undertaken, in spite of its demonstrably formative influence on the shape of ascetic theory in the late Middle Ages. The defense of mendicant religion presented a particularly difficult challenge since,

[49] *Legenda Minor*, ii, 6; *Legendae*, p. 660: "tamquam qui in spiritu veniens et virtute Eliae, spiritualis esset militiae princeps effectus, ut currus Israel et auriga eius."

[50] See Joseph Ratzinger, *Die Geschichtstheologie des heiligen Bonaventura* (Munich, 1959), pp. 32-33; and below, pp. 141ff.

[51] See Jean Steinmann, "La Geste d'Elie dans l'Ancien Testament," in *Elie le prophète* (Paris, 1956), I, 93-115.

[52] Jean Plagnieux, "Saint Grégoire de Nazianze," in *Théologie de la vie monastique: Etudes sur la tradition patristique* (Paris, 1961), p. 121, and passim.

in the eyes of Benedictine tradition, many features of mendicant
life, including mendicancy itself, seemed shocking innovations. The
strategy of mendicant apologetics, which commanded the exertions
of Bonaventure and Thomas Aquinas, to mention but two lumi-
naries out of many, was to attempt to establish the authority of
mendicant life in the descriptions of the *vita apostolica* in the New
Testament itself.

Some friars sought sources more primitive still. The tradition of
the Carmelite brothers, confidently believed and proudly promul-
gated, was that their order was founded by the prophet Elijah on
Mount Carmel.[53] "But syn Elye was, or Elise," says Chaucer's friar
in the "Summoner's Tale," "Han freres been, that fynde I of rec-
ord." Elijah's eremitic shagginess and dress (II Kings 1:8), his
refuge at the brook Carith (I Kings 17:3), his night beneath the
juniper tree, his solitary habitation in Moses' cave on Mount Horeb
(I Kings 19:9), became for many friars powerful allegorical images
linking mendicant religion with the Mosaic alliance, with John the
Baptist, and with Antonine eremitism. Among the most influential
books to develop these themes is an anonymous work of lyrical
asceticism called *De Institutione primorum monachorum qui in
lege veteri exortorum et in nova perseverantium*, which is probably
a product of the late Middle Ages but which was then universally
attributed to the fifth-century prelate John of Jerusalem.

The *De Institutione primorum monachorum*, after identifying
Elijah, "a prophet of the tribe of Aaron," as the founder of monastic
life, goes on to explain the meaning of God's injunction to him:
"Hide thyself by the torrent of Carith, which is over-against the
Jordan" (I Kings 17:3). Carith, says the exegete, means "charity,"
and "charity covereth all sins" (Proverbs 10:12). That is, the pre-
cepts of the New Law (*caritas*) find their expression in eremitic
retreat. The solitude characteristic of the highest form of Christian
perfection is the explicit subject of the fifth chapter of the book,
and it is here that we find the inevitable development of *Quis liberet
onagrum?* The *onager* represents those who follow the eremitic

[53] See Robert A. Koch, "Elijah the Prophet, Founder of the Carmelite
Order," *Speculum* 34 (1959): 547-560.

life; his liberation betokens the ascetic's escape from the bondage of sin.[54]

We may expect that Francis, too, like John the Baptist a *praeco* or herald of the Lord, will himself come "in the spirit and power of Elijah." Bellini does not disappoint us. In his natural landscape, so wonderfully realized, any fabric of the hand of man is immediately conspicuous if not obtrusive; yet the whole of the foreground is defined by a sweeping curve of human imposition on the face of nature, man's presence in his manufacture and his vestiges. The most artificial, not to say preposterous, of these define the two extremes of the panel: at the right, the finely joined reading desk; at the left, a gutter lip fired in ceramic or cut from the stone, and a parchment signature in Latin pinned to a snarled shrub of indefinite but unprepossessing character. Between these two extremes, the impress of human industry is more subtle and acceptable, and also more various. The latticed cell is the merest reordering of natural elements of branch and vine, and if the clogs have come from the cobbler's bench, the walking stick is nothing more than a carefully chosen stalk. Meiss has drawn attention to the wonderful "joining of the natural and the artificial" in the detail of the stone terrace in particular (fig. 15). This visual oxymoron of a flower bed in the wilderness is an important "Carmelite" emblem. It is, in fact, a *carmel*, a desert garden.

"Mullein, juniper, and orris root grow luxuriantly in this earth" writes Meiss, "kept moist, it would seem, by water carried from the spring in the saint's jug."[55] Though dogmatic botany beckons us alluringly, we should first turn our attention to the ceramic jug at the foot of the terrace garden, surely one of the most jarring bits of *realia* in the painting. What is a jug doing on Mount Alverna/Horeb/Sinai?

Once again, an analogue from classic Franciscan literature may perhaps be illuminating. There is in the *Sacrum Commercium* a "chapter" that describes the visit of Lady Poverty to the friars'

[54] *De Institutione primorum monachorum*, v; in *Maxima Bibliotheca Patrum*, ed. M. de la Bigne (Lyon, 1677), v, 864-865. The image is discussed by François de Sainte Marie in *Les Plus Vieux Textes du Carmel*, 2nd ed. (Paris, [1961]), pp. 104-105.

[55] Meiss, p. 15.

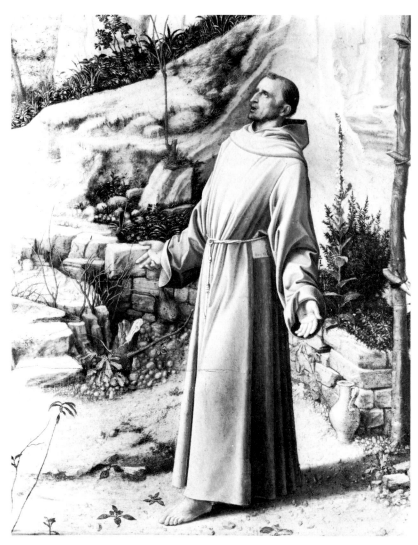

15. Bellini, San Francesco, *detail: Francis and his desert garden.*

mountain hermitage.[56] In order to test their devotion, she pretends to desire various amenities of hospitality: a washbasin and towel, cooked food and wine, table utensils. It is impossible for the Franciscans to provide even such modest luxuries, of course, but they do organize an ascetic "banquet" with such meager resources as they have—"three or four bits of barley- or bran-cake" and a vessel of cold water.

I should once again stress that I am not adducing a literary "source" for a pictorial image in Bellini, but suggesting that two great artists, one a poet and one a painter, have instinctively turned to a shared vocabulary of scriptural images in their deep meditations on the meaning of the Franciscan mystery. I have tried elsewhere to suggest the quite remarkable way in which the author of the *Sacrum Commercium* has infused his narrative with an almost continuous flow of scriptural images and echoes, which, while providing a sufficient vocabulary for his own literal fable, at once unloose centrifugal and complicated potentialities.[57] One scriptural "type" of Franciscan poverty submerged within this text is the episode of the angelic refreshment of Elijah (III Kings 19). Elijah, threatened by Jezebel, flees into the wilderness, where, despondent and fatigued, he lies down beneath a juniper and asks to die. But an angel comes to him with refreshment—a cake of coarse bread and a jug of water. Refreshed and encouraged he sets off on the forty days' march to a cave on Mount Horeb.[58]

Bellini's ceramic jug echoes the vessel of ascetic refreshment, called in the Vulgate simply a *vas* and in the *Sacrum Commercium* a *scutella*. A *vas* can be any vessel intended to hold liquids, and in the rich iconography of III Kings 19 we shall find it in many forms.[59] In those renditions that focus upon its typical relationships

[56] *Sacrum Commercium Sancti Francisci cum domina Paupertate* (Florence, 1929), pp. 70-71.

[57] Fleming, pp. 81-82.

[58] The "Angelic Refreshment" is the most common motif of Elian iconography; see Cécile Emond, *L'Iconographie carmélitaine dans les anciens Pays-Bas méridionaux* (Brussels, 1961), pp. 63ff. Earlier examples are documented by L. Réau, "L'Iconographie du prophète Elie," in *Elie le prophète* (Paris, 1956), I, 254ff.

[59] Ferd. Peeters, *Le Triptyque eucharistique de Thierry Bouts à l'église de Saint Pierre, Louvain* (Léau, 1926), pp. 24-27.

with the institution of the Eucharist (in the famous Bouts polyptic at Louvain, for example, or in Rubens), it is a simple cup or an actual chalice; but elsewhere it is a bottle and, frequently, a handled jug (fig. 16) like the one in Bellini.[60] The connection of the jug in the Bellini with Elijah is also strongly suggested by two particular features of the painting. The first is its visual collation with the juniper bush in the terrace immediately above it: "And he cast himself down, and slept in the shadow of a juniper tree . . . He looked, and behold there was . . . a vessel of water" (III Kings 19:4-5). The second is that the jug is carefully positioned to draw attention to its relationship with the rock-dwelling rabbit, the jug at one end of the terrace wall, the rabbit at the other. If we realize that the rabbit "is" Moses in the cave on Horeb, another connection becomes obvious, for the goal of Elijah's flight, for which he is sustained by the angelic refreshment, is the very same cave on Horeb.

Yet Meiss is surely not wrong in suggesting that the jug is used for irrigating this desert garden, for the literal implication he drew from it had already been incorporated into a spiritual emblem of Carmelite iconography.[61] We shall find a friar filling his jug from the "fountain of Elijah" on Mount Carmel in the background of the Frankfurt retable (fig. 17). Waters from this well, transported in a handled jug, water the "vinea Carmeli." The fountain itself was a standard feature of pilgrim guides to the Holy Land;[62] and the vessel was probably associated with the *vas novum* with which Elisha, the first in the succession of the "power and the spirit of Elijah" cleansed the waters (IV Kings 2:20).

[60] It appears thus commonly in Venetian eucharistic painting. See Maurice E. Cope, *The Venetian Chapel of the Sacrament in the Sixteenth Century* (New York, 1979), plates 173, 265, 275, etc.; further examples will be found in Emond, *L'Iconographie carmélitaine*.

[61] This "watering" is connected with a somewhat complex bit of "reverse typology" by which the Carmelites applied the apostolic imagery of I Cor. 3:6 ("I [Paul] have planted, Apollo watered, but God gave the increase") to their Old Testament "founders": *Elias plantavit, Eliseus rigavit*. See Réau, "L'Iconographie du prophète Elie," p. 244.

[62] One late medieval guide reads thus: "En sus de cel liu haut sus la montaigne à main senestre est un beau liu et seint, où i a en hermitage de hermites latins, ki s'apelent frères de Carme, e si a une eglise de Nostre Dame, e si a mut de bones fontaignes curantes e mut de bonnes herbes flairans." See *Les Plus Vieux Textes du Carmel*, p. 66.

16. Elijah and the Angel (sixteenth-century).

17. Panel of retable with scenes from the life of St. Ann.
Detail: Carmelites salute members of the Holy Family.

It was the Carmelite Order that most conspicuously fostered the medieval iconography of Elijah and Mount Carmel in the Middle Ages, and at a later date some Carmelites came preposterously close to claiming the exclusive ownership of the "prophet of fire."[63] There is, however, nothing surprising in Bellini's use of "Carmelite" themes and images in developing a portrait of Francis of Assisi, a "second Elijah."

The inescapably revolutionary character of Christianity ("He hath filled the hungry with good things, but the rich He hath sent empty away") found its poetic preparation in those texts of the Old Testament that speak of the past or future history of Israel's redemption. There is in the Pentateuch, in the major prophets, and in the Psalms in particular, a recurrent pattern of imagery that speaks of the manifestations of the Lord's power in terms of marvellous and benign disruptions of the natural order—waters parted, mountains razed, hills leaping like roebucks.[64] Perhaps the most powerful image in the pattern, a "comic" pattern in that deep sense that Dante would understand, points at once backward to the miracles of the Exodus and forward to the coming of Jesus: it is the image of the transformation of desert into garden.

We have already seen in Joachim's discussion of the "gaudium onagrorum" that the idea of the desert-garden has an ascetic sense that points to the radical renovation of the church through the hermit order: "The desert shall be as a charmel, and charmel shall be counted a forest. And Judgment shall dwell in the wilderness, and justice shall sit in charmel" (Isa. 32:14-16). The image is, indeed, one of the most familiar in the literature of antique monasticism, and its special development in medieval Carmel is merely the appropriation of a commonplace. When in a famous description Jacques de Vitry spoke of the community of mountain friars as a kind of spiritual apiary, buzzing with spiritual energy and purposefulness,

[63] See the amusing account of David Knowles, *Great Historical Enterprises* (London, 1963), pp. 15ff.; cf. Réau, "L'Iconographie du prophète Elie," p. 244.

[64] See A. Feuillet, "Le Messianisme du livre d'Isaïe," *Recherches de Sciences Religieuses* 36 (1949): 182-228; cf. F. A. Llanillo Garcia, "El lenguaje figurado en el libro de Isaias," *Miscelánea de estudios árabes y hebráicos* 4 (1955): 214-240.

he was echoing the poetic watchword of Antonine eremitism: the desert a city.[65]

Bellini's Alverna submits to the scriptural expectations of a charmel in its obvious contrast of the briars and the fig stump at Francis' right hand with the healthy green plants of the rocky garden behind him, a contrast of fruitfulness with sterility: "instead of the nettle shall come up the myrtle tree" (Isa. 55:13).[66] Because this feature of the painting is so commonplace, we risk denying it its rightful significance. The whole of Bellini's Franciscan landscape had already been sketched for him in its rough outline by the poets of the Old Testament and the exegetes and ascetics of the deserts of the East. Wilderness chapels, the fauna of waterless places, the visual contrast of eremitic foreground with the distant city background— all of these forms are, to be sure, clichés, but that is not to say that they have no potential for significant expression. The sonnet and the sonata are also clichés.

[65] On the testimony of Jacques de Vitry, see *Les Plus Vieux Textes du Carmel*, pp. 63-65. Derwas Chitty, *The Desert a City* (Oxford, 1966), explicates the image he takes for his title.

[66] The nettle is a purposefully ambiguous emblem. As the special figure of evangelical poverty, we find it in the pseudo-Giotto allegory in the lower church at Assisi, in Hieronymite iconography, and elsewhere.

The Feast of Tabernacles

I n an earlier chapter, I made the claim that those Franciscan exegetes who saw Francis of Assisi as a "second Moses" had a clear warrant to do so, not merely on the basis of traditional monastic biography but as a response to Francis' own patterns of thought and action. Kajetan Esser, perhaps the most profound of modern Franciscan scholars, has demonstrated Francis' peculiarly pictorial habits of mind, how he thinks not in the familiar modes of academic logic and argumentation but in a "pictorial" mode, which moves from image to image rather than from premise to conclusion.[1] Francis' mental tableaux were scriptural in origin, and the most prominent of them came from a vividly imagined identification with the human person of Jesus Christ and from a profoundly historical identification with the Exodus. The evidence of his "exodal" thinking will be found both in actions, which will seem puzzling until we recognize their "iconographic" control, and in the superficially confusing structure of his writings.

That those writings are so few in number probably magnified even further their extraordinary authority within the Franciscan Order; all of the major controversies of the poverty contest centered on the interpretation of a few short works and on the scriptural images that they repeated or reshaped. Of these writings the most famous is surely the *Cantico di frate sole*, and the most authori-

[1] Kajetan Esser, *Das Testament des heiligen Franziskus von Assisi: eine Untersuchung über seine Echtheit und seine Bedeutung* (Münster, 1949), pp. 125ff.

tative, the *Regula bullata*; but the most surprising, and perhaps the most revealing, is the *Testamentum*. It would not be to our purpose to give a detailed account of this work, or to trace the history of its special prominence in the poverty debate and in modern discussions of the "Franciscan question." What *is* of interest to us is the pictorial meaning of the *Testamentum*, and this has been the subject of a recent and brilliant essay by Auspicius van Corstanje.[2] He shows that the primary meaning of *testamentum* in Francis' mind must have been precisely that scriptural meaning of "alliance," and that Francis thought of this alliance as a contract between God and a pilgrim race of God's poor, and that as a consequence, the Order of Friars Minor was the living extension of the Exodus within the Church of God. That is to say that the whole book is controlled at a subliminal level by images of the Exodus. So, indeed, was Francis' whole life, and we must now turn our attention to those striking features of Giovanni Bellini's exegesis that speak of the Exodus not as the historical preparation for Francis but as continuing process and promise.

We may begin with a famous puzzle in the history of the Franciscan Order. The sixty-eighth chapter of the *Speculum Perfectionis* describes an important meeting of the Pentecost Chapter General at which, among other things, Francis addressed the question of the relationship between academic learning and Franciscan life. Because of its description in the *Speculum*, it has come to be known in English as the "Chapter of the Mats." The relevant phrases in Latin read as follow: "Dum beatus Franciscus esset in capitulo generali apud Sanctam Mariam de Portiuncula, quod dictum est capitulum storiorum, quia non erant ibi habitacula nisi de storiis . . ." ("While blessed Francis was at the Chapter General at the Portiuncula, which is called the 'chapter of the mats' because they had no other dwellings but mats . . .").[3] Jordan of Giano alludes in his *Chronicle*, under the year 1221, to what most historians have taken to be the same event: "Fratres autem, cum pro tot fratribus edificia non haberent, in campo spacioso et circumsepto sub

[2] *Un Peuple de pèlerins* (Paris, 1964), originally published in Dutch as *Het Verbond van Gods armen*.

[3] *Le Speculum Perfectionis ou Mémoires de frère Léon*, ed. Paul Sabatier (Manchester, 1928), p. 194.

umbraculis habitabant, comedebant et dormiebant, viginti tribus mensis ordinate et distincte et spaciose compositis."[4] Jordan's dating of the event, however, has raised historical problems. "There has been much debate over the date of this chapter-meeting," writes John Moorman, "which has been set in almost every year between 1218 and 1222."[5]

Before taking a closer look at the "mats" themselves, it is worth noting that the historical confusion of dates disappears if we accept a very useful but apparently forgotten suggestion of Paul Sabatier. The *Speculum Perfectionis* and Jordan's *Chronicle* may well be referring to different annual meetings. In turn, the *Speculum*'s phrase "quod dictum est capitulum storiorum" may have generic rather than a specific meaning: "The Chapters General of Pentecost celebrated at the Portiuncula during Francis' lifetime were all 'chapters of mats.' "[6]

But what of the mats? It is clear enough that what is being described are rough, temporary shelters, camping tents of some kind. The *Speculum Perfectionis* uses the word *storium*; Jordan of Giano, *umbraculum*. *Storium* is a rare word. DuCange does provide a thirteenth-century example, however, where it is used to indicate the kinds of awnings set up by shopkeepers for their stalls in the marketplace. Its modern Italian reflex is *stuoia*, a doormat; and in the early Italian examples adduced by the Crusca dictionary, it means a weaving or plaiting of the kind associated, as we shall see, with the Desert Fathers, that is, wicker-work.

If it is not already clear that the friars at the Portiuncula were dwelling in "tabernacles," Jordan of Giano's use of the word *umbraculum*, a privileged term from the Vulgate, should clinch the matter. The biblical *umbraculum* is a shady arbor or bower of the sort constructed for the Feast of Tabernacles. Indeed Jordan's precise phrase, "sub umbraculis habitabant," is a verbal echo of "habitabitis in umbraculis" in Leviticus 23:42, in which the ceremonial

[4] *Chronica Fratris Jordani*, ed. H. Boemer (Paris, 1908), p. 16.

[5] John Moorman, *A History of the Franciscan Order from its Origins to the Year 1517* (Oxford, 1968), p. 54n.

[6] "Les Chapitres généraux de la Pentecôte, célébrés à la Portioncule du vivant de saint François, furent tous des chapitres des nattes," *Speculum Perfectionis*, p. 194n.

of the feast is prescribed: "And you shall dwell in bowers [*umbrac-ulis*] seven days: every one that is of the race of Israel shall dwell in tabernacles [*tabernaculis*]." In other words, whether we think of Francis' mats as tabernacles, awnings, booths, bowers, or um-bracles, Jordan of Giano makes clear through his choice of words that they were the same kind of dwelling in which the children of Israel renewed the spiritual meaning of the Exodus.

The term *tabernaculum* in the Vulgate has a number of discrete but related meanings, and for the purpose of discussing Bellini's painting, it is necessary to distinguish among several of them. First, a tabernacle is a tent, or rude temporary dwelling, characteristic of nomadic cultures. Jacob is a tent-dweller, as are the children of Israel during the Exodus. Second, *the* tabernacle, or tent of meeting, is the elaborate collapsable and portable structure of frame and skins ordered by God in very considerable detail in the twenty-fifth chapter of Exodus. In this tabernacle was kept the ark of the covenant. Over it hovered the pillar of cloud by day and shone the pillar of fire by night. At its door (Ex. 33:11), "the Lord spoke to Moses face to face, as a man is wont to speak to his friend." Third, the Latin word tabernacle also renders the word that had in the Hebrew text been *sukkāh*, the booth or hut made of the branches of trees, the building of which characterized the Feast of Taber-nacles in which the Jews commemorated the nomadism of the Exodus and the great goodness of God in their deliverance.

The three meanings are of course continuous rather than dis-crete, and we may in particular regard the third as merely the liturgical or memorial form of the first. It is this sacramental taber-nacle, the *sukkāh*, that most insistently claims our attention, for St. Francis dwells in one on Alverna. The whole right-hand quarter of Bellini's painting is dominated by an extraordinary structure made of poles, branches, withies, vines, and foliage. It has been called, appropriately enough, a "rustic cell," but it is in fact a *suk-kāh*, or what Francis and Bellini alike would have called a taber-nacle (fig. 18). The fact takes us by surprise: Giovanni Bellini, a fifteenth-century Venetian Christian, is making an explicit and in-formed reference to an ancient Jewish festival, the Feast of Taber-

18. Bellini, San Frances-
co, *detail: the tabernacle*
(sukkāh).

nacles.[7] The image claims its place in his painting for the very good reason that it first claimed a place in the life of Francis of Assisi.

The Feast of Tabernacles, known to the Jews as Sukkoth, presents certain archaeological confusions of fascinating complexity, but these are fortunately of greater moment for Old Testament scholars than they need be for us.[8] The *sukkāh* made from branches "gathered from the mountains" probably reflects a settled agricultural community in which such temporary shelters were customarily built in the fields at harvest time to house the overseers of the harvest work. It was, therefore, and in a general sense continues to be, the emblem of a harvest festival; but its actual seasonal associations have already been lost sight of in the theologizing interpretation given by the Pentateuch, which makes the festival (like the other "pilgrimage" feasts) a memorial of the Exodus.

The ceremonial of the Feast of Tabernacles (Hebrew *Sukkoth*, Greek *Skenophegia*) is described at some length twice in the Old Testament, and in somewhat differing detail. The legislation in Leviticus (23:40) prescribes the gathering of "the fruits of the fairest tree, and branches of palm trees, and boughs of thick trees, and willows of the brook." The formula is slightly different in II Esdras [Nehemiah] 8:15: "Go forth to the mount, and fetch branches of olive, and branches of beautiful wood, branches of myrtle, and branches of palm, and branches of thick trees, to make tabernacles, as it is written." The individual arboreal species probably had quite definite allegorical significance in Jewish ceremonial, as they certainly did for Christian exegetes; but their functional use was to provide the rough yet festive materials for the tabernacles.

[7] It is by no means unlikely that Bellini's *sukkāh* has been drafted after his own visual experience. There are existing visual representations of the festival booths in Jewish liturgical books dating from the Italy of Bellini's day, the Pesaro sidhur and the Weill Mahzor. The trellis-like shape of the *sukkāh* in the latter is particularly striking. For illustrations, see *Sukkot*, ed. Hayim Halevy Donin (Jerusalem, 1974), pp. 6, 86.

[8] The full study of Hans-Joachim Kraus, *Gottesdienst in Israel: Studien zur Geschichte des Laubhüttenfestes* (Munich, 1954), presents detailed but controversial arguments about the liturgical origins and nature of the feast; for an excellent introduction, see G. W. MacRae, "The Meaning and Evolution of the Feast of Tabernacles," *Catholic Biblical Quarterly* 22 (1960): 251-276.

The "historical" explanation of the *sukkāh* in the Pentateuch is that it memorializes the nomadic tents of the Israelites in their desert wanderings—tents that actually would have been made of cloth and skins. The linguistic confusion of the Vulgate *tabernaculum*, meaning both a tent and a hut, thus merely reflects a similar and chronic imprecision in the poetic vocabulary of the Old Testament.[9] But it was, of course, the *Christian* understanding of the Feast of Tabernacles that concerned Francis and that informs *San Francesco nel deserto*, and it is that complex understanding which we must now address. We shall find that just as the word *tabernaculum* has three principal biblical meanings, so also does the Feast of Tabernacles have three principal strands of meaning: one ascetic, another ecclesiological, still another eschatological. In *San Francesco nel deserto*, Bellini has joined these themes in a single construct of complex iconographic meaning; and while the following analysis must perforce ravel them out, it must not be allowed to obscure what may in fact be the painter's greatest intellectual achievements, his power of synthetic imagination and his thrilling ability to impose a visual and thematic unity on complex materials of disparate origin and nature.

Medieval Christians knew something of the Feast of Tabernacles, or rather Skenophegia, to use the Greek term from the Septuagint swallowed whole in the Vulgate, not merely from the Old Testament but from the history of the New Israel. "What Skenophegia is," writes Augustine, "no one who reads the gospels can ignore."[10] Augustine is here commenting upon the single *explicit* mention of the Feast of Tabernacles in the New Testament, in John 7. There Jesus himself goes up to Jerusalem to keep the feast, "not openly, but as it were in secret," for he is already a wanted man. During the week of the festival, he was repeatedly threatened with arrest, yet "no man laid hands on him, because his hour was not yet come."

The exegetes did not fail to notice the importance of this festival, which commanded the presence of the Lord; and the fact that its

[9] See Wilhelm Michaelis, "Zelt und Hütte im biblischen Denken," *Evangelische Theologie* 14 (1954): 29-49. The imprecision is, of course, carried over into the Vulgate with its single word *tabernaculum*.

[10] "Quid sit Scenopegia, Scripturas qui legerunt, noverunt." *In Joannis Evangelium tractatus*, xxviii, 3.

celebration was a prelude to his Passion gave them warrant, in effect, to turn a feast into a fast. Thus Bede, whose discussion of the Feast of Tabernacles and much other Judaica was regarded as authoritative during the Middle Ages, links the season with the forty-day fasts of Moses (Ex. 24:18), Elijah (III Kings 19:8), and of Christ (Matt. 4:2)—the scriptural types of the Christian season of Lent.[11] Such an interpretation makes entirely logical the introduction of two other ideas that claim Bellini's attention but merit only a peremptory mention now—the blood of the lamb, the sacramental token of the liberation from Egypt, and its antitype in the New Dispensation, the Passion of Christ, which liberated mankind from bondage to the devil. We shall find parallel evidence of this typological imagination in the first of the *Considerazioni*, when Francis goes with his disciples to the festivities held by Count Orlando for the dubbing of his son, just before his own "Passion Week" and stigmatization.[12]

The easiest and most natural ascetic associations of the tabernacle would have been inevitable to Francis. The pilgrims of the Exodus dwelt in tents; tents are therefore the proper habitation of the Church *in via*. Just as the desert is par excellence the Christian image of religious life, the *tabernaculum*, the desert dwelling, is its natural cognate. The metaphoric implications of the tents of the Exodus are, furthermore, repeatedly ratified by other scriptural passages. "Jacob, a simple man who dwelt in tents" (Gen. 25:27), for example, is a founder of medieval ascetic institutions. Salimbene of Adam, a keen reader of Joachim, has no doubt at all that Jacob typifies the Franciscan Order.[13] The "Chapter of the Mats" is a logical implication of one of Francis' most troublesome habits: he read the Scriptures with utmost seriousness.

Thus it is that we may adduce a peculiar Franciscan significance of Skenophegia. Indeed, Paul Sabatier has done so, although his insight seems to have remained entombed in its brilliant footnote. In

[11] *In Zachariam*, III, xiv, 16 (CC, LXXVI, ii, 894-895).

[12] Gemelli, pp. 227-228.

[13] Thus Salimbene understands Joachim: "*Iacob autem, vir simplex, habitabat in tabernaculis.* Hic fuit Ordo fratrum Minorum, qui in principio sue apparitionis in mundo dedit se orationi et devotioni contemplationis." *Cronicà*, I, 30.

Francis' vision of religious life, the image of the tabernacle could point to discrete but converging spiritual truths, speaking at once of simple men who dwelt in tents, a race of pilgrims, and an army in campaign. There was, furthermore, a particular and witty justness to the manufacture of these temporary dwellings. Franciscanism, like so much that was dynamic in the spiritual life of the twelfth and thirteenth centuries, was an "apostolic" movement, founded on "the imitation of the Apostles." By happy chance, Paul, Prince of the Apostles, was by trade a tentmaker: *erat autem scenofactoriae artis* (Acts 18:3).

Early theoreticians of Christian ascetic life found a double lesson in this particular form of apostolic industry, which at once commended manual labor and exemplified evangelical poverty. In the Greek East, John Chrysostom, the eulogist of the Apostle Paul, doubted that there could have been a more appropriate worldly trade for a "pilgrim";[14] and the Desert Fathers paid honor to their model with their own crude textiles—baskets, plaited rushwork, and strange vegetable haberdashery. In the West, similar ideas were broadcast by Jerome, Cassian, and above all by Augustine's book on *De Opere Monachorum*. Basket-weaving can be a militant art as well as a contemplative one, and one of the commonest metaphoric associations of "tent-dwelling," made famous in another page of John Chrysostom widely disseminated in the Latin Church, saw the religious life as a military campaign. Chrysostom's image found its definitive Latin adaptation in the beautiful *Epistola aurea*:

> I beg you therefore, while we are pilgrims in this world and soldiers on earth, let us not build for ourselves houses to settle down in but make tents we can leave at a moment's notice, we who are liable to be called away from them in the near future to our fatherland and our own city, to the home where we shall spend our eternity. We are in camp, we are campaigning in a foreign country. Whatever is natural is easy, but in a strange land hard work is the rule. Is it not easy for a solitary and enough for nature and in keeping with conscience to weave for himself a cell out of pliant boughs, plaster it with mud, cover it with any-

[14] *In Praise of St. Paul*, trans. Thomas Halton (Boston, 1963), pp. 61ff.; Migne, *Patrologia graeca*, 1, 491ff.

thing that comes to hand and so come by a dwelling-place emi-
nently suited to him? What could be more desired?[15]

The military metaphor of an army on campaign necessarily has
a communal as well as an individual reference, for an army is a *so-
ciety* at war. Thus it is that the "tent" is also an image of the Church
itself, for the pattern of thought that linked church and desert was
both powerful and popular. From Paul to Augustine, thence
through all the tributaries of the mainstream of medieval ecclesio-
logical discussion, came the image of the pilgrim church. Augustine,
as always, was decisive.[16] In his classic formulation in *De Civitate
Dei*, this "church" might find its origins in the just Abel, a simple
agrarian murdered by Cain, the world's first urban planner. What
was involved was not only a conflict between two cities, one carnal
and temporal, the other spiritual and eternal, but a contrast between
the desert, the arena of pilgrimage, and the city built by hand, the
monument to man's Babylonian pride. A similar moralization of
city and "country," a recurrent preoccupation of pre-Romantic
and Romantic Europe, is by no means entirely absent from Renais-
sance landscapes. The village and fortified hilltops that form the
backdrop for Bellini's Alverna both delight and instruct. The con-
trast is not so much one of simple rural virtue and citified corrup-
tion as one between God's city and man's.

The scriptural origins of the "tabernacle church" are complex,
but one particularly powerful and explicit statement of the theme
exercised a defining influence upon the idea of the *ecclesia spiritu-
alis* during the Franciscan reform of the thirteenth and fourteenth
centuries. That is the lengthy speech made by the protomartyr
Steven before the Jewish council (Acts 7), an apology that is in
effect an extended Christian interpretation of the Alliance and the
Exodus.

Steven rehearses in summary form the history of the patriarchs
and dwells at length on the vocation of Moses and the deliverance
from Egypt; but the heart of his argument is a contrast between the

[15] *Epistola Aurea*, I, xxxvii, 151; in William of St-Thierry, *The Golden
Epistle*, trans. Berkeley, pp. 60-61.

[16] See the detailed exposition in Joseph Ratzinger, *Volk und Haus Gottes
in Augustins Lehre von der Kirche* (Munich, 1954), pp. 237ff.

spiritual purity represented by Moses and the prophetic line right down to Jesus on the one hand, and the "stiff-necked and uncircumcised in heart and ears" of ceremonial Judaism on the other. For Steven it is a contrast between a religion of the tents and a religion of the sumptuous and imposing stone temple: "The tabernacle of the testimony was with our fathers in the desert, as God ordained for them . . . which also our fathers receiving brought in with Jesus, into the possession of the gentiles whom God drove out before the face of our fathers; unto the days of David who found grace before God, and desired to find a tabernacle for the God of Jacob. But Solomon built him a house. Yet the Most High dwelleth not in houses made by hand . . ." (Acts 7:44-48).

Steven's attack on the ceremonial worship of the Temple reflects a major impulse of "apostolic" spirituality.[17] It is hardly surprising that its language, its metaphoric vocabulary, left a deep impress on the "apostolic" movements of the later Middle Ages.[18] The idea of a "church of the wilderness" had a significant impact on the poetic consciousness, and indeed the actual institutional practices, of primitive Franciscanism. In a general sense, the hostility to imposing building of any kind, which is a strong feature of Franciscan poverty, is clearly linked in Francis' rule with the theme of pilgrimage.[19]

But in the *Testamentum*, in a passage of great importance for one aspect of the poverty debate, the thematic link is not merely clear but insistent: "Caveant sibi fratres, ut ecclesias, habitacula paupercula et omnia, quae pro ipsis construuntur, penitus non recipiant, nisi essent, sicut decet sanctum paupertatem, quam in regula promisi-

[17] See Johannes Bihler, *Die Stephanusgeschichte in Zusammenhang der Apostelgeschichte* (Munich, 1963), pp. 71-77.

[18] The classic work on "apostolic" Franciscanism is Ernst Benz, *Ecclesia Spiritualis: Kirchenidee und Geschichtstheologie der Franziskanischen Reformation* (Stuttgart, 1934). There is a more profound treatment of primary Franciscan sources in Duane V. Lapsanski, *Perfectio evangelica: Eine begriffsgeschichtliche Untersuchung im frühfranziskanischen Schrifttum* (Paderborn, 1974). I have benefited from the unpublished dissertation of Doyne Dawson, "The Tradition of the Apostles: A Study of the Uses of History in the Thirteenth Century" (Princeton, 1974).

[19] See the *Regula bullata*, vi; *Regula non bullata*, ix; and *Documents*, p. 65, n. 35.

mus, semper ibi hospitantes sicut advenae et peregrini."[20] The term
habitacula paupercula is, of course sufficiently general to cover a
wide variety of modest shelter, but the suggestion of the earliest
texts is that it was not only at the camp meeting of the General
Chapter that the brothers dwelt in "tabernacles."[21] Insofar as there
was a specific architectural model for the friars' pilgrim shacks, it
would have indeed been that of the Portiuncula.[22] Yet that is simply
another way of saying what the first of the *Considerazioni* says in
reporting that the friars on Alverna "made a little cell out of the
branches of trees"—namely, that for Francis, "real life" and scrip-
tural history shared a common world.[23]

If we look again at Bellini's *sukkāh*, we shall see that it seems to be
an ecclesiastical rather than a domestic construction, suggesting a
church, not a dwelling. Two details in particular seem decisive in
this regard: the choir lectern, with its book, skull, and cross (fig.
19); and the chapel bell, casually mounted in a crotch conveniently
left untrimmed from the foremost vertical pole (fig. 20). Yet the
most visually obvious emblem of the church may escape the casual
eye, for it lies hidden beneath a thin veil of allegory. I refer to the
large grapevine covering the *sukkāh*.

The vine is one of the many wildly unrealistic details of the
painting that Bellini forces upon our imaginative consent by the
sheer power of visual verisimilitude. Like so many of the New
Testament images of the Church, the vine is rich in polysemous
possibility.[24] The Old Testament phrase "to sit beneath one's vine

[20] "Let the brothers beware of receiving other churches, or humble dwell-
ings, or anything else that is built for them unless it be consistent with holy
poverty, which we promise in the rule; let them always be guests of the
roadside, like strangers and pilgrims." *Testamentum*, p. 24; *Opuscula*, ed.
Esser, p. 312.

[21] Kajetan Esser, *Anfänge und Ursprüngliche Zielsetzungen des Ordens
der Mindenbrüder* (Leiden, 1966), pp. 182ff.; see further S. Clasen, "Apos-
tolisches oder liturgisches Franziskanertum?" *FS* 40 (1958): 176-177.

[22] Francis De Beer, *La Conversion de saint François* (Paris, 1963), p. 249.

[23] "E insieme coll'ajuto di quelli uomini armati, che erano in loro com-
pagnia, feciono alcuna celluzza di rami d'alberi." Gemelli, p. 230.

[24] Detailed documentation of the background for this image is provided
by Jean Daniélou, "Die Kirche: Pflanzung des Vaters—zur Kirchenfröm-
migkeit der frühen Christenheit," in *Sentire Ecclesiam: Das Bewusstsein von
der Kirche als gestaltende Kraft der Frömmigkeit* [Festschrift for Hugo
Rahner] (Freiburg, 1961), pp. 92-103.

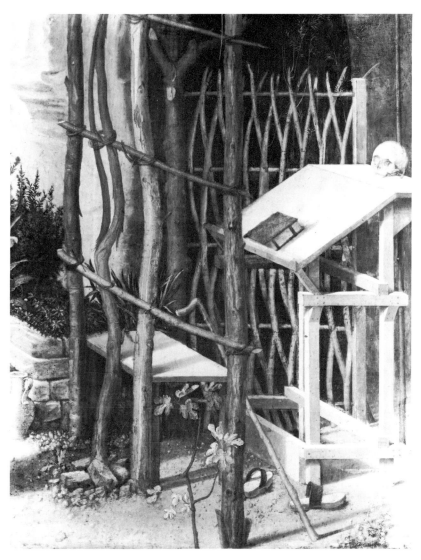

19. Bellini, San Francesco, *detail: the lectern.*

20. Bellini, San Francesco, *detail: chapel bell.*

[and one's fig tree]," a metaphoric expression of peace and security, became in Christian exegetical tradition a suggestion of the refreshment of the saints. Bellini's imaginative rendition probably echoes the striking phrase in Isa. 1:8, "a sunshade in the vineyard" (*umbraculum in vinea*), but the ecclesiological and christological associations of the image are determined by Jer. 2:21, and Isa. 5:2, and Jesus' identification of himself as the "true vine" (John 15:1).

These and other scriptural associations, which may be regarded as medieval exegetical commonplaces, are brought together in the lovely essay that was probably the specific source, direct or indirect, of Bellini's inspiration: the *Vitis mystica* of Bonaventure. One of the finest but also one of the least studied of Bonaventure's mystical opuscula, the *Vitis mystica* is essentially an affective meditation on the Passion, which examines in considerable detail the implications of Christ's statement, "I am the true vine." The whole of the work, of course, is relevant to Bellini's painting in a general sense, but two of Bonaventure's points have a specific applicability. The first is that the "vineyard" is the peregrine Israel, the people of the Exodus—or, to use the phrase used by Steven in Acts 7, "the church of the wilderness." The image of the vine, therefore, ratifies the suggestion of the ecclesiastical appointments of the tabernacle. A second point has to do with a connection between the dressing of the vine and the Passion.

> Since the shade of vine leaves is generally more agreeable when the vine itself is supported by a wooden structure and thus spread out, let us see how our true Vine was also lifted up and stretched forth. . . . See how clearly the woodwork of the trellis upon which the vine is often spread symbolizes the cross. A trellis is a latticed structure made of crossed pieces. It is upon this structure that the vine is spread out. What image could be closer? The beams of the gibbet are crosses; our Vine, the good Jesus, is lifted up on it . . . (vi, 1-2).[25]

[25] Sed quia gratior soler esse umbra foliorum vitis, cum ipsa, elevata super quandam struem lignorum, huc illucque distenditur; videamus, si vera vitis nostra aliquando levata fuerit et distenta. . . . Et vide, quam aperte lignorum strues, super quam solent vites elevari, crucem signat. Cancellantur, id est, ex transverso ponuntur, et sic super haec vitis distenditur. Quid convenientius? Cancellantur ligna crucis, elevatur in illam, distenditur brachiis et toto

If we look again at Bellini's remarkable *sukkāh*, we shall see that it at once incorporates the vine as a structural member and supports it by the lashings of its lattice work (see fig. 17).

The allegorical implications of Francis' rough hut, whether regarded from the ascetical or the ecclesiological point of view, are closely related to the Passion of Jesus Christ and are therefore entirely appropriate to a painting that, while not a narrative depiction of the Stigmatization, everywhere alludes to the mystery of that great miracle. At yet a third level of meaning, the crucial connection between the Feast of Tabernacles and the Stigmatization is yet more brilliantly developed. In the familiar terminology of late medieval scriptural exegesis, the ascetic associations of the tabernacle may be thought of as its tropological sense, and its ecclesiological suggestions as its allegorical sense. It has also an "anagogical" meaning, one that points to the life of the Church outside human time. The specific eschatological implications of the Feast of Tabernacles, indeed, are those that in the past have been most lucidly explored, especially in the illuminating essays of Jean Daniélou.[26]

Daniélou has demonstrated how, in Greco-Roman Judaism, the festival had developed explicit messianic overtones, which are clearly present, for example, in the mural paintings of the synagogue of Dura-Europos, dating from the middle of the third century (fig. 21). The tents of the sanctified Israel are a recurrent metaphor of the Old Testament prophetic books, as, for example, in Isaiah 32:18: "And my people shall sit in the beauty of peace, and in the tabernacles of confidence, and in wealthy rest." Daniélou makes the further point that the post-exilic liturgy of the Feast of Tabernacles included the recitation of the clearly messianic Psalm 118, *Confitemini Domino quoniam bonus.* Thus, already in antique Judaism, tabernacles were associated with the coming of the Christ and with the refreshment of Israel.

corpore vitis nostra, vonus Iesus." *Opera*, VIII, 171-172. *The Works of Bonaventure*, trans. José de Vinck (Paterson, 1960), I, 169.

[26] "Le Symbolisme eschatologique de la Fête des Tabernacles," *Irénikon* 21 (1958); this essay is published in a slightly different form in Daniélou's *Bible et liturgie*, 2nd ed. (Paris, 1958). See also Daniélou, "La Fête des Tabernacles dans l'exégèse patristique," in *Studia patristica*, ed. Kurt Aland and F. L. Cross (Berlin, 1957), I, 262-279.

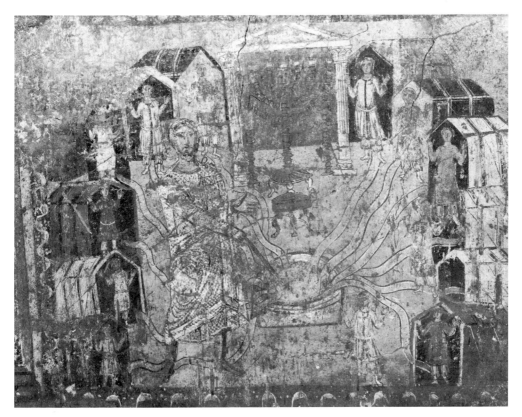

21. Dura-Europos Synagogue: Moses refreshes the twelve tribes.

Such associations entered the Christian consciousness not merely through the rabbinic exegesis of Alexandria but from their somewhat oblique reflections in the New Testament, whose authors—as we sometimes forget—were Jewish exegetes. The seventh chapter of John's gospel is the only explicit reference to Skenophegia in the New Testament, but the image of the eschatological tabernacle is subtly yet decisively linked to an important event in the life of Jesus, to which Giovanni Bellini elsewhere devoted his major attention and which medieval Franciscans regarded as a prefiguration of the Stigmatization. That event was the Transfiguration on the Mount, which, in the tradition of medieval scriptural exegesis, was believed to have taken place on Mount Tabor—of which Alverna

is the Franciscan antitype.[27] Jesus took his disciples to a high mountain where they saw him, gloriously transfigured, in conversation with Moses and Elijah. In all three of the synoptic accounts (Matt. 17:4; Mark 4:4; and Luke 9:33), Peter is reported as saying, "It is good for us to be here. Let us make three tabernacles, one for thee, one for Moses, and one for Elijah." Luke adds the phrase, "not knowing what he said," comfortable words, perhaps, to the many biblical scholars who have struggled with the passages.

Harald Riesenfeld's brilliant study of the Transfiguration has explained in detail the implications of Peter's reference to "tabernacles."[28] The idea of the tents comes naturally to the pens of the evangelists because they associate the *sukkāh* with the glorious, messianic epiphany that is the Transfiguration: "Ces cabanes étaient conçues non seulement comme une réminiscence de la protection divine dans le desert mais aussi, ce qui est important, comme une préfiguration des sukkot dans lesquelles les justes habiteront au siècle à venir."[29] Other New Testament scholars have taken the matter further still to show, for example, that the themes of ecclesiological and eschatological tabernacles are radically linked.[30] Certainly they were in the minds of the zealots in the poverty debate. For the immediate context of our medieval painting, however, it may be sufficient merely to underscore the scriptural connection between the *tabernaculum* and the glorification of Jesus, together with the two most prominent Old Testament types of ascetic life, in the landscape of a mountain wilderness. But the early texts could, and did, go much further, and the history of the Stigmatization could be yoked with that of the Transfiguration in a way that emphasized concepts of prophetic history and of church renewal. One particularly striking poetic expression of this complex of ideas

[27] Barthelmy of Pisa, *Liber Conformitatum*, II, 388.

[28] *Jésus transfiguré: L'Arrière-Plan du récit évangelique de la Transfiguration de Notre-Seigneur* (Copenhagen, 1947); see esp. "La Cabane," pp. 146-205.

[29] Riesenfeld, *Jésus transfiguré*, pp. 188-189; cited by Daniélou, *Bible et liturgie*, p. 451.

[30] Roger le Déaut, "*Actes* 7, 48 et *Matthieu* 17, 4 (par.) à la lumière du Targum Palestinien," *Recherches de Sciences Religieuses* 52 (1964): 85-90; see also E. des Places, "'Des temples faits de main d'homme' (Actes des Apôtres, 17, 24)," *Biblica* 42 (1961): 217-223.

is the vesper hymn *Proles de caelo prodiit*, written by Gregory IX (Hugolino), which, because of its antiquity and authority, is among the best known of early Franciscan liturgical hymns.[31]

The poem begins with an evocation of the "new wonders" of Francis' life, a term that in the early texts is usually associated with the "new sign" par excellence, the reception of the stigmata. But Gregory specifically constructs a parallel between the history of Francis' life and the history of the Exodus with the image of the crossing of the Red Sea (stanza 1) and the spoiling of the Egyptians (stanza 2). The handling of this latter theme is particularly witty, since Gregory identifies true Franciscan wealth with holy poverty. In the third stanza, Francis, taken up the Mount of the Transfiguration with the Apostles, the "mountain of the new light," speaks to Christ even as Peter had spoken: "Make three tabernacles" (stanza 4). What follows is, perhaps, the intellectually richest part of the poem. The three tabernacles are associated with a trinitarian scheme of history—ages of the Law, of the Prophets, and of Grace—and then with the renewal of the Church. The *triplex hospitium* (stanza 6) is at once an allusion to the three churches physically repaired by Francis and a metaphor for the three orders within the Franciscan family. The final stanza advances a soteriological suggestion that, were it not protected by the vagueness of poetic formulation, might be startling. Indeed, there is in the poem as a whole a range

[31] The text used is that published in the *Legendae*, pp. 376-377:

1. Proles de caelo prodiit,
 Novis utens prodigiis:
 Caelum caecis aperuit;
 Siccis mare vestigiis,

2. Spoliatis Aegyptiis,
 Transit dives: sed pauperis
 Nec rem vel nomen perdidit,
 Factus felix pro miseris.

3. Assumptus cum Apostolis
 In montem novi luminis,
 In paupertatis praediis
 Christo Franciscus intulit:

4. "Fac tria tabernacula",
 Votum secutus Simonis;
 Quem huius non deseruit
 Numen vel omen nominis.

5. Legi, Prophetae, Gratiae
 Gratum gerens obsequium,
 Trinitatis officium
 Festo solemni celebrat,

6. Dum reparat virtutibus
 Hospes triplex hospitium,
 Et beatarum mentium
 Cum templum Christo consecrat.

7. Domum, portam et tumulum,
 Pater Francisce, visita;
 Et Evae prolem miseram
 A somno mortis excita. Amen

of extravagant poetic suggestion not far removed from the more flamboyant and troublesome excesses of Franciscan Joachimism as it would develop later in the century.

Just as the eschatological meaning of the tabernacle informs the gospel accounts of the Transfiguration, so also does the scriptural event of the Transfiguration on Tabor inform the event of the Stigmatization on Alverna. When we understand that, we are prepared to enjoy a delightful and pious witticism that Bellini offers us as a *jeu d'esprit* and as a manifestation of his habit of *vagare*, "wandering at will through the pictures." Francis' physical pose, standing erect, his hands open, the wounded palms outward, has invited repeated comment, for it seems at once to deny the traditional iconography of the Stigmatization (in the erect stance) and to submit to it (in the prominent exposure of the open hands). Yet though this posture is unknown in narrative treatments of the Stigmatization with which Bellini could have been familiar, it approaches that of the transfigured Christ in important paintings of the *quattrocento*, including those of Fra Angelico and, for that matter, of Bellini himself.

In the iconographic formula of the Transfiguration, Christ stands between the two greatest prophets of the Old Law in a definite tableau: Moses is on his right hand, Elijah on his left. So does the *alter Christus* stand in Bellini's painting—if we remember that the rabbit of the rocks "is" Moses and that the fine ceramic jug recalls Elijah! Bellini says in paint what the *Breviary* says in words: the Stigmatization of Francis echoes the Transfiguration of Christ.

An admirable principle of patristic exegesis of the Scriptures can often help us in our understanding of biblical images as they appear in medieval and Renaissance poetry and painting as well. Absurdity of literal detail is a symptom of allegory.[32] Several critics of *San Francesco nel deserto* have stressed the point that in it Bellini has made a conscious and consistent effort to suppress any overt manifestations of the supernatural order—as, for example, in omitting the winged seraph from his "Stigmatization"—with the purpose, as one of them argues, of presenting the viewer only with things that

[32] See Jean Pépin, "Apropos De L'Histoire de l'exégèse allégorique: L'Absurdité, signe de l'allégorie," *Studia patristica*, ed. Kurt Aland and F. L. Cross (Berlin, 1957), I, 395-413.

he actually could have seen.[33] There is probably something in this, but not much, for the painting is full of "absurdities," as the desert fathers would have called them: water birds in the desert, trees and vines growing from solid rock, unearthly light.

One of the absurdest of all such details is the "mat" of peeled willow switches separating Francis' *sukkāh* from the dark cave behind it (see fig. 18). Little fronds of greenery shoot out from the tops of the dead withies in stark profile against the blackness of the concavity in the rock. Millard Meiss noticed them and found in their miracle evidence of spiritual force. "The slender willow branches, all of one size, that have been cut and woven to form a gate to the saint's cell have burst into life again and sprout leaves," he writes, adding in another place that they have been regenerated by "an unseen power, symbolized by the light."[34]

Bellini has made willow wood a conspicuous part of his rustic tabernacle for the very good reason that "willows of the brook" are explicitly designated for that purpose in Leviticus. But that explains the occasion of the absurdity rather than the absurdity itself. Hugo Rahner has written wonderfully of the early Christian symbolism of the willow wood, showing how the Greek Fathers collated the language of the Pentateuch and the Psalms with a mysterious phrase in Homer, "fruit-destroying willows," to discover an allegory of striking elegance.[35] That elegance may have been lost to the Latin West, where Homer was not read, but its substance was not. The willow is, above all, an emblem of chastity, like the burning bush, a symbol of the supernatural fruitfulness of virginity.[36] Thus Hilary writes of the willow's remarkable vitality, how the cut wood can green up, its severed branches root in moist soil.[37] Bede goes further still, attributing to the plant the powers of

[33] Fletcher, p. 212.

[34] Meiss, pp. 15, 33.

[35] Hugo Rahner, *Griechische Mythen in christlicher Deutung* (Zürich, 1954), pp. 390ff.

[36] "Ligni nomen quod Grace dicitur *agnos*, indicat castitem." Bede, *In Zachariam*, III, xiv, 16; CC, lxxvi, 2, p. 895.

[37] *Tractatus in Psalm cxxxvi*: "Lignorum salicum natura ea est, ut arefacta licet, si modo aquis adluantur, virescant; deinde excis atque in humido fixa, radicibus sese ipsa demergant." *Opera*, I, 550.

a sexual depressant claimed for saltpeter in the locker-room *materia medica* of my adolescence.[38]

It is worth making the point that these allegories are not the often debased coin of a Berchorius or a Picinelli, the Sears and Roebuck of academic iconographers, but the pure gold of major fathers of the Church, and that they appear not in general handbooks of dogmatic botany but in precise and focused discussions of the meaning of the willow wood *used in the construction of tabernacles.* We are obliged to take them seriously and, I would argue, to give them hermeneutic priority to romantic impressions of an "unseen power . . . symbolized by the light." To paraphrase the great Henri Leclercq, an ounce of Augustine is worth three whole pecks of Walter Pater.[39]

Meiss' sharp eye has, however, caught an important literal significance of the willow wickers: they "have been cut and woven to form a gate to the saint's cell."[40] Yet a gate to where? It does not open to the viewer's space, nor to the space in which Francis himself stands. It offers ingress to one place and one place only, a cave in the side of the mountain. This cave offers a final topic of obligatory interest concerning the tabernacle, and one that brings us to the threshold of those "mystical" themes of the stigmatized Francis soon to occupy our attention.

The cave is another mute witness to Bellini's love of *vagare.* What was Francis' actual habitation during his stay on Alverna?[41] We have already seen that the tabernacle is an oratory, not a dor-

[38] "Aiunt medici et hi, qui de arborum et herbarum scripsere naturis, quod si quis florem salicis, siue populi mixtum aqua biberit, omnis in eo frigescat calor, et libidinis uena siccetur, ultraque filios generare non possit." *In Zachariam,* p. 895.

[39] "Un seul texte d'un Père de l'Eglise, écrit à la date même d'une vieille peinture chrétienne, ou peu de temps après, est un guide infiniment plus digne de foi que tout un volume d'hypothèses, ingénieuses et de savants commentaires." *Dictionnaire d'Archéologie Chrétienne et de Liturgie* 15 (1779); cited by J. B. Bauer, "L'Exégèse patristique créatrice des symboles," *Sacra Pagina: Miscellanea biblica Congressus Internationalis Catholici de re biblica,* ed. J. Coppens et al. (Gembloux, 1959), I, 182.

[40] Meiss, p. 15.

[41] The evidence is fully presented and carefully discussed by Octavianus a Rieden, "De S. Francisci Assisiensis Stigmatum Susceptione," *CF* 24 (1964): 30-33.

mitory; and the medieval *vitae*, with their happy confusion of Palestinian and Tuscan topography invite us to look further. Thomas of Celano used the phrase *cella reclusus*, "hidden in a cell," which in context may suggest nothing more than a cell set at a distance from the other friars and out of their sight. But the *Actus* give a slightly more specific suggestion: "he made a humble little cell in the side of the mountain . . ." (*fecit unam pauperculam cellam in latere dicti montis*). The suggestion here, perhaps, is of quarters even more rustic, perhaps a cave. Such, certainly, was Francis' vision of Christ's own quadragesima, for in one of the many anecdotes illustrative of Francis' hostility to any kind of architectural pretension in the friars' houses or churches he said, "The Lord, when he was in the desert where he prayed and fasted for forty days, did not set up a cell for himself there, nor any house, but he lived beneath the rock of the mountain."

The *Speculum Perfectionis*, like the *Actus* a fourteenth-century text that imposes upon the events of the Stigmatization a carefully considered theological rationale, actually speaks of "another cell" (*aliam cellam*). It is here that Francis retreats, taking with him his missal, for on those days when he did not attend Mass, he wished always to be able to read for himself the gospel proper. It was in this "remoter" cell ("hidden" cell, "cell in the side of the mountain") that Francis was graced with those mystical experiences and demonic assaults that were the spiritual preparation for the great miracle itself.

Neither in the written nor the painted *testimonia*, however, should we expect precision or a literal authenticity, for the cave is a Cave of Contemplation. It is the same cave alluded to in the cony of the rocks, the cave on Horeb where Moses hid, and Elijah, and where both "saw" that God whom no man hath seen. The cave has a "gate" because it had one (*ostium*) for Elijah when, with veiled face, he heard the awful question, "What dost thou here, Elijah?" (III Kings 19:13); and as Gregory had maintained in a work greatly beloved by medieval monastic tradition, that gate is the doorway between the unfinished knowledge of mortal life and the perfect knowing of the blessed in heaven.[42] In the christocentric piety of

[42] "Quia ergo perfecte exire non possumus, saltem in speluncae nostrae ostio stemus, exituri quandoque prospere per gratiam Redemptoris nostri."

the Franciscans, the cave would be associated with the Passion, in the unique imitation of which Francis of Assisi had walked where only one had walked before.[43]

We shall soon have occasion to see that a very important school of Franciscan exegetes took a special and informed interest in Judaica. It is an interest by no means absent from the pages of Bonaventure himself, but the most prominent Judaic scholars of the order were those of the circle of Nicholas of Lyra, whose *postillae* were often regarded as definitive in the late Middle Ages and Renaissance, when they were very widely published with the introductory essays of Paul of Burgos, a former rabbi. Francis' own understanding of the Feast of Tabernacles was not academic but intuitive or "prophetic" in that medieval sense shared by Joachim and Bonaventure; but there were certain elementary facts of scriptural archaeology with which he would have been familiar, homiletic commonplaces from Bede and others.

The Feast of Tabernacles fell between the fifteenth and the twenty-second of *Tishri*, the seventh month, corresponding in the Western calendar to parts of September and October. The "Lent of Saint Michael," which Francis kept on Alverna, began at the Feast of the Assumption (August 15) and lasted until Michaelmas (September 29). The actual date of the Stigmatization is not known, but its liturgical assignment of September 17 cannot be far from actual historical accuracy. Nor can Francis himself have been unaware that the finger of God must have come upon him near that time when "on the last day, the great day of the feast, Jesus stood and cried saying, 'If any man thirst, let him come unto me and drink' " (John 7:37).

Homilia in Ezechielem, II, i; *Opera Omnia*, iii, 1,320. The image is discussed by François de Sainte Marie, *Les Plus Vieux Textes du Carmel*, p. 35. See Bonaventure, "Sermo iii," *Opera*, V, 558.

[43] "Si in monte aliquid timueris, curras ad cavernam lateris Christi." Thus James of Milan, *Stimulus Amoris* (Quaracchi, 1949), p. 129.

The Scribe of the Tau

Payment now falls due on a promise made in an earlier chapter when, in connection with the very curious phrase in the encyclical obituary sent by Elias of Cortona to all the provincials of the Order, I deferred an explanation of how Francis could be a second Aaron as well as a second Moses. We have seen how brilliantly Bellini has followed out two parallel exegetical lines of inquiry, first with a sustained Mosaic typology and then with the polysemous imagery of a pilgrim Church. He has also penetrated, as no other painter before or after him ever has, deeply into secret chambers of Francis' own pictorial imagination and seen there the mysterious image that Francis himself loved above all other pictures—the sign of the *tau*. Bellini's rendition of the Aaronic theme is wonderful testimony to the profundity of his understanding of the principle on which the vast edifice of medieval scriptural exegesis rested, the principle of the relationship between letter and spirit. We shall find advanced here the boldest spiritual claims concealed beneath the letter—in every sense of that word—of local, historical, time-bound details.

One of the classical "problems" related to *San Francesco nel deserto* is the absence of Brother Leo, whose presence is invited by the conventional iconography of the Stigmatization.[1] This "problem" is solved by the realization that the painting is not now and never has in the past been a depiction of the Stigmatization of St. Francis; but the problem of Brother Leo himself cannot be so

[1] See Meiss, p. 21.

easily exorcised. He was present with Francis on Alverna; and he is present with him in Bellini's painting, much as Elijah or the pilgrim Israel is there, betokened by a piece of his property.

If we look carefully at the central figure of Francis—indeed, even if we look casually at him—we cannot fail to notice that there is something unexpected at the point where his cord belt disappears beneath the left sleeve of his habit (fig. 22). It is the sort of empirical embarrassment that has convinced me, to my regret, that no more in art history than in literary criticism is there such a thing as "objective" description. We may pretend that to give an account of the mere content of a poem or a painting is the discrete prolegomenon to the critical deed itself, but in this we are certainly deceived; every act of description is an act of interpretation. When I first saw this thing to which I refer, I immediately "described" it to myself, with the same invincible certainty shared by several art historians, as a cloth patch.[2] Francis was God's little poor man, dressed in rags and tatters. This was a well-known fact of Franciscan biography, and a visible truth of Franciscan iconography. Lady Poverty herself, the personification of the quality thus represented allegorically, wears a garment patched in virtually the identical spot on her gown in the "Mystical Marriage" in the lower church at Assisi. One sees the patch very clearly, for believing is seeing.

Then I read Meiss. "The small sheet of paper slipped below his girdle together with the fact that he addresses the heavens," he wrote, "might suggest that he is engaged in composing, perhaps the Hymn to the Sun."[3] I continued to see a patch, of course; and one irony of my own book is that it owes its origins to the fact that while I was ignorantly prepared to bow to Meiss' authority on numerous points on which his iconographic analysis was faulty, I rashly set out to challenge him on one of his observations that is certainly right. It is impossible to look at the painting itself (as opposed to photographs of the painting) and believe that this square of discoloration is a patch. That it is not attached to the cloth of the habit

[2] Fletcher, p. 211; Smart, p. 475.

[3] Meiss, p. 21. The suggestion concerning the *Cantico* was a rhetorical device, and Meiss goes on to explain that the historical circumstances of the composition of the *Cantico* would make the suggestion untenable for this painting.

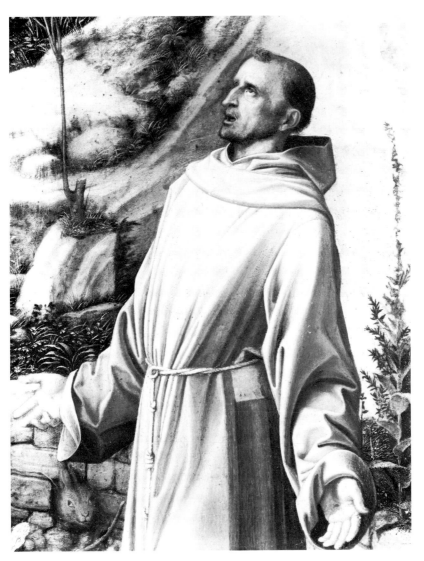

22. Bellini, San Francesco, *detail showing paper under Francis' belt.*

is proved by the fact that it breaks the dark shadow of the fold, a
feature particularly noticeable at its extreme lower left-hand corner,
where the dark of the hollow in the cloth can be seen both to its
left and below it. Rather, it is something tucked under Francis' belt,
not actually a piece of paper but a folded sheet of parchment, what
Francis himself would have known as a *chartula*. It is, in my opinion,
Bellini's single most brilliant touch.

The reception of the stigmata was indeed the unheard of wonder
that Elias of Cortona described in his encyclical letter of October
1226; and in the biographies of Thomas of Celano and St. Bona-
venture alike, it was to be the absolutely final and definitive sign of
Christ's special, indeed unique, grace to Brother Francis.[4] Here was
the authoritative proof, visible in the flesh to the fleshly eye, that
Francis was indeed all that he had seemed to be, *alter Christus*.
Dante's word for this sign is *ultimo*:

> nel crudo sasso intra Tevero e Arno
> da Cristo prese l'ultimo sigillo . . .[5]

Under these circumstances, the narrative history of the miracle
would inevitably be handled with a careful precision in the bio-
graphical documents. Thus it is that we know a good deal more
about the mystery of Mount Alverna than about most mysteries.[6]

At the Feast of the Assumption, August 15, 1224, St. Francis
withdrew to the desolate wilds of Mount Alverna, where he stayed
until Michaelmas, at the end of September. In the middle of Sep-
tember, possibly on the fourteenth, he received the stigmata. During
this time he was not entirely alone. He had with him his dear friend
and confessor, Brother Leo. Though during much of their retreat
they were separated from each other in private meditation, they
were together at least on certain occasions. One of them, recorded
without the name of Brother Leo, is to be found both in the *Vita*

[4] See Fleming, pp. 40-41.

[5] *Paradiso*, XI, 106-107: "on the harsh rock between Tiber and Arno he
received from Christ the last seal. . . ." Ed. and trans. Charles Singleton
(Princeton, 1975), pp. 124-125.

[6] See the meticulous arrangement of evidence by Oktavian von Rieden,
"De Sancti Francisci Assisiensis Stigmatum Susceptione: Disquisitio histo-
rico-critica luce testimonium saeculi XIII," CF 33 (1963): 210-266, 392-422;
34 (1964): 5-62, 241-338.

secunda of Thomas of Celano and in the *Legenda Major* of Bonaventure. Thomas of Celano writes thus:

> While the Saint was living on Mount Alverna alone in a cell, one
> of his companions [i.e., Leo] longed with a great desire to have
> something encouraging from the words of the Lord noted down
> briefly in the hand of St. Francis. For he believed he would
> escape by this means a serious temptation that troubled him, not
> indeed of the flesh but of the spirit, or at least that he would be
> able to resist it more easily. Languishing with such a desire, he
> nevertheless was afraid to make known the matter to the most
> holy father. But what man did not tell Francis, the Spirit revealed
> to him. One day Blessed Francis called this brother and said:
> "Bring me some paper and ink, for I want to write down the
> words of the Lord and his praises which I have meditated upon
> in my heart." After these things he had asked for were quickly
> brought to him, he wrote down with his own hand the *Praises of
> God* and the words he wanted, and lastly a blessing for that
> brother, saying "Take this paper and guard it carefully till the
> day of your death." Immediately every temptation was put to
> flight, and the writing was kept and afterwards it worked won-
> derful things.[7]

Bonaventure gives the story in almost the same words. "Francis
asked him to bring a pen and paper," he writes. "Then he wrote a
number of phrases in praise of God with his own hand and added a
blessing for the friar, saying, 'Take this piece of paper and keep it
carefully as long as you live.' . . . The page of writing was after-
wards preserved and worked miracles, testifying to St. Francis'
wonderful power."[8]

But the most precise and detailed account of the episode will be
found only in the *Considerazioni sulle stimmate*, a kind of appendix
to the *Fioretti* and a work that claims to be based on the eye-witness
account of Leo himself. Here is the story as we find it in the second
of the *Considerazioni*:

> Brother Leo suffered a very great spiritual (not physical) temp-
> tation from the devil, so that there came to him an intense de-

[7] *Vita secunda*, II, xx, 49; *Legendae*, p. 161.
[8] *Legenda Major*, xi, 9; *Legendae*, p. 609.

sire to have some inspiring words written by St. Francis' own hand. For he believed that if he had them, the temptation would leave him either entirely or partly. And although he had that desire, through shame or reverence he did not dare tell St. Francis about it. But the Holy Spirit revealed to the Saint what Brother Leo did not tell him. St. Francis therefore called him and had him bring an inkhorn and pen and paper. And with his own hand he wrote a Praise of Christ, just as Leo had wished. And at the end he made the sign of the Tau and gave it to him saying, "Take this paper, dear Brother, and keep it carefully until you die." . . . He carefully put the paper away and kept it. And later the friars performed many miracles with it.[9]

This is "the small sheet of paper" at Francis' belt; but we shall understand why it is at his belt only when we know precisely what was on it. That, happily, is a matter for empirical observation rather than for speculative or hypothetical reconstruction.

Brother Leo, who lived until the 1270s, followed Francis' instructions and kept the paper with him, preciously preserved, until his death. It then fell into the hands of Franciscan authorities no less solicitous for its care, and it exists today in the Sacro Convento at Assisi, one of the most treasured of the relics of the *poverello* and one of the least controversial. Kajetan Esser is the most recent of the paleographical and textual scholars to insist upon its indisputable authenticity.[10]

There are two texts on the *chartula*, one on either side. One is the lauda *Tu es sanctus Dominus Deus.* The other is the blessing, consisting of a few lines of autograph and a little drawing, to which, at some later time, Brother Leo has added his own brief memoir. If there was a man on earth who knew of the circumstances under which the *chartula* was written, it was Brother Leo of Assisi, and his account differs in one particular from that in the *Legenda Major* and the other biographical sources. Bonaventure's account makes it seem that Francis wrote out the lauda and the blessing on the same occasion: "Then he wrote a number of phrases in praise of God

[9] Gemelli, pp. 240-241.

[10] *Opuscula Sancti Patris Francisci Assisiensis*, ed. C. Esser (Grottaferrata, 1978), p. 89.

with his own hand and added a blessing for the friar."[11] Leo's own
testimony is somewhat different. He says that after the reception
of the stigmata Francis "composed and wrote out in his own hand
the laudes written on the other side of the chartula, giving thanks to
God for the grace granted to him." Concerning the blessing itself he
wrote: "Blessed Francis wrote this blessing for me, Brother Leo,
with his own hand."[12] Leo's implication is that the two texts were
written at *different* times separated by a measurable interval.

The matter is in one sense unimportant, except that it provides us
with a tidy literal and historical moment in human time in a paint-
ing dominated by the timeless and the allegorical. Francis has writ-
ten the laudes, and a few dark marks can be seen through the back
of the folded parchment. He has not yet written the blessing for
Leo (fig. 23). Such, at any rate, is the surmise that I would offer—
without, however, asking it to bear the weight of even a single
ounce of argument. My assumption is that Bellini's "source" is the
chartula itself, which I am confident that he knew, text and picture,
either from having seen it himself or from a more careful descrip-
tion of it than has survived in any of the public documents. The
evidence for that knowledge is in his painting, where he has picked
up and developed Francis' own iconographic themes—themes no-
where made explicit in the legendary texts.

That we have perfectly preserved a letter written by a poor man
who died seven hundred and fifty-four years ago is a remarkable
fact. That the letter should include as well as a written message a
free-hand sketch makes it doubly marvellous. The same circum-
stance that explains its survival—the person of the letter-writer—
made it a relic rather than merely an old manuscript, and this in
turn has meant that it has been more often venerated than read.

The blessing (fig. 24) is composed of two parts. Roughly cen-
tered in the top half of the *chartula*, Francis has written out, in
five lines, the following: "Benedicat tibi Dominus et custo / diat te.
Ostendat faciem / suam tibi et misereatur tui. / Convertat vultum
suum ad te / et det tibi pacem" ("The Lord bless thee and keep
thee; may He show thee His face and be merciful to Thee; may He

[11] "Laudesque Domini iuxta fratris desiderium propria manu scripsit et
ultimo benedictionem ipsius." *Legendae,* p. 609.

[12] *Opuscula,* ed. Esser, p. 92. See note 13 below.

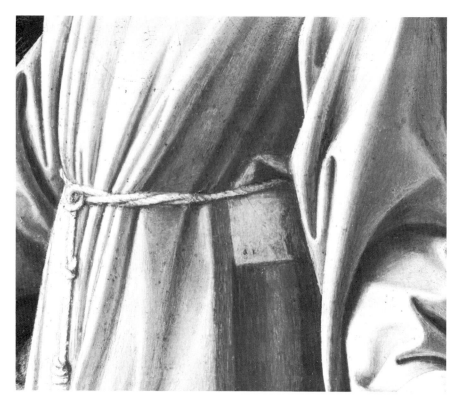

23. Bellini, San Francesco, *detail: the* chartula.

turn His face to thee and give thee peace"). Two further short lines
of text are written below. They have been transcribed by Kajetan
Esser, and most editors, as "Dominus benedicat, frater Leo, te"
("The Lord bless thee, Brother Leo"). There is a somewhat ob-
scure sketch at the bottom of the page, and rising from it, through
the final line of the blessing, is a large *tau* cross, the horizontal bar
of which separates the first five lines of the blessing from the last
two. In spaces left empty at the top of the *chartula*, just above the
cross-bar of the *tau* at the center, and at the bottom below the hand-
drawn sketch, Brother Leo has in a smaller hand made rubric notes
of explanatory character.[13]

[13] These notes read as follow (*Opuscula*, ed. Esser, pp. 92-93): [At the
top] "Beatus Franciscus duobus annis ante mortem suam fecit quadragesi-

Francis' blessing is at once a deeply personal expression of sympathy for a dear friend and a construct of traditional liturgical and pictorial form; brief and occasional as it obviously is, it still has much to teach us about Francis' sense of the mystery of Scripture.[14] As far as Bellini's painting is concerned, its chief relevance lies in its peculiar relationship of text and picture. The following brief analysis, summarizing a more detailed study published elsewhere, will treat first its verbal, then its pictorial part; but we must try always to bear in mind that Francis intends a quite specific iconographic unity of text and image. The first five lines of text are a citation, very slightly altered, of Numbers 6:24-26, the only difference between the two being that in the Bible the subject "Dominus" is repeated in the second and third clauses: "Benedicat tibi Dominus . . . Ostendat Dominus . . . Convertat Dominus." The final lines of text, in which the generalized blessing is given specific application to Brother Leo, has been plausibly described as an adaptation of the scriptural verse immediately following, Numbers 6:27: "Invocabuntque nomen meum super filios Israel, et ego [Jahweh] benedicam eis."

mam in loco Alvernae ad honorem beatae Virginis, matris Dei, et beati Michaelis archangeli a festo assumptionis sanctae Mariae virginis usque ad festum sancti Michaelis septembris; et facta est super eum manus Domini; post visionem et allocutionem Seraphim et impressionem stigmatum Christi in corpore suo fecit has laudes ex alio latere chartulae scriptas et manu sua scripsit gratias agens Deo de beneficio sibi collato" ("Two years before his death, Saint Francis made a forty-day fast in honor of the Blessed Virgin Mother of God and of Saint Michael the Archangel, at Mount LaVerna, from the feast of the Assumption of Saint Mary the Virgin, until Michaelmas in September; and the hand of God came upon him. After his vision, the revelation of the Seraph, and the printing of the wounds of Christ in his body, he composed the *laudes* on the other side of the paper, which he wrote out in his own hand in thanksgiving for the gift he had been given"). [Below the first five lines of autograph and above the cross-bar of the *tau*] "Beatus Franciscus scripsit manu sua istam benedictionem mihi fratri Leoni" ("Saint Francis wrote this in his own hand for me, Brother Leo"). [At the bottom] "Simili modo fecit istud signum thau cum capite manu sua" ("In like manner he made this *tau* sign with the head in his own handwriting").

[14] The final lines of the blessing contain a cryptogram of considerable interest for the study of Francis' mental habits but not directly related to the principal themes of *San Francesco nel deserto*. See my article, "The Iconographic Unity of the Blessing for Brother Leo," *FS* 63 (1981): 203-220.

The context of these verses is highly significant. They follow, in the first place, a lengthy description of the establishment of the Nazarites, an ascetic order within antique Judaism frequently taken by Christian exegetes as types of Christian ascetic life. A second important point is this: Francis' blessing is actually *Aaron's*. "And the Lord spake unto Moses, saying, Speak unto Aaron and unto his sons, saying, On this wise ye shall bless the children of Israel; ye shall say unto them . . ." (Num. 6:22-23). Given two facts of Francis' spiritual mentality well known to us—his vision of the Friars Minor as the pilgrims of the Exodus, on the one hand, and his view of the words of Scripture as sacramental *things*, on the other—it becomes apparent that he is "playing" Aaron, as in other contexts we have seen him "playing" Moses, Elijah, John the Baptist, and Christ on the road to Emmaus.[15] The Aaronic blessing, instituted by God's command for the refreshment of the pilgrim Israel *in via*, is the appropriate formula for a friar facing difficulties in *his* pilgrimage.

The connection of the Exodus with temptation, a connection that to us may seem somewhat oblique, was powerful and obvious to Francis, because he thought of the Exodus not merely as a definitive historical event from the Pentateuch but as an event remembered with its many different spiritual faces as they are reflected throughout the whole of Scripture. We may recall in this connection that Dante, when in the letter to Can Grande della Scalla he posits the Exodus as the significant analogue for our understanding of the *Divine Comedy*, cites not the book of Exodus but Psalm 114, *In exitu Israel de Egypto*, a poetic reminiscence of history rather than history itself.[16] Francis likewise is appealing to the greater poetic possibilities of the Exodus in exegetical tradition, one important theme of which—as has been demonstrated in a profound article by Jacques Guillet—is the theme of temptation.[17]

[15] On this general phenomenon, see Auspicius van Corstanje, "Franciscus de Christusspeler," *Sint Franciscus*, 63 (1956): 7-24; and above, pp. 25-27.

[16] This psalm is a perfect model of the allegorical use of the Exodus theme, for it deals with the event of the salvation of Israel in poetic rather than historical fashion, collapsing the whole history of the pilgrimage, from the flight to Egypt to the crossing of the Jordan, in its first three verses.

[17] Jacques Guillet, "La Thème de la Marche au Désert dans l'Ancien et le Nouveau Testament," 26 (1949): 161-181.

What of Francis' little drawing? There is a considerable bibliography of studies aimed at its explication. The *tau* is obvious enough, but the form at the bottom of the sheet has been variously described as a flower, an acorn, a leaf, a fish, and Mount Alverna. There is now general agreement, however, that it is what Brother Leo says it is, a head: "In like manner he made this *tau* sign with the head." What Francis' own mediocre draughtsmanship and the ravages of time have perhaps made mysterious is much more obvious in the copy in Assisi MS 344, made in the late fourteenth century (fig. 25). Controversy, never long banished from any interesting subject, re-emerges over the question of whose head it is. One leading Franciscan scholar maintains that it is Friar Leo's, but, as I have argued elsewhere, the overwhelming evidence of iconographic tradition is that it is Adam's.[18] Francis' little drawing is a somewhat eccentric adaptation of a Gothic crucifixion, with Christ's cross rising above the grace of Adam on Golgotha, the "place of a skull." The substitution of an uncorrupted head for the expected skull is unusual, but by no means unparalleled.[19] The more distinctive feature of the drawing is that the cross rising from the head is a *tau*. In the *tau* is the heart of the mystery—by which I mean not our petty puzzles as art historians and literary critics but the secret voice of God speaking to men in word and deed.

The meaning of the *tau* can, however, solve two mysteries of the lesser sort, for it can explain why Francis chose to join in a blessing the words of Aaron and a cross like the letter T and why Giovanni Bellini should put that blessing under Francis' belt. Incidentally and in passing, we may note that the mere *fact* of Francis' drawing has perhaps solved one iconographic difficulty in *San Francesco nel deserto*. Meiss noted that "the skull in the Frick picture . . . is some-

[18] Oktavian von Rieden, "Das Leiden Christi im Leben des hl. Franziskus," *CF* 30 (1960): 25; see my extended iconographic analysis in "The Iconographic Unity of the Blessing for Brother Leo," note 14 *supra*.

[19] See L. H. Grondijs, *L'Iconographie byzantine du crucifié mort sur la croix* (Leiden, n.d.), p. 145: "C'est un visage entier et vivant avec les yeux ouverts . . . et non un crâne." The living Adam at the foot of the Cross is frequently in the process of rising from his grave, but there are fairly close parallels to Francis' drawing. See, for example, George Swarenski, "Aus dem Kunstkreis Heinrichs des Löwen," *Städel-Jahrbuch* 7/8 (1932): 273, fig. 222.

24. *Assisi, Sacro Convento: autograph of Francis of Assisi.*

25. *Fourteenth-century copy of the* signum tau cum capite *in the auto-graph.*

thing of an innovation,"[20] and Smart calls it an "unusual feature," one "more to be expected in a representation of St. Jerome," a feature suggesting that "Bellini was concerned to enlarge the theme of the Stigmatization at La Verna into a more general, and more comprehensive, tribute to the Poverello of Assisi."[21] The Hieronymite associations are not wide of the mark, for the painted deserts of Renaissance asceticism share an undeniable generic kinship. There is, however, a distinctive feature about the skull in the Bellini painting that may lead us to speculate that he is once again indulging his taste for *vagare*. He has so arranged matters that a cross seems to rise from the skull (see fig. 18). The open framework of the lectern allows us to see at once that this is an optical illusion; the cross is actually raised on a very tall standard that reaches, one would judge, some six feet or so from the ground behind the lectern. Its crown of thorns certainly makes effective and apt allusion to the

[20] Meiss, p. 20. [21] Smart, p. 475.

Passion of Christ and the Stigmatization of St. Francis, but I suspect
that the unusual geometry of the configuration, for which I have
found no model elsewhere in medieval or Renaissance painting, is a
witty allusion to the drawing by Francis of Assisi in the Sacro Con-
vento. One great artist pays homage to another.

We know that Francis was a mystagogue with a deep attachment
to signs and portents. He regularly practiced scriptural *sortes*; he
walked reverently over rocks because "rock" was a scriptural thing
that betokened Christ (I Cor. 10); and like Browning's monk, who
refuted the Arian by downing his watered orange pulp in three sips,
he honored the Trinity with triplex consultations of Holy Writ.
One sign above all others claimed his special devotion. "He took
for a special token the sign *tau*," writes Thomas of Celano. "He
used it as the signature on all his letters, and he painted it on the
walls of all the cells."[22] The pages of Franciscan biography are
regularly punctuated with the *tau* sign. With a stick marked with a
tau, Francis performs a medical miracle.[23] Brother Pacificus sees a
panchromatic *tau* appear on Francis' forehead.[24] In the little chapel
at Fonte Colombo in the Rieti Valley, where Francis composed the
rule, there is on the wall a *tau* probably painted by his hand. And it
is of course unquestionably a large and commanding *tau* that "signs"
the blessing to Leo.

The rich history of the mystical *tau* could claim a book of its
own, and the following remarks are its faintest sketch.[25] Though
one sign of the cross, the Christian symbol par excellence, the *tau*
has a complex pre-Christian history. In Egypt it was prefigured by

[22] "Familiare sibi signum Thau, prae caeteris signis, quo solo et missivas
chartulas consignabat et cellarum parietes ubilibet depingebat." *Tractatus
de miraculis*, II, 3; *Legendae*, p. 273.

[23] "Tetigit locum doloris cum baculo parvulo, qui figuram *Thau* in se
habebat, et fracto mox apostemate, perfectam tribuit sanitatem." *Legenda
Major: Miracula*, x, 6; *Legendae*, p. 651.

[24] "Aspexit enim post pauca magnum *signum Thau super frontem* beati
Francisci, quod diversicoloribus circulis pavonis pulchritudinem praefere-
bat." Thomas of Celano, *Vita secunda*, II, lxxii, 106; *Legendae*, p. 193.

[25] I hope perhaps to undertake such a study myself one day. Of the vast
bibliography, the most comprehensive introductory study is that of Hugo
Rahner, "Antenna crucis, v: Das mystische Tau," *ZkTh* 75 (1953): 385-
410.

the hieroglyph *ankh*, the *crux ansata* or "handled" cross, a sign that
the Christian mystagogues of Alexandria knew also meant "life."[26]
In the high Middle Ages, it would fittingly become through other
associations the distinctive attribute of Egypt's greatest saint, An-
tonius Abbas, father of monks. From the brutal realities of antique
society, it was enriched by the *sphragis*, the brand of ownership on
slaves, and with the protocol for military executions.[27] Its richest
associations were of course Judaic and scriptural. The *tau* was the
final letter of the Hebrew alphabet as it had once been in archaic
Greek, and in the Christian imagination its shape, transmuted in
Hebrew graphology, remained that of the majuscule Roman T. In
the European Middle Ages, the *tau* cross has a very complex icono-
graphic history, claiming a prominent place in the learned specula-
tions of the doctors of the Church and in the superstitious practices
of unlearned peasants alike.

There is one passage, and one only, in which the word *tau* (*thau*)
appears in the Vulgate. The ninth chapter of Ezechiel is a terrifying
vision of the destruction of Jerusalem, blasted by God for its spirit-
ual fornications. Six men, their lethal weapons in hand, stand ready
to slaughter every living creature in the city. In their midst, how-
ever, is a seventh, a man "clothed with linen, with a writer's ink-
horn at his reins" (9:2). "And the Lord said to him: Go through
the midst of the city, through the midst of Jerusalem; and mark
Thau upon the foreheads of the men that sigh and mourn for all
the abominations that are committed in the midst thereof. And to
the others he said in my hearing: Go ye after him through the city,
and strike. Let not your eye spare, nor be ye moved with pity. Ut-
terly destroy old and young, maidens, children, and women: but
upon whomsoever you shall see Thau, kill him not" (9:4-6).

Francis of Assisi made a deep and mystical identification with

[26] This association was made in the fourth century by the historian Soc-
rates (*Historia ecclesiastica* 5:17; in Migne, *PG* 67:608-609) and in the fifth
by Sozomenos (*Historia ecclesiastica* 7:15; in *PG* 67:1,467); see further
R. Wünsch, "Der Antoniterkreuz," *Hessische Blätter für Volkskunde* 12
(1912): 49ff.

[27] These associations are demonstrated by Franz Joseph Dölger, *Sphragis:
Eine altchristliche Taufbezeichnung in ihren Beziehungen zur profanen und
religiösen Kultur des Altertums* (Paderborn, 1911).

this image of the man in linen with an inkhorn at his waist, and even as the cryptic *tau*-writer imposed himself on Francis' own spiritual imagination, inviting him to take the *tau* as his own signature, so he also imposed himself on the historical imagination of Bonaventure. In no less a prominent place than the prologue to the *Legenda Major*, Bonaventure explicitly identifies Francis first with the New Testament reflex of the man in linen, the *tau*-writing Angel of the Sixth Seal (Apoc. 7:2), and then with the redemptive amanuensis himself. There are many proofs, writes Bonaventure, that Francis was the Angel of the Sixth Seal: "First of all, there is the mission which he had received 'to summon all men to mourn and lament, to shave their heads and wear sackcloth' [Isa. 22:12] 'and to mark the brows of those that weep and wail with a Thau' [Ezech. 9:4]."

It is clear that for Francis one major strand of association with the man in linen was penitential, and the "men who weep and wail" were the lesser brothers who followed him in a life of penance. That they weep and wail for the abominations of Jerusalem, however, suggests also the mission of institutional reformation that was certainly at least subliminally in Francis' mind and was in the forefront of the ambitions of many of those who sponsored and followed him.

In this connection, it has more than once been suggested that Francis' specific initiation to the mystery of the *tau* was a famous sermon preached by Innocent III at the invocation of the Fourth Lateran Council in 1215.[28] The pope took as his text Luke 22:15—"Desiderio desideravi hoc paschua manducare vobiscum, antequam patiar"—and began with a review of the various meanings that Scripture assigned to the word *pascha*—the day of the feast, the precise hour of its celebration, the feast itself, and so forth. The meaning he chose to expound, however, was that he found in Exodus 12, where he identified the words *pascua* and *transitus*, journey, the journey of the Exodus. To the assembled bishops, he proposed a triple *transitus*: in the temporal realm, a new crusade against Islam; in the spiritual realm, a cleansing reformation of the Church; in the realm of anagogic mystery, a journey of the Church from militancy to triumph.

[28] *PL* 217:673ff. (Mansi, xxii, 968ff.)

In his discussion of the spiritual *transitus*, the reformation of the Church, he developed at considerable length the image of the *tau*-marker, the man in linen, the inquisitor who walks the streets of Jerusalem seeking the penitent and righteous remnant who will escape the sword of the avenger. For Innocent, of course, the man in linen was a prefiguration of the pope himself, whose apostolic duty it was to seek out and to extirpate the scandalous abominations of the Temple, which were all too visible to him and to his colleagues, and which encouraged many searchers of the Scriptures to the hazardous conclusion that true religion was to be found not in the episcopal palaces of Rome but in the more severe habitations of poor folk in Provence and Lombardy. Though we can have no certain proof that Francis was moved by reports of this sermon, it remains an extremely useful analogue for his own pattern of thought, and the scriptural associations developed by Innocent are clearly those that dominated Francis' imagination as well. It is to those associations that our own inquiry into *San Francesco nel deserto* must now be turned.

I have said in passing that the Angel of the Sixth Seal (Apoc. 7:2) was a "*tau*-writer," and for this claim I could now adduce support from Innocent III.[29] The fact that the word *tau* makes its sole appearance in Ezechiel 9 is something of a philological accident. The word *thau*, the sign T, actually denoted "sign" or "mark," as in the phrase "X marks the spot" in modern English. The Hebrew word that became *signum thau* in the Vulgate text of Ezechiel 9, is merely "sign" or "mark" in the Septuagint and other translations, as it indeed is elsewhere in the Vulgate itself. Hence, the saving angel who makes a mark on the forehead of the servants of God is perforce a *tau*-writer, for to write a mark is to write a *tau*. The Angel of the Sixth Seal is an obvious New Testament reflex of the man in linen, and Bonaventure, who was sure that Francis was the former, naturally therefore identified him as well with the latter.[30]

To read Francis into the Apocalypse too zealously was the fatal

[29] *PL* 217:673.

[30] The considerable number of such images provided Christian exegetes with a familiar and "historical" grounding in a superficially confusing apocalyptic vocabulary. See J. Cambier, "Les Images de l'Ancien Testament dans l'Apocalypse de saint Jean," *NRT* 77 (1955): 118ff.

error of Gerard of Borgo San Donnino and other Franciscan apoca-
lyptics, and there is no reason to believe that Francis himself did so.
On the other hand, we know for a certainty that Francis "read him-
self" into the history of the Exodus, and it was certainly in the his-
tory of the Exodus that Francis found much of what fascinated him
with the *tau*. There, in the desert of Sinai, we ourselves can find the
warrant for Elias of Cortona's superficially puzzling identification
of Francis and Aaron.

The episodes of the man in linen and of the Angel of the Sixth
Seal echo each other because they first echo a common antecedent.
Since *tau* means "sign," Jerome and other early Christian exegetes,
many of whom were competent and clever philologists, naturally
and correctly made a connection between the saving "sign" of the
man in linen and other protective and redemptive signs in the Old
Testament. Of these, the two most important were both connected
with the Exodus and one of them specifically with Aaron. They
were the blood-mark of the Passover, and the brazen serpent.

In the twelfth chapter of Exodus are recorded God's detailed in-
structions to Moses and Aaron concerning the arrangements for
the Passover. The blood of the slain paschal lamb was to be used to
mark the doorjambs and the lintels of the houses in which the chil-
dren of Israel dwelt, indicating which were to be spared by the an-
gel of death: "Transibit enim Dominus percutiens Aegyptios,
cumque viderit sanguinem in superliminari et in utroque poste
transcendet ostium et non sinet percussorem ingredi domos vestra
et laedere" (Ex. 12:23). Here the blood marked upon the houses
has precisely the effect of the mark of the *tau* upon the foreheads
of those to be saved in the general slaughter of Ezechiel 9. It might
be described as a prophylactic sign; there is also a curative or re-
storative sign.

Numbers 21 relates the history of the "fiery serpents." Israel
grutched against God for the difficulties of the pilgrimage, and
"the Lord sent fiery serpents among the people, and they bit the
people; and much of Israel died" (Num. 21:6). The people repent-
ed; Moses intervened; God relented: "And the Lord said unto
Moses, make thee a fiery serpent and set it on a pole. . . . And Moses
made a serpent of brass, and put it upon a pole, and it came to pass
that if a serpent had bitten any man, when he beheld the serpent of
brass, he lived" (Num. 21:8-9).

That Christian exegetes should identify these two "signs" with the Crucifixion of Christ was inexorable. The first to do so was Jesus himself: "And as Moses lifted up the serpent in the wilderness, even so must the Son of Man be lifted up" (John 3:14). The image of the "blood of the Lamb" in the Apocalypse is somewhat more complex, but it has clear connections with the paschal sacrifice, as indeed does Jesus' death throughout the typology of the gospels. The exegetical development of this family of themes was a particularly rich and influential one, but for the purposes of the present inquiry its most salient feature is its iconographic manifestation. Both the "signs" of the blood-daubed door-posts and of the brazen serpents were visualized as *taus* (figs. 26 and 27).

The standard on which the brazen serpent was raised is almost universally given the shape of a *tau* in Christian iconography, and since the "fiery serpents" of the Book of Numbers were equated in the Middle Ages with various forms of pestilential disease, the *tau* came to occupy a prominent position in medical iconography.[31] Through a series of complex but logical developments, the *tau* cross became the special attribute of St. Anthony Abbot and, in the late Middle Ages, of the Antonine Order, which made its special ministry to victims of the disease called St. Anthony's Fire (ergotism), a prominent and horrible aspect of which was an excruciating pain as of burning in the afflicted limbs. The "magical" properties of the *tau*—widely evidenced in medieval folklore and popular art— no doubt reflected a good deal of vulgar superstition, but a superstition remotely based in scriptural exegesis. Francis' own consciousness of the image is certainly biblical, and the special medical application he made of the *tau* clearly involves a ritual reminiscence of Numbers 21, for the instrument he employed was a stick marked with the *tau*.

We may believe, however, that for Francis the most imaginatively powerful *tau* was Aaron's own, the *tau* of the Passover. Though the Bible implies that the bloody mark on the lintels of the elect was the work of a random asperges, medieval Christians imagined and painted it as a specific graphic character. It was a *tau*, a *crux commissa*, a Latin T; and its writer was Aaron, priest of Israel. The evidence for this fact is copious, and it includes works of classical

[31] See the excellent study, rich in bibliographical citation, of Veit Harold Bauer, *Das Antonius-Feuer in Kunst und Medizin* (Berlin, 1973).

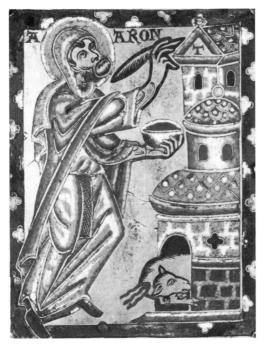

26. *Plaque from a Mosan cross: Aaron marking the* tau.

27. *The brazen serpent. Woodcut by Tobias Stimmer for* Neue künstliche Figurer biblischer Historien *(Basel, 1576).*

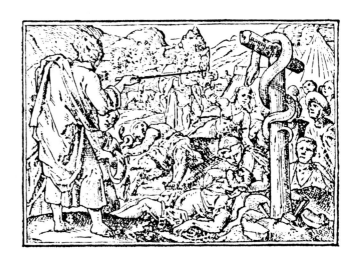

scriptural exegesis, works of imaginative literature, and, above all, a wide range of surviving monuments of visual art.[32]

For Francis, the history of Redemption was a line, not a circle. The line began at a moment in time, the moment of the promise made to Abraham, and it moved toward a terminus in time, a time unknown but surely not far distant, which he called simply and repeatedly "the end."[33] That line was punctuated, literally crossed indeed, by the moment of the Crucifixion of Christ. All of redemptive history on either side of this crossing made reference to it, in the time of the Old Dispensation by anticipation and prefiguration, in the time of the New by memorial and quotation. At the time when Francis wrote out the blessing for Brother Leo, it can at most have been a matter of days since he had seen scribed into his own flesh a sign as mighty and as wonderful as a bloodied door-post, or a brass snake, or a painted forehead. What other sign could be more appropriate for that moment than a sign which was at once a cross, a prefiguration of a cross, and the memory of a cross?

I have already drawn attention to Esser's pioneering study of the *Testamentum* of Francis and to his demonstration of the absence of abstract concepts in Francis' habitual mode of thought, which is typified instead by the conjunction of mental images or "pictures."[34] We look for verbal concepts in Francis' writings but find instead verbal images: images of lepers, images of barefoot Apostles, images of the nude Christ, a pauper crucified. The connections between these images as we find them in the *Regula* or the *Testamentum*,

[32] See, for example, Jerome, *In Esaiam xviii* (lxvi, 18-19), CC 73a:788 [PL 24:668]. For an example from thirteenth-century literature, see *Das Evangelium Nicodemi von Heinrich von Hesler*, ed. K. Helm (Tübingen, 1902), p. 70: "als Moyses der wissage / vor Cristes marter manige tage / bedutte den juden vore, / an den ubertorn enpore / da er sie 'tau' scriben liez, / als in got selben tun hiez / mit des lammes blute." For iconographical references, see "Aaron als Tauschreiber" in Hans Aurenhammer, *Lexikon der christlichen Ikonographie*, I, 4; and the learned article by Philippe Verdier, "A Mosan Plaque with Ezechiel's Vision of the Sign Thau (Tau)," *Journal of the Walters Art Gallery* 29/30 (1966-1967): 17-47.

[33] See, for example, Bertrand Cornet, "Le 'De Reverentia Corporis Christi,'" *Etudes Franciscaines* 8 (1957): 49ff.

[34] Kajetan Esser, *Das Testament des heiligen Franziskus von Assisi* (Münster, 1949), pp. 125ff.

which were clearly logical enough in Francis' own mind, often
seem to escape discursive textual analysis. Hence it is, I believe, that
we shall find the essential unity of the blessing for Leo in the pic-
torial relationships between Francis' *image* of Aaron and his *image*
of the *tau*.

The "passover" of Ezechiel 9 is of course an echo of the Passover
of Exodus 12, and the exegetical collation of the two episodes, such
as we find in Innocent's conciliar homily, is far from unexpected.
My own suggestion, however, is that we shall understand Francis'
mentality better in light of the *pictorial* traditions with which he
would have been familiar. Among the most exquisite witnesses of
the twelfth-century cult of the Cross are a substantial number of
ornamented altar and reliquary crosses worked in precious metals,
jewels, and enamel. A family of Mosan crosses, decorated with
more or less elaborate series of plaques illustrating the Old Testa-
ment types of the Cross of Christ, are particularly spectacular. The
most famous of them in its own day was doubtless the great altar
cross that the Abbot Suger had made for the church of Saint Denis
at Paris, which remained there, one of the most fabulous treasures
of Christendom, until the time of the French Revolution.[35] Suger's
own description of it is vague, but we get a fair sense of it from
later inventories and from works that imitated it, particularly the
so-called St.-Bertin cross now in the Hotel de Sandelin at St. Omer,
thought to be its less ambitious "copy."

The Saint Denis altarpiece certainly had among its decorative
enameled plaques scenes depicting the marking of the *tau* by the
man in linen, the raising of the *tau* standard by Moses, and the writ-
ing of the *tau* on the houses of Israel by Aaron.[36] Such typological
crosses were probably numerous in the twelfth and thirteenth cen-
turies, judging from the number that have survived whole or in part
into our own day, and it seems to me a likely possibility that the

[35] See Blaise de Montesquiou-Fézensac, "Les Derniers jours du Crucifix
d'or de Suger," *Archives de l'art français* 22 (1950-1957): 150-158.

[36] See Rosalie B. Green, "Ex Ungue Leonem," *De Artibus Opuscula XL:
Essays in Honor of Erwin Panofsky*, ed. M. Meiss (New York, 1961), I,
163f.; Blaise de Montesquiou-Fézensac, "Le Chapiteau du Pied de Croix de
Suger à l'Abbaye de Saint-Denis," in *L'Art mosan*, ed. Pierre Francastel
(Paris, 1953), pp. 153-154.

fundamental exegetical principle behind their iconographic sched-
ules is that which in a general sense has determined the form of
Francis' *chartula*. Nor is it altogether impossible that Francis, a
lover of crosses and a lover of the French way of doing things, has
been actually inspired by a great Mosan cross, perhaps the cross of
Saint Denis itself. That is, of course, speculation and, perhaps, idle;
what seems more certain is that Francis of Assisi has thoughtfully
and deliberately collated the words of Aaron with the mark of
Aaron in a unified document that speaks of penance and salvation in
the Age of Grace.

One aspect of Mosan enamel plaques particularly helpful to
iconographers is the unequivocal nature of their narrative captions.
One Old Testament figure of the Cross of Christ is the wood, two
sticks, gathered by the widow of Zarephath (III Kings 17:12).
These sticks are hardly mistakable in the fine plaque devoted to the
image on the St.-Bertin cross, but lest there be any doubt at all, the
artist has clearly denoted them as DUO LIGNA (fig. 28). Aaron,
too, penning his meticulous *tau* on an Israelite house that now has
the architectural features and function of a Romanesque church, is
clearly named: AARON (see fig. 23). The man in linen with a writ-
er's inkhorn at his loins is given no name by Ezechiel, but in time
the Mosan artists gave him one, or at any rate, something like a
name. He became the SIMILIS AARON (fig. 29), the man like
Aaron, like him because he too was the writer of the *tau*, and this
means perforce that he was also a man like Francis.

Bonaventure's identification of Francis with the *tau*-writer, the
Similis Aaron of Ezechiel 9, was inexorable. He argues no case
but merely states what for him is an empirical fact. His confidence
probably explains what otherwise might seem odd to students of
his exegetical method. He makes no reference to the fact that the
tau-writer makes a seventh among the six avenging messengers, a
transformation of the *senarius* to the *septenarius* on which he would
hardly have held silence if he thought that a proof were required.[37]
He used instead such phrases as "we have every reason to believe"
and "there can be no doubt."

[37] See H. Gunkel, "Der Schreiberengel Nabû im alten Testament und im
Judentum," *Archiv für Religionswissenschaft* 1 (1898): 294-300.

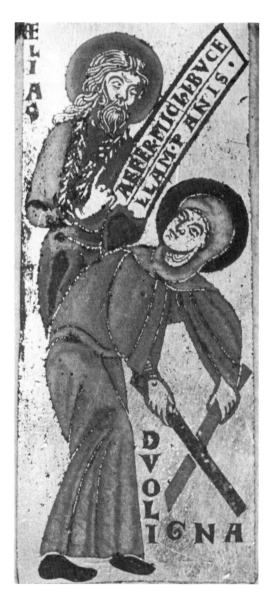

28. Detail of the St.-Bertin cross: Elijah and the widow of Zarephath.

How wonderfully intelligent is Bellini's solution to the problem of communicating this complex of ideas. The *tau*-writer of Ezechiel 9 is described as having an inkhorn (*atramentarium*) at his reins (*renes*), loins (*lumbis*), or back (*dorso*). Modern scriptural exegetes have long recognized in this figure the description of a Middle Eastern scribe or public stenographer, who carried an inkhorn in his girdle.[38] In similar wise do the Mosan artists imagine Aaron and the "man like Aaron"—a scribe with an inkhorn dangling from his girdle (fig. 30). Bellini, whose task was to show in a single detail the historical Francis of the Stigmatization on Alverna and the emblematic *Franciscus similis Aaron*, has given his scribe not an inkhorn but the cognate attribute of a slip of parchment. This bit of *vagare* is very witty. It is also subtle, and the price of subtlety is often enough that it goes unnoticed. Our most errant imaginings, however, are not a patch on Bellini's own imaginative powers.

There is, of course, no surprise in the fact that Bellini knew of Francis' blessing and—here I speculate—probably had seen it or its copy at first hand. The cult of relics in the Middle Ages was founded on the belief that they perpetuated in mysterious but efficacious fashion the earthly power and presence of the living saint with whom they were associated.[39] The special associations of the blessing with the Stigmatization and with the long-lived Leo, a figure who took on a unique authority in the minds of many friars of the fourteenth and fifteen centuries, gave this parchment relic a peculiarly powerful claim to veneration. It had a further advantage not enjoyed by knucklebones and phials of blood. Although the parchment itself was a unique specimen, the *words* of the blessing could be infinitely and ubiquitously reproduced by voice and pen. "In the Middle Ages its success was immense, and bordered on superstition."[40] In the *Petit Jehan de Santré*, a fifteenth-century "novel" by Antoine de la Salle, a man who could scarcely be accused of either

[38] See J. A. Selbie, s.v., "Inkhorn," in *A Dictionary of the Bible*, ed. James Hastings (Edinburgh, 1899), II, 473; for an illustration, see I, 626.

[39] Patrick J. Geary, *Furta Sacra: Thefts of Relics in the Central Middle Ages* (Princeton, 1978), pp. 18ff.

[40] Damien Vorreux, in *Saint François d'Assise: Documents*, p. 173n.

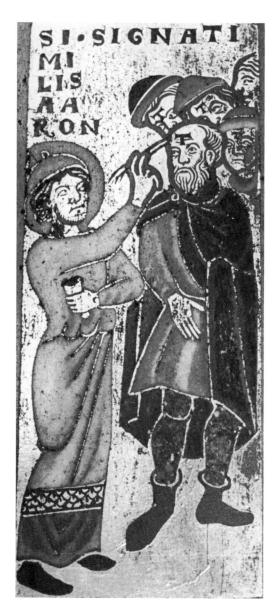

29. Detail of the St.-Bertin cross: the man in linen (homo similis Aaron) *marks the penitents on their foreheads.*

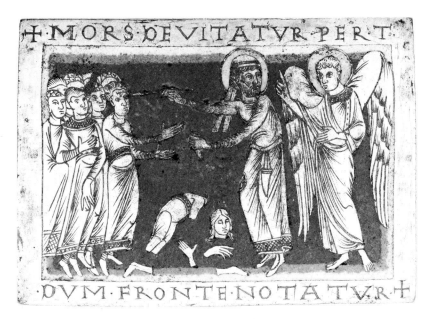

30. Enamel plaque: the similis Aaron, *writer of the* tau.

uncommon knowledge or uncommon piety, there is clear testimony
to its currency.[41]

There is even more distinguished literary evidence that by the
middle of the fourteenth century the general cultivated public
would have associated the Franciscan Order with the mission of
the *tau*-writer. In the *Philobiblon* by Richard de Bury, a widely
known essay in episcopal humanism chiefly distinguished for its
elegant expression of cherished traditional ideas, personified books
take up a shrill quarrel with the friars, whom they tax with indo-
lence and ignorance. The image of the *tau*-writer, according to
Richard de Bury, proves that those who are negligent about writing
books should not presume to the office of preaching penance.[42]

[41] "Laquelle beneiçon monseigneur Saint François dist a frere Lyon son
conpaignon, tempté de aucune diabolique temptacion." Antoine de la Salle,
Jehan de Santré, ed. Jean Misrahi and Charles A. Knudson (Geneva, 1965),
pp. 41-42; cited in *Documents*, p. 173n.

[42] "Atramentarium scriptoris gestabat in renibus vir qui frontes gemen-
tium *tau* signabat, insinuans figurate quod, si quis scribendi peritia careat,

Bellini makes a last lateral allusion to the *tau* with an unassuming detail in the *sukkāh* (see fig. 12): the walking stick. The walking stick is so unexpected in a Franciscan painting that I am tempted to hazard the untested guess that Bellini's must be unique. Smart, who noticed it, suggested that it may allude to the infirmities of Francis' last years, but this seems to me doubtful.[43] The walking stick is expressly forbidden in those gospel texts ("Take nothing with you for the journey, neither scrips nor staves . . .") that provide the plastic "pictures" behind the Franciscan rule, and it is explicitly forbidden in the *Regula non bullata*.[44] Its appearance in Chaucer's "Summoner's Tale" is an obvious satirical swipe at friars who do not live up to their own rule.

That it has been left behind, along with the similarly proscribed shoes, makes one kind of moral statement; but its very form makes another. It is the kind of walking stick called a potence, a term used more widely in medieval and early modern Europe to describe a variety of objects in the shape of a majuscule Greek *tau* or *gamma*. The potence is the particular attribute of St. Anthony Abbot and then, by more general extension, of eremitic saints generally. Often, the head of Anthony's potence has the shape of the *tau*, his appropriate symbol (fig. 31); but it often has the *gamma* form too, as it does, for instance, in the flamboyantly complex "Temptation of St. Anthony" by Bosch.[45]

The conies are but a feeble folk yet make their houses in the rocks. There is no *thing* in *San Francesco nel deserto* so feeble or

predicandi penitentiam officium non presumat." *Philobiblon*, ed. Antonio Altamura (Naples, 1954), p. 95.

[43] Smart, p. 475.

[44] See Matt. 10:10 and Luke 9:3; *Regula non bullata* 14 (*Opuscula*, p. 266). The text of Mark 6:8, which reads, "And he commanded them that they should take nothing for the way, but a staff only [*nisi virgam*]," guaranteed that the image would receive involved exegetical explanation; see J. V. Fleming, *The Roman de la Rose: A Study in Allegory and Iconography* (Princeton, 1969), p. 239.

[45] Bosch's painting is, among other things, an orgy of potences, as cross, gallows, crutch, and cane. The central figure of Anthony is shown in the act of making the trinitarian blessing (sign of the cross made with the thumb and first fingers); and he is given three different cross emblems: the potence, the *tau* marked on his right shoulder, the pendant cross of his beads.

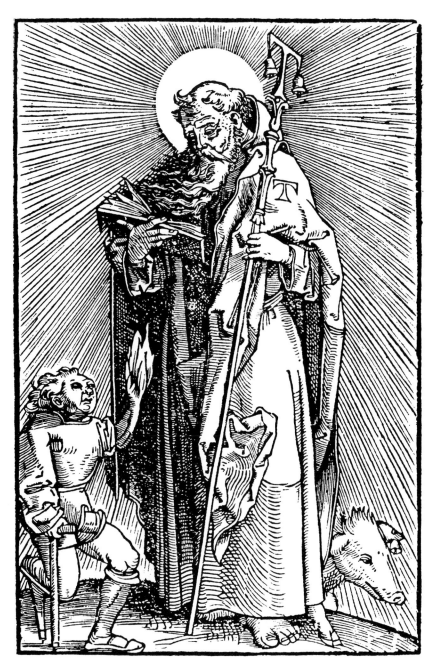

31. *St. Anthony Abbot. Woodcut from the* Feldtbuch der Wundtartz-
ney *(Strassburg, 1517).*

so humble that it cannot speak of deep mysteries, not a feeble cony nor a humble walking stick. The mystery of the *tau* is like the mystery of the Stigmatization itself in that it reveals Christ's Passion both as agony and as grace. Our English words "cross" and "crutch" are the same word; similarly, the "power" of the potence is double: it slays, and it vivifies. We are not asked to "see" all of this in an old stick or in any other single "motif" or "detail." Though the iconographer must perforce attempt to explain the whole in terms of its parts, those parts in fact claim meaning only by warrant of the whole. The aesthetic principle involved is nowhere more beautifully stated than in the prologue of the *Breviloquium*, where Bonaventure explains the mind of the great artist of the Scriptures:

> And so the whole course of the universe is shown by the Scriptures to run in a most orderly fashion from beginning to end, like a beautifully composed poem in which every mind may discover, through the succession of events, the diversity, multiplicity, and justice, the order, rectitude, and beauty, of the countless divine decrees that proceed from God's wisdom ruling the universe. But as no one can appreciate the beauty of a poem unless his vision embraces it as a whole, so no one can see the beauty of the orderly governance of creation unless he has an integral view of it.[46]

We see the walking stick only when we see the writer of the *tau*, the man like Aaron; and *him* we see only when we see also the Angel of the Sixth Seal.

[46] "Sic igitur totus iste mundus ordinatissimo de cursu a Scriptura describitur procedere a principio usque ad finem, ad modum cuiusdam pulcherrimi carminis ordinati, ubi potest quis speculari secundum decursum temporis varietatem, multiplicitatem et aequitatem, ordinem, rectitudinem et pulcritudinem multorum divinorum iudiciorum, procedentium a sapientia Dei gubernante mundum. Unde sicut nullus potest videre pulcritudinem carminis, nisi aspectus eius feratur super totum versum; sic nullus videt pulcritudinem ordinis et regiminis universi, nisi eam totam speculetur." *Breviloquium*, prologue, 2; *Opera*, V, 204. *The Works of Bonaventure*, ed. de Vinck, II, 11-12.

The Angel of the Sixth Seal

I n *San Francesco nel deserto*, the stigmatized Francis stands in
an artificial pose of rapt attention, looking, with intense concentra-
tion, toward a source of light outside of the picture. If one projects
his line of sight beyond the painting's frame—as one can do with
only tolerable precision at best—his gaze seems fixed on something
elevated, but only slightly so, and whether far or near we cannot
say. One theory used to be that he is gazing in the direction of a
winged seraph, once there but since removed with a carpenter's
saw for reasons altogether mysterious.[1] The light toward which
Francis looks has been called "unearthly"; Meiss' word for it is "un-
natural," and he says that "one has the impression that his experience
is somehow bound up with it."[2]

There is in pictorial analysis no more empirical certainty than
there is in poetic analysis. One man's patch is another man's parch-
ment, and so it goes. I cannot therefore appeal, as I would wish to
do, to the empirical fact that in this painting Francis of Assisi faces
the rising sun, as obvious as that seems to me. Meiss sees the light as
mysterious and unnatural, a symbolic force of divine animation and
the actual effective agent of stigmatization. He hints that the scene
is a nocturnal one, with the landscape "supernaturally lighted at
night," and suggests the details of the "empty town and the watch-
ful shepherd" as possible corroboration.[3] This ill accords, however,
with the literalist principles that inform his general iconographic

[1] See John Steer in *The Burlington Magazine* 108 (1965): 533-534.
[2] Meiss, p. 26. [3] Meiss, p. 27.

analysis, for sheep do not graze in the darkness nor do donkeys promenade at midnight.

Those critics who have sought a connection between the painting and the composition of the *Cantico di frate sole* have, in my view, been following a much safer path, for they have responded, as Francis himself did, to a source of light mysterious enough for any man. All natural light is, after all, "unearthly," in that its source is not the earth but a celestial body. I myself can find no features in the painting that are inconsistent with a most natural and common-sensical interpretation of Bellini's illumination: it is sunlight. The scene of the painting is Mount Alverna, the time sunrise. Francis stands looking toward the rising sun. He does so, however, not be-cause he is composing a poem, but because he is the Angel of the Sixth Seal.

The number forty-two is a number of fulfillment. It is, for ex-ample, the number of boys eaten by bears for calling Elisha "Baldy" (IV Kings 2:24). It is also the term of office of the seven-headed beast: "power was given to him to do two-and-forty months" (Apoc. 13:5). Forty-two is the number of chapters in the *Vita Nuova* of Dante Alighieri and in other medieval books too numer-ous to mention. None of this is an accident, of course, for forty-two is the number of fulfillment, and especially of the fulfillment of the promise made to Abraham; for the number of generations from Abraham to Christ is forty-two (Matt. 1:17).

One fulfillment points to another, for Bible history is the history of the future as well as of the past. If one multiplies the number forty-two by thirty, which is the number of years in a generation, the product is 1260. The mathematics is confirmed by the explicit testimony of Holy Writ, for the two witnesses "shall prophesy a thousand two hundred sixty days, clothed in sackcloth" (Apoc. 11:3), and the woman clothed with the sun will be fed for "a thousand two hundred sixty days" (Apoc. 12:6).

As the year 1260 bore down upon Europe, many searchers of the Scriptures looked with hope or terror, and sometimes with both, for the end—or for that kind of beginning that involves an end. For many of them the expectation, though powerful, was vague and wary, but for some, including conspicuously a group of heretical Franciscan Joachites, the promise of fulfillment was quite clear.

Raoul Manselli, who has sketched for us the context of thirteenth-century apocalypticism, has shown how, first, the ideas of Joachim of Fiore almost naturally became preeminent in eschatological speculation and then found their most spirited advocates within the Franciscan Order.[4] Joachim did not create the Franciscan Order; but that order, or rather a certain powerful tendency within that order, came tolerably close to creating "Joachimism." "Joachimism" in return came tolerably close to destroying the order.

A Franciscan, Gerard of Borgo San Donnino, produced in 1254 at the University of Paris a special edition of the major works of Joachim, together with a prefatory essay and interpretive notes. He treated three of Joachim's books—the Apocalypse commentary, the *Concordance* of the Old and New Testaments, and the *Psalterium decem chordarum*—as the divisions of a single tripartite work to which he gave the name *The Everlasting Gospel*.[5] There is a great deal we do not know about *The Everlasting Gospel*, including whether or not Gerard was its actual as opposed to its titular author.[6] The book was suppressed and burnt, and the "Liber Introductorius," or preface to the anthology, is known to us only through those parts of it preserved in adversary proceedings.[7]

[4] Raoul Manselli, *La "Lectura super Apocalipsim" di Pietro di Giovanni Olivi: Ricerche sull'escatalogismo medioevale* (Rome, 1955). Whether the speculation concerning the year 1260 had a specific connection with Joachim's doctrine is uncertain. See Manselli, "L'Anno 1260 fu anno gioachimitico?" *Il Movimento dei Disciplinati nel Settimo Centenario di suo inizio (Perugia, 1260)* (Perugia, 1962), pp. 99-108. For specific "Franciscan" prophecies, see Francesco Russo, "S. Francesco e i francescani nella letteratura profetica gioachimita," *MF* 66 (1946): 232-242.

[5] The title was taken from Apoc. 14:6: "Et vidi alterum angelum volantem per medium coeli, habentem evangelium aeternum." Gerard of Borgo San Donnino interpreted this figure as Joachim rather than Christ.

[6] Felice Tocco, for example, argued that John of Parma was its actual promoter; see "L'Evangelo Eterno," in Tocco's *Studii francescani* (Naples, 1901), pp. 191ff. Few scholars share this view today.

[7] These proceedings are studied by H. Denifle, "Das Evangelium aeternum und die Commission zu Anagni," *Archiv für Literatur und Kirchengeschichte des Mittelalters* 1 (1885): 49-142. B. Töpfer, "Eine Handschrift des Evangelium aeternum des Gerardino von Borgo San Donnino," *Zeitschrift für Geschichtswissenschaft* 7 (1960): 156-163 claims to have discovered in a Dresden MS the greater part of the anthology itself, without the *Introductorius*.

Those parts are enough to explain why the book's publication caused one of the most outrageous scandals in the history of a university for which scandal was a way of life. Gerard of Borgo San Donnino firmly believed in the imminent advent of Joachim's third *status*, in fact, its advent in the year 1260. He further maintained—and herein lies the significance of the title *The Everlasting Gospel*—that the advent of the Age of the Holy Ghost would abrogate the authority of Old and New Testaments alike, which would be dissolved and supplanted by a new and eternal evangel. A more shocking blasphemy could hardly be imagined—nor a more outrageous misrepresentation of the Calabrian prophet: "Thus Joachim, who had always upheld two Dispensations, even while expecting the third *status*, and had maintained that the two Testaments would last till the end of time, became the prophet of a system which might involve the overthrow of all previous institutions and authorities in a third and final Dispensation."[8]

What was particularly damaging to the Franciscans, quite aside from the fact that this outrage had been perpetrated by a visible member of their brotherhood, was the fact that the person of Francis and the establishment of the Franciscan Order became themselves prominent apocalyptic "proofs" of a deranged eschatology. The secular masters of the university, whose hostility to the friars, based on a combination of legitimate grievance and simple jealousy, was already intense, were outraged beyond measure by *The Everlasting Gospel* and exploited its scandal in an effort to discredit all friars.

Excess breeds excess, and the secular masters' "answer" to Gerard—Guillaume de St-Amour's famous *De periculis novissimorum temporum*—is a sizzling attack on the theological foundations of mendicancy based on an alternative apocalypticism that saw the friars as the "pseudoapostles," heralds of the "last times" of II Timothy. Guillaume and his book were themselves condemned in time, but the judgments of prelates are not always the judgments of poets, and some of Guillaume's racier satire, along with the unfaded memory of *The Everlasting Gospel*, were preserved in perpetuity in the pages of the *Roman de la Rose* of Jean de Meun.

[8] Reeves, p. 60.

Bonaventure was in the thick of this imbroglio. He received his teaching license at Paris at the end of the academic year 1252-1253 and received his chair there in 1257. He was the "official" Franciscan apologist in the contest with Guillaume de St-Amour. At the beginning of February 1257, he was elected Minister General, succeeding John of Parma, a man discredited in large measure by his real or imagined association with *The Everlasting Gospel*.[9] It was Bonaventure who presided at the Pentecost Chapter General at Narbonne in 1260 at which the decision was taken to suppress all extant biographical materials relating to the life of the founder and to replace them with a single, authorized, definitive *vita*. And, finally, it was he who received the commission for its writing.

In other words, if there was ever a man likely to be sensitive to the difficulties raised by Franciscan Joachimism, and eager to avoid them at all costs, that man was Bonaventura of Bagnoregio. There were no doubt many reasons why the Chapter General of 1260 moved as it did to control its own literary history, but the inference is inescapable that the very special character of the year itself played its part. The year 1260 was a year in which to be cautious about discussing Francis of Assisi and the "Last things" in the same breath. We might expect, therefore, that the prophetic and apocalyptic overtones of Joachimist Franciscanism would be altogether absent from the *Legenda Major*. Instead they are there present in powerful and theologically sophisticated form.

The opening words of the prologue unmistakably insinuate that Francis of Assisi is a "second Christ," and the prologue's first paragraph ends with an apocalyptic identification of remarkable audacity:

> Like a man who has joined the ranks of the Angels, he was taken up in a chariot of fire, so that there can be no doubt whatever that he "came in the spirit and power of an Elias," as we shall see in the course of his life. Therefore there is every reason to believe that it is he who is referred to under the image of an Angel coming up from the east, with the seal of the living God, in the prophecy made by another Friend of Christ the Bridegroom, St.

[9] See John Moorman, *A History of the Franciscan Order* (Oxford, 1968), p. 146.

John the Apostle and Evangelist. When the sixth seal was broken, St. John tells us in the Apocalypse, "I saw a second Angel coming up from the east, with the seal of the living God."[10]

The full text of Apocalypse 7:2-3 reads as follows: "And I saw another Angel ascending from the rising of the sun, having the sign of the living God; and he cried with a loud voice to the four Angels, to whom it was given to hurt the earth and the sea, saying: Hurt not the earth, nor the sea, nor the trees, till we sign the servants of our God in their foreheads."

The Angel of the Sixth Seal is a powerfully benign image. Joachim himself had taken the angel as a figure for Christ, but for Franciscans, who enjoyed the advantages of much fuller historical evidence, the conclusion that he was their founder was nearly inescapable. The fact was spoken to by a threefold evidence of the texts. Each aspect of this evidence was on its own powerfully suggestive; in its aggregate, it was decisively convincing. The Angel of the Sixth Seal was (1) solar; (2) marked with the sign of the living God; (3) empowered to write on the foreheads of the blessed. It may be convenient to examine these ideas serially, but beginning with the last and by now the most familiar and moving to the first and most difficult.

We may note first that the Angel of the Sixth Seal is an obvious New Testament reflex of the apocalyptic image from Ezechiel, which Bellini has so brilliantly insinuated into his painting with the detail of the piece of writing paper. He is a forehead marker; he is the scribe dressed in linen; he is Aaron. These associations are commonplaces of Franciscan exegesis, and Bonaventure makes them quite explicitly in the prologue of the *Legenda Major*. The angel's sign marked upon the forehead is the seal of redemption; but whereas Joachim had taken this as an immediate image of Christ's salvation, the Franciscans preferred to view it as speaking to an event fully within human time. Their angel is a precursor, the preparer for a final and awful time when foreheads will be inspected. In his call to penance, the angel is another Moses, another Elijah, above all another *praeco Regis*.

Next, the angel has "the sign of the living God." This sign is, of

[10] *Legenda Major*, prologue, i; *Legendae*, pp. 557-558.

course, the mark of the cross, the stigmata; and here the identification with Francis deepens. Francis is himself like the book of the seven seals; he is "written within and without." He is both scribe and inscribed, *scribens* and *scriptus*. The word "sign," which is of course the literal meaning of the word *tau*, has here a concrete sense. It is a letter, a visible character.[11] Bonaventure links the active and passive implications of the *tau*-writing in a particularly beautiful way. He equates it with the investment in the Franciscan habit, "which was shaped like a cross." Such a suggestion, as we have seen in earlier chapters, echoes an habitual mental identification of the Franciscan Order both as a second Exodus and as a just remnant. Here Bonaventure insists that Francis' authority for such a claim is manifest, attested to by "the seal of truth itself which was impressed on his body and which made him like the living God, Christ crucified." We shall return to the question of Francis' "likeness" to Christ when we come to study the meaning of the phrase *"alter angelus."*

We come last to the richest and most mysterious implications of the Angel of the Sixth Seal, his solar associations. He is an angel *ascendens ab ortu solis*, "rising from the rising of the sun." Before we can appreciate the meaning of the appropriation of this strange phrase to Francis, we must first recognize, as any sophisticated medieval scriptural student would have done, its christological meaning. The noun *ortus* is associated with the verb *orior*, "to rise," the participle of which is *oriens*. *Oriens*, in turn, is one of the Old Testament names for Christ (Zach. 2:9 and 6:12), and that is the word quoted in the Vulgate (Luke 1:78) in the passage so beautifully rendered in the Authorized Version as "the dayspring from on high hath visited us."

The allegorical patterns deriving from the identification of *Oriens* and *Christus*, which are very rich, had already been considerably elaborated in the early Christian period.[12] They included a classical

[11] The *textual* nature of this "sign" is implied by the larger metaphoric patterns of the Apocalypse, and particularly that relating to the book of the seven seals (Apoc. 5:1). Hence it is that early Franciscans "naturally" thought of the stigmata as God's *writing* on Francis' body. See *supra*, p. 13.

[12] Franz Joseph Dölger, *Sol Salutis: Gebet und Gesang im christlichen Altertum* (Münster, 1925), esp. pp. 143ff.

motif that would be effectively exploited by Christian poets and painters for the next thousand years and more—the idea of Christ as Apollo—as well as the identification of Christ with the imperial *Sol Justitiae*. In this connection, the figure of *Christus Oriens* took on obvious soteriological implications, as in the well-known Advent hymn from the *Breviary*:

> O Oriens / splendor lucis aeternae,
> et sol iustitiae, / veni, et illumina
> sedentes in tenebris, / et umbra mortis.[13]

Here the explicit references are to the Messianic prophecy of Isaiah 9:2 as it is applied to Jesus in Matthew 4:16. The illumination of the rising sun is, metaphorically, the saving grace of Christ. The clichés associated with the idea of *Christus Oriens* were central to the liturgical orientation of church buildings and to widespread practices of popular piety, such as the custom of praying facing eastward. Bellini's Francis—elevated on a mountain, arms open in a suggestion of crucifixion, praying into the rising sun—might almost be an emblem of the Alexandrian allegoresis of Christian prayer.[14]

A famous text in Dante can remind us of the vivacity of such imagery for the later Middle Ages. In the famous panegyric of Francis delivered by Thomas Aquinas in *Paradiso* XI, we have the following plays on words:

> Di quest costa, là dov' ella frange
> più sua rattezza, nacque al mondo un sole,
> come fa questo talvolta di Gange.
> Però chi d'esso loco fa parole,
> non dica Ascesi, ché direbbe corto,
> ma Orïente, se proprio dir vuole.[15]

We have here described the birth of a sun—an idea whose arresting originality is obscured in English by a pun that has been a staple of

[13] Cited by Dölger, *Sol Salutis*, p. 157; cf. Smart, p. 475.

[14] See Dölger, *Sol Salutis*, pp. 178ff.

[15] *Paradiso*, XI, 49-54: "From this slope, where most it breaks its steepness a sun rose on the world, even as this is wont to rise from Ganges. Therefore let him who talks of this place not say *Ascesi*, which would be to speak short, but *Orient*, if he would name it rightly." *Paradiso*, ed. and trans. Singleton, I, 120-122, 121-123.

our religious poetry since at least the thirteenth century—but the controlling text from the Scriptures is Apocalypse 7.[16] The birthplace of the sun should not be called *Ascesi* (pseudo-Latin for "I have risen," from *ascendo*), except by way of ellipsis. Its real name should be *Oriente* (the Italian reflex of *Oriens*). The first element of the dominant rhyme in the next terzina, which catches up the *corto*, is *orto*: "Non era anco molto lontan da l'orto."

A meditation on *Oriens*, incidentally, can illuminate a curious feature of Bellini's painting which, as far as I know, has received no comment at all. St. Francis is bald. The wispy forelock, the last remnant of a receding hairline, seems particularly conspicuous amid the baldness of the temples. It would be difficult if not impossible to say what is the work of nature and what of the *tonsor*, but my impression is of a balding man with a tonsure. Since I have not been entirely indulgent of art historical "impressions" as unleashed upon this painting, I can hardly claim a privileged status for my own. What is objectively certain is that Bellini's treatment of Francis here is markedly different from most of the pictures with which he could have been familiar, and different from his own treatment of Francis in other paintings.

Francis is reported to have worn a small *corona*—meaning, as I suppose, a scant but circular band of hair.[17] If we look to Giotto, we shall find Francis (like most other friars) wearing a full fringe of hair even after a severe tonsure.[18] Such is also the case in the large majority of other "portraits" of the *trecento* and *quattrocento*. It is of considerable significance, in my view, that we do find a bald Francis in Sassetta, by far the most sophisticated Franciscan allegorist among Bellini's predecessors. Bellini's own evidence is less clear. In the San Giobbe altarpiece Francis wears a thick *corona*; at Pesaro, a noticeable gap has appeared in the hairline at the left tem-

[16] I follow the commentary of *Paradiso*, ed. and trans. Singleton, II, 198.

[17] "Quando radebatur sanctus Franciscus, saepe rasori dicebat: 'Cave, ne mihi magnam coronam facias! Volo enim, quod fratres mei simplices partem habeant in capite meo.'" Thomas of Celano, *Vita secunda*, II, cxlv, 193; *Legendae*, p. 241. I cannot explain what Francis meant.

[18] That Giotto knew how to paint a balding, tonsured man when he wanted to is clearly evidenced by the old friar immediately behind Francis' [restored] head in the Bardi Chapel, "Confirmation of the Stigmata."

ple. But what is only hinted at in Pesaro has in *San Francesco nel deserto* become a bald fact.

Baldness would have an allegorical warrant in Franciscan exegesis, bearing in mind that, as we have already seen, Francis came in the spirit and the power of Elijah. The *Meditatio Pauperis in solitudine*, one of the most brilliant Franciscan books of the thirteenth century, finds a crucial significance in the fact that the Apocalypse says "*ascendentem* ab ortus solis" and not *descendentem*.[19] The "coming up from the east" speaks of the special mystery of Franciscan poverty, since the East, the land of sumptuous material life, means the world's riches that Francis rises above. The exegete then provides some scriptural models of what might be called ascetic occidentation. "Lot chose to himself the country about the Jordan, and he departed from the east" (Gen. 13:11). The name "Lot" means "declining," and he prefigures Francis, who declined the world's riches. So did Elisha. Soon after receiving Elijah's mantle and his double spirit (II Kings 2), Elisha left Jericho and went to Bethel. The Vulgate phrase is "ascendit autem inde Bethel" (IV Kings 2:23) and the author of the *Meditatio Pauperis*, who knew that the direction from Jericho to Bethel is a few degrees off due west, takes the liberty of saying "cum ab ortu solis ascenderet in Bethel . . ."; and *this* westward ascent means entry into the Order of Friars Minor. We may now recall, as the author of the *Meditatio Pauperis* certainly does, that as Elisha ascended into Bethel he was mocked by a large gang of naughty boys (forty-two of them, to wit) who shouted at him, "Go up, thou bald-head; go up, thou bald-head" (*Ascende, calve; ascende, calve*).

This event had long been considered a "type" of the mocking of Christ on his road to the mount of crucifixion, partly because of the apparent verbal connection between *calvus* and *Calvaria*.[20] The *Meditatio Pauperis* applies it to Francis, both in a spiritual sense and *ad litteram*.[21] It is a literal prefiguration of the abuse heaped upon

[19] *Meditatio pauperis in solitudine auctore anonymo saec. xiii*, ed. F. M. Delorme (Quaracchi, 1929), pp. 142-143.

[20] See Cornelius à Lapide in IV Reg. ii, 23 (*Commentarius in Josue, Judicum, Ruth, IV Libros Regum et II Paralipomenon* [Antwerp, 1700], I, 227ff.) for an anthology of patristic opinions.

[21] *Meditatio Pauperis*, pp. 146-147.

him at the time of his conversion by the townspeople of Assisi, who "threw stones and mud from the streets at him, shouting insults after him as if he were a lunatic" (*Legenda Major*, ii, 2); but it is also a spiritual adumbration of a *spiritual* baldpate: "Iste ergo vere *calvus* est, qui utique vocare vereat *ad fletum et calvitium et cingulam sacci*, ut dicitur Is. xxii, 12"—the same text used of Francis in the prologue to the *Legenda Major*.[22]

The idea of the Angel of the Sixth Seal is closely identified with another image: that of Francis as an *alter Christus*. In fact, these are not two discrete ideas but cognate facets of a single perception, for the Angel of the Sixth Seal is himself a reflection of Christ.[23] Once again the brilliant exegete of the *Meditatio Pauperis in solitudine* offers exciting suggestions. In a lengthy essay on the Franciscan meaning of Apocalypse 7, he pays particular attention to the word *alterum*: "*Vidi alterum angelum. . . .*" "Why does he not simply say *angelum*, as he often says in this very book, but *alterum angelum*?"[24] The answer to his self-posed question is lengthy, but its general effect is to argue that the special function of the word "alter" is to suggest a similarity between this angel and another. When we say of someone that he is an "alter Alexander" or an "alter Solomon," we do not mean that he *is* Alexander or Solomon, but that he is like them in his magnificence or wisdom. This is the use of the word in Apocalypse 7:2; the Angel of the Sixth Seal is *alter* because he is like another angel—Christ. The particular application of this perception to the history of the Stigmatization—an application only implied in the *Meditatio Pauperis*—is obvious when we remember that the seraph of the vision was Christ in seraphic form.

The pictorial history of the Franciscan *alter Christus* has been

[22] *Meditatio Pauperis*, p. 148.

[23] See Stanislao da Compagnola [Umberto Santachiara], *L'Angelo del sesto sigillo et l'"Alter Christus": Genesi e sviluppo di due temi francescani nei secoli XIII-XIV* (Rome, 1971). This book, rich in primary citations and secondary bibliography, has played an important part in my formulation of the ideas in this chapter. Mature thought leads me to repent of an idiocy in my *Introduction to Franciscan Literature*, p. 72, in which I succumb to exaggeration in speaking of Barthelmy of Pisa's development of the idea of the *alter Christus*. Barthelmy is no more and no less "staggering" than Bonaventure or Bellini.

[24] *Meditatio Pauperis*, pp. 139-140.

traced in a brilliant essay by H. W. van Os, the art historian who in my view has most clearly seen the fundamental principles of Franciscan iconography.[25] My only quarrel with this essay is perhaps a mere verbal quibble. The *alter Christus* is not a "theme" of Franciscan thought, but a fact about Francis of Assisi. Francis was an *alter Christus* in the same and fundamental way that he was a man, an Umbrian, and a pauper. We would not, I think, define the subject of a painting as "Francis as an Italian beggar." He *was* an Italian beggar, and that is all there is to it. It is quite true, of course, that different painters—and particularly Sienese painters of the fifteenth century—consciously appropriated to his pictures explicit christological emblems and attributes; but they were painting what for them was a fact, not developing a "theme."

The book of the seven seals was, by the nearly absolute consensus of patristic exegesis, the Holy Scriptures, and among the standard interpretations of the seven seals was Ambrose's widely followed opinion that they represented the seven ages of the world.[26] In the eschatological traditions common to Joachim and Bonaventure alike, this interpretation was assumed implicitly, though with varying patterns of complexity and elaboration. The Angel of the Sixth Seal accordingly is the necessary messenger of the sixth age, and whether that age be reckoned in terms of a simple or duplex septenary system, the identification with Francis is inescapable. "In view of the amazing coincidence of the particular factors," writes Ratzinger, "it is no longer surprising that the identification of Francis with the angel of the Apocalypse should have become an historico-theological axiom of practically unimpeachable certitude."[27] It is this axiom that Bellini states in his painting—for which the title "St. Francis as the Angel of the Sixth Seal," though eventually inadequate, would be much more accurate than most that have been suggested.

[25] H. W. van Os, "St Francis of Assisi as a Second Christ in Early Italian Painting," *Simiolus* (1974), VII, 115-132, copiously illustrated; see further E. James Mundy, "*Franciscus alter Christus*: The Intercessory Function of a Late Quattrocento Panel," *Record of the Art Museum Princeton University* 36 (1977). The Christ of this panel is very conspicuously bald, incidentally.

[26] See the very detailed schematic presentation by Ratzinger, pp. 12ff.

[27] Ratzinger, p. 37.

Two particular constraints of the painter's own choosing—submission to a coherent literal surface and the treatment of his subject as within human time—presented Bellini with formidable difficulties in conveying an apocalyptic content in pictorial form. His response to the challenge was sound but obvious, and it is Francis' role as the Angel of the Sixth Seal, the image par excellence of Franciscan apocalypticism, which explains the two iconographic "peculiarities" discussed by Meiss and others: the status of the stigmatization wounds and the conspicuous eastern light. Bellini presents us not with an action in process (stigmatization, by light or otherwise) but with a static image, that of the Angel of the Sixth Seal "having the sign of the living God." There is indeed the closest possible connection between the light and the "sign" of the Stigmatization, but it is not that of creator and creature. The angel with the sign rises from the rising of the sun. But there is less obtrusive eschatology as well.

The word "apocalyptic" has been nearly ruined by popular journalists—and popular historians—and it can no longer serve to suggest the optimism of much late medieval eschatology. We may not think of men like John of Parma or Angelo Clareno as blithe spirits, but there actually is a kind of cheerful confidence about one important aspect of their thought—precisely that which could be most justly described as apocalyptic or having to do with the revelation of God's final plan for human history. The miseries of the world, the failures of the Crusades, the despotism of tyrants, the persecution of poverty, and the flowering of the carnal church—all these painful signs might portend that things were soon to be better, indeed wholly made new.

The grounds for optimism were various.[28] Many searchers found inexorable demonstrations of the approach of Joachim's third *status* in the affairs of both church and state, and this could be true whether they were or were not in any schematic sense Joachites.

[28] See the collection of essays in *L'Attesa dell'età nuova nella spiritualità della fine del medioevo* [Convegni del Centro di Studi sulla Spiritualità Medievale, iii] (Todi, 1962); particularly relevant to the present discussion are Raoul Manselli, "L'Attesa dell'età nuova ed il gioachimismo," 146-170; and Ilarino da Milano, "L'Incentivo escatologico nel reformismo dell'Ordine francescano," 283-337.

Dante's enthusiasm for the "angelic pope" and his hopes for a re-
forming emperor are distinctive expressions of a characteristic
frame of mind. Jacques de Vitry could point to a broadly based
renewal of "apostolic life," conspicuously represented by the Fran-
ciscans but by no means limited to them.[29] Within the Franciscan
Order itself, there was a vague but general intuition of eschato-
logical mission, of which the ideas of Gerard of Borgo San Don-
nino might be regarded as a fanatic's parody. Once again it should
be pointed out that the idea of eschatological mission, like so many
other arresting Franciscan ideas, was clearly present in Francis' own
mind, in an undeveloped but nonetheless inescapable form, so that
it is also present in the early biographical materials.[30] The basis of
Bonaventure's own optimism is quite explicit: it is the advent of
Francis of Assisi. "The day of the formation of man [i.e., the sixth
day of the Creation, or the Sixth Age of history], the time of the
prophetical voice, and the time of the clear doctrine, in which the
prophesied life would come: for it was necessary in this time that
there come a single order, that is, a prophetical disposition similar
to the order of Jesus Christ, and of which the head would be an
angel ascending from the rising of the sun, having the seal of the
living God, and conforming to Christ."[31]

[29] "Singulis autem diebus status occidentalis ecclesie reformabatur in me-
lius, et illuminabantur per uerbum domini qui diu sederant in tenebris et in
umbra mortis." *The Historia Occidentalis of Jacques de Vitry*, ed. John F.
Hinnebusch (Fribourg, 1972), p. 107. The use of the scriptural language of
messianic prophecy is a commonplace of the time.

[30] Ratzinger (p. 41) credits Francis with an "eschatological" as opposed to
an "apocalyptic" set of mind ("schon Franziskus selbst von einem starken
eschatologischen Bewusstsein geleitet wurde, dem freilich jedwede apokalyp-
tische Färbung fehlte") and cites considerable evidence, including the ha-
bitual use of the *tau*, to demonstrate its self-conscious operation in his life.

[31] "Dies *humanae formae*, tempus *vocis propheticae*, tempus *clarae doc-
trinae*, in quo esset vita prophetica. Et necesse fuit, ut in hoc tempore veniret
unus ordo, scilicet habitus propheticus, similis ordini Iesu Christi, cuius caput
esset *Angelus, ascendens ab ortu solis habens signum Dei vivi*, et conformis
Christo." *Collatio*, xvi, 16; *Opera*, V, 405. The word *ordo* as used by Bona-
venture means a historical dispensation, but one imagines he tolerates the pun
comfortably. The Quaracchi text of the *Collationes* includes various "lecture
notes" by Bonaventure's auditors, and it adds at this point, "Et dixit, quod
iam venerat." This can mean only that Bonaventure said, in connection with

The *Collationes in Hexameron*, in which Bonaventure developed at length his extraordinary theology of history and spoke in most explicit and protracted fashion of the role of Francis and the Franciscan Order within its economy, begins in a somewhat disturbing way. Its first sentence is a citation from Ecclesiasticus 15:5: "And in the midst of the church she shall open his mouth and shall fill him with the spirit of wisdom and understanding, and shall clothe him in a robe of glory." "In these words," writes Bonaventure, "the Holy Spirit teaches the prudent man to whom he should address his speech, from where he should begin it, and finally where he should end it."[32] He should address it to the Church. He should begin with Christ. And he should end in the spirit of wisdom and understanding.

He goes on to elaborate each part of this trinity in considerable detail, beginning with a definition of the Church: "First, we must speak of ourselves and consider what qualities we must possess. For a ray of light offered to a weak eye blinds it instead of enlightening it. Hence we should speak of the Church which is the assembly of rational men, while the synagogue is the gathering of herds of men living like animals."[33] This apparently coarse contrast, which one embarrassed editor takes as "expressing the strong anti-Semitism of the theologians of the time," repays some closer consideration.[34]

Bonaventure's definition of the Church is based on an unacknowl-

this passage, that the Angel of the Sixth Seal had already come, and that he was Francis, especially as a second hand has added: "et forte intendebat de Ordine S. Francisci." Cf. Ratzinger, p. 25; and Reeves, p. 180. Bonaventure's opinions on such matters were decisively influential, especially as they were used by such writers as Ubertino da Casale and Bernardino da Siena. See, for example, Bernardino's sermon, "De stigmatibus sacris gloriosi Francisci," *Opera Omnia* (Quaracchi, 1966), V, 204ff.

[32] "In verbis istis docet Spiritus sanctus prudentem, quibus debet sermonem *depromere*, unde *incipere*, ubi *terminare*." *Collatio*, I, 1; *Opera*, V, 329.

[33] "Sed primo loquendum est de nobis ipsis et vivendum, quales esse debemus. Si enim oculo infirmo apponatur radius, potius excaecatur, quam illuminetur. Loquendum est igitur *Ecclesiae*, quae quidem est convocatio *rationalium*; synagoga autem est congregatio *gregum* et hominum brutaliter viventium." *Opera*, V, 329.

[34] *The Works of Bonaventure*, trans. de Vinck (Paterson, 1970), V, 2n. See Heinrich Stoevesandt, *Die letzten Dinge in der Theologie Bonaventuras* (Zürich, 1969), p. 61n.

edged loan from St. Augustine, taken from the very beginning of
his unfinished commentary on Romans, from a place where he is
defining the epistle's central theme. That is, according to Augustine, the question of whether the gospel of Christ came to the Jews
alone because of the merits of the Law, or whether, irrespective of
prior merits, it came to all Gentiles through justification by faith.
Summarizing a doctrine made explicit only deeper in the letter, Augustine says that neither the Jews (to whom Christ came but who
crucified him) nor the Gentiles (to whom the Law was not given
but who were made sons by adoption) are in a position to boast.
Rather both Jew and Greek are now united in a single bond:
"utrumque populum tam ex Judaeis quam ex Gentibus connectit in
Christo per vinculum gratiae." It is in this irenic context that Augustine sets out to explain the implications of Romans 1:1: "Paul a
servant of Jesus Christ called [*vocatus*] to be an apostle, separated
[*segregatus*] unto the gospel of God."[35]

These words speak, respectively, to the "dignity of the Church"
and the "antiquity of the Synagogue"; for to "convoke" is a verb
best used of people, to "congregate," best used of animals. Those
numerous passages in Scripture in which the Church is called the
flock or herd or sheepfold of God invariably speak of its life in the
age before the fulfillment of its promise—that is, before its "calling"
by God in Christ. The burden of the doctrine summarized by Augustine is, as we shall see, that of Romans 11. That Bonaventure is
aware of the context of his quotation is indicated by his prefatory
comment about blindness: "a ray of light offered to a weak eye
blinds it instead of enlightening it." This is a thematic allusion to
Romans 11:7: "That which Israel sought, he hath not obtained; but
the election hath obtained it, and the rest have been blinded."

The blindness of the "animal" synagogue is a scandal of history;
but it also bespeaks a great promise of the future, for as Paul himself

[35] *Epistolae ad Romanos inchoata expositio*, I, 1: "In Epistola quam Paulus
apostolus scripsit ad Romanos, quantum ex ejus textu intelligi potest, quaestionem habet talem: Utrum Judaeis solis Evangelium Domini nostri Jesu
Christi venerit propter merita operum Legis, an vero nullis operum meritis
praecedentibus, omnibus Gentibus venerit justificatio fidei, quae est in
Christo Jesu, ut non quia justi erant homines, crederent; sed credendo justificati, deinceps juste vivere inciperent."

states unequivocally, all Israel shall be saved in the fulness of time (Rom. 11:26-27). The "conversion of the Jews" is, in fact, one of the most constant apocalyptic expectations of medieval Christendom, an expectation that goes far toward explaining the ambiguous attitudes of such historical thinkers as Augustine and Joachim in their discussions of Jewry.[36] It is an ambiguity already fully present in Paul: "As concerning the gospel, indeed, they are enemies for your sake: but as touching the election, they are most dear for the sake of the fathers" (Rom. 11:28).

Apocalyptic expectations concerning the conversion of the Jews were widespread in Mediterranean Europe in the second half of the fifteenth century, stimulated in part by the aggressive policies of the Reyes Católicos in Spain and by increasing concern about the Eastern "Turk." It is well known, for example, that such prophetic expectations loomed large in the mind of Columbus.[37] In Italy, we find an obscure Florentine *vates* named Francesco da Meleto reporting, with considerable excitement and on the confidential authority of a Byzantine rabbi, that the Jews will be converted in the year 1484 if their Messiah has by then not arrived.[38]

For Bonaventure, all Bible history is the history of the Church; but as Ratzinger and others have taught us, Bonaventure was more interested in the history of the future than in that of the past. Or, to put it another way, the past was chiefly important for what it could teach about the future. The promise of the "sabbath rest" of the seventh age was the promise of peace, and its prelude was the restoration of the Church through a "contemplative order." This order was clearly identified in Bonaventure's mind with the Franciscan life if not with the Franciscan Order itself.[39] It would therefore be almost surprising if Bellini, who has captured so emphatically the idea of the Angel of the Sixth Seal, had not captured as

[36] See Beatrice Hirsch-Reich, "Joachim von Fiore und das Judentum," in *Judentum im Mittelalter* [Miscellanea Mediaevalia, iv] (Berlin, 1966), pp. 228-263.

[37] Salvador de Madariaga, *Christopher Columbus*, 2nd ed. (New York, 1967), p. 123.

[38] S. Bongi, "Francesco da Meleto, un profeta fiorentino ai tempi del Machiavelli," *ASI*, 5th ser., III (1889), 63; cited by Reeves, p. 437.

[39] See Ratzinger, pp. 35ff.; and note 31 above.

well some specific historical evidence of the promise the angel bears.

At a certain point, Panofsky's principle of common sense in iconographic analysis begins to work against skepticism, and wherever that point may be for a given painting, we have surely long since passed it in *San Francesco nel deserto*.[40] To doubt the iconological potential of any *thing* in the painting, to imagine that the "simulated self" of anything in it is a sufficient argument for its being there, is to reward emblematic genius with critical dullness and is, in fact, to do violence to "common sense." It is my view that our working hypothesis should be that every pictorial item in the painting is "guilty" of symbolic intention unless the unequivocal innocence of its self-simulation is demonstrable—and not, as various connoisseurs would have it, the other way around. Whether or not this view has any merit as a general principle, two particular botanical sore thumbs attract inexorable suspicion. Two trees, or parts of trees, claim the prestige of Francis' right hand. Below it is a shattered stump; above it, a leafing sapling. Meiss identifies these as a "broken fig tree" and a "plum tree." One identification is certainly right, the other certainly wrong.

The fig stump is particularly conspicuous (fig. 32). It has been crudely hacked off near the ground, apparently with a dull axe; yet its species is easily identifiable through its vigorous show of sprouting leaf. Its show of leaves on a stob makes clear allusion to two New Testament texts: Christ's blasting of the fruitless fig (Matt. 21:19) and the parable of the barren fig tree (Luke 13:6-9). Oswald Goetz, who has written an iconographic study of the fig tree, draws attention to its widespread appearance in Bellini and other Renaissance painters, and offers the exegetical clues that can lead to its explanation here.[41] The salient point about the blasted fig, not ap-

[40] This principle, cited with warm approval by Meiss, p. 24, enjoins "the use of historical methods tempered, if possible, by common sense. We have to ask ourselves whether or not the symbolical significance of a given motif is a matter of established representational tradition . . . whether or not a symbolical interpretation can be justified by definite texts . . . and to what extent such a symbolical interpretation is in keeping with the historical position and personal tendencies of the individual master." *Early Netherlandish Painting* (Cambridge, Mass., 1958), I, 142-143.

[41] Oswald Goetz, *Der Feigenbaum in der religiösen Kunst des Abendlandes* (Berlin, 1965), pp. 62-63.

32. Bellini, San Francesco, *detail: the fig stump.*

parent in the scriptural text but insisted upon by medieval exegetes, is that the fig fruits before it fully foliates, so that a tree with leaves but no fruit is a sterile aberration. Spiritually, such a tree is the external show of religion without its spiritual fruit.

The more important text for our purposes, Luke 13, explains why Bellini's tree has been felled: "A certain man had a fig-tree in his vineyard, and he came seeking fruit on it, and found none. And he said to the dresser of the vineyard: Behold for these three years I come seeking fruit on this fig-tree, and I find none. Cut it down therefore; why cumbereth it the ground? But he answering said to

him: Lord, let it alone this year also, until I dig about it, and dung it. And if it bear fruit, good enough, but if not then after that thou shalt cut it down." Its context in Luke makes clear that the essential moral point of the parable is the necessity for penance, and this is the tropological reading made by Bonaventure and others.[42] The broken tree represents those impenitents who deny God's grace. There is certainly no place for this tree in the Franciscan charmel or on this sacred mountain especially chosen by God for its suitability *per fare penitenzia*.

That is the tropological meaning of Luke 8. There is, of course, an allegorical meaning as well, and it is also relevant. The fig tree, in terms of the history of the Church, makes specific reference to the Jews, to whom Christ preached the good news "for these three years." At the end of that time, some brought forth the fruit of belief and some did not. Those who did not have been hewn down.

Just above Francis' right hand there is a young tree, a sapling or a start, growing, with the same improbability of so much of Bellini's flora, directly upon a rock (fig. 33). Meiss, who acknowledges the consultations of professional botanists, calls it a plum tree but says no more.[43] Alastair Smart draws special attention to it, observing its privileged position within the painting and noting its generic kinship to other "lopped" trees in Bellini and elsewhere, trees that "have been variously interpreted, whether as disguised symbols or simply as naturalistic details, according to their context."[44] He goes on to suggest that the image may be explained by Francis' special love of trees, for according to the *Speculum Perfectionis*, the *poverello* is supposed to have ordered that a woodcutter "should never cut down a whole tree, so that some part of any such tree would remain entire and unspoilt."

I have already outlined my theoretical objections to Smart's article and will not repeat them now.[45] The force of this specific suggestion is in my view weakened by the fact that the "lopped" tree stands in obvious binary conjunction with the fig stump, a tree that has indeed been utterly felled, leaving no part entire or unspoilt.

[42] "Per *ficum infructuosam*, sed foliis plenam, intelligitur anima, quae recusat poenitentiam propter negligentiam." Bonaventure, *Opera*, VII, 339.

[43] Meiss, caption to fig. 7.

[44] Smart, p. 473. [45] See pp. 14ff. *supra*.

33. Bellini, San Francesco, *detail: sapling growing from rock behind Francis.*

The two trees invite an interpretation that relates them thematically even as they are related visually. A literal approach seems to teach us only that Francis' orders were sometimes carried out and sometimes not. As for Meiss' identification of the species of the tree, I see little to recommend it. The characteristic leaf of the plum (family *prunus*) is elliptical, ovate or obovate, and serrated. The leaves on Bellini's tree are lanceolate, without serration. This fact is, in and of itself, of no particular significance, for Bellini takes many liberties with observed nature, and even those arboreal species like the fig and the juniper that are *obvious* are not, in fact, entirely *accurate*.

A correct identification of this tree would, one hopes, account for what I take to be the three most remarkable facts about it. The first is that it insistently invites comparison with the fig stump, an emblem of the impenitent and unfruitful synagogue. Secondly and quite preposterously it stands smack upon a rock. Finally, the tree has been grafted. Its lopped base is a staddle, and there is a conspicuous grafting knot just below the sharply defined line in the background that separates bare rock from greensward (see fig. 34). From the knot a tripartite scion springs, forming the meager branches of this infant plant. In short, this is a very odd tree indeed, and botanical expertise may be of less urgency than biblical exegesis in explaining it.

The tree takes us back to Romans 11, and Paul's discussion of Jews and Gentiles, synagogue and church.[46] He speaks of the relationship between the two through the elaborate figure of a grafted olive tree.[47] After a brief history of the derelictions of Israel—in which the image of the "saving remnant" is precisely the one we have already found in Bellini's painting, that of the prophet Elijah hounded to the solitary exile of Moses' cave—the Apostle speaks of the Gentiles as wild olive stock (*oleaster*) grafted into the broken

[46] For a bibliographic essay on interpretations of this passage, see Peter Stuhlmacher, "Zur Interpretation von Römer 11₂₅₋₃₂," in *Probleme biblischer Theologie* [Gerhard von Rad festschrift], ed. Hans Walter Wolff (Munich, 1971), 555-570.

[47] On the botanical and rhetorical aspects of this figure, see Matthaeus Hiller, *Hierophyticon* (Mainz, 1725), I, 58-60; and J. Albani, "Die Parabel bei Paulus," *Zeitschrift für wissenschaftliche Theologie* 44 (1903), 162-163.

34. Bellini, San Francesco, *detail: grafting knot.*

staddle of a domestic olive (*oliva*). This is a mystery, says Paul, that speaks of "the goodness and the severity of God." The root of the olive Israel has been saved, though its branches severed; the wild Gentile oleaster has been saved, but only through its grafting into the root. The scion is "made partaker of the root and fatness" of the staddle. That is, the fruit will be faithful to the promise of the staddle, not of the scion: "And [the Jews] also, if they abide not still in unbelief, shall be grafted in: for God is able to graft them in again. For if thou were cut out of the wild olive-tree, which is natural to thee: and, contrary to nature, wert grafted into the good olive tree; how much more shall they, that are the natural branches, be grafted into their own olive-tree? For I would not have you ignorant, brethren, of this mystery (lest you should be wise in your own conceits) that blindness in part has happened in Israel, until the fulness of the gentiles should come in. And so all Israel should be saved" (Rom. 11:23-26).

This passage was very well known to Bonaventure, and he offers it as certain proof that "the Jews will be converted."[48] Augustine, his greatest teacher, had devoted a spirited medley to the Pauline metaphor in a lengthy discussion of the meaning of "Asaf" in the *titulus* to Psalm 72.[49] Augustine knew that Paul's agronomy was deranged: the fruit is true to the *scion*, not to the staddle. But he took the grafted olive as a figure of a supernatural and eschatological mystery. The promises of the Old Law were carnal and terrestrial, and though their carnal fulfillment was slavery, exile, and the sack of Jerusalem, they were spiritually true to future events. The promise of the olive tree has no part in the carnal sciences of politics and agriculture and is free of their constraints.

The Angel of the Sixth Seal is the herald of things to come, the contemplative navigator of that brief period still remaining in the sixth age before the sabbath rest begins. The church has a past, in the smashed stump of the fruitless fig tree. It has a present, in the hybrid olive-oleaster, with its trinitarian scions and its arboreal argument that "there is no distinction of the Jew and the Greek."

[48] "Quod autem Iudaei *convertantur*, certum est per Isaiam et Apostolum." *Collatio*, xv, 25; *Opera*, V, 401.

[49] Augustine, *Enarratio in ps. lxxii*, 4: "Asaph Synagoga interpretatur."

More dramatic than its past and more glorious than its present is its future, suggested by Bellini with the visual shock of Francis' right hand, wounded, imprinted with the sign of the living God, artificially extended above the fig and below the olive: "In the midst of the Church the Lord shall open his mouth. . . . In these words the Holy Spirit teaches the prudent man to whom he should address his speech [and] where he should begin it. First, to whom he should address it, that is, to the Church. . . . Second, from where to begin, that is from the center, which is Christ; for if this Medium is overlooked, no result is obtained."[50]

If we have to place Bonaventure within a single school of medieval Christian thought, there can be no doubt what that assignment will be: he is a son of St. Augustine.[51] His mind is saturated with the works of Augustine, and his greatest debts to the spiritual thought of the twelfth century are to Anselm and the Victorines, who provided him brilliant alternative models of a more "contemporary" Augustinianism. This central and defining fact of his spiritual personality limits the practical usefulness of attempting to adjudicate with final precision the ambiguities of his attitude toward Joachim. That he was an anti-*Joachimist*, as any politic and sensible leader of his order would have to be under those historical circumstances, is certain; so also is it certain that he refuted Joachim's attack on Peter Lombard. But to the extent—and it was a very large extent—that Joachim's central theories themselves grew out of a profound Augustinianism, Bonaventure assumed his "prophetic" attitude toward history as a matter of course. Marjorie Reeves has put it very nicely: "Bonaventure was a Joachite *malgré lui*."[52]

The foundation of their shared attitude was a radical Trinitarianism. That the doctrine of the Trinity was also the specific locus of their disagreement, however profound it was made to be, is less im-

[50] The "centrality" of Christ—literalized in pictorial form in *San Francesco nel deserto*—is Bonaventure's fundamental theological axiom. See Werner Dettloff, "'Christus tenens medium in omnibus': Sinn und Funktion der Theologie bei Bonaventura," *Wissenschaft und Weisheit* 20 (1957): 28-42, 120-140.

[51] Bonaventure himself is quite explicit on this point. See Ludger Meier, "Bonaventuras Selbstzeugnis über seinem Augustinismus," *FS* 17 (1930): 342-355.

[52] Reeves, p. 181.

portant for our purposes than the fact that for both of them the meaning of history lay in the Trinity's mystery. Indeed, in all the vast theological literature of the thirteenth century, there is no more brilliant or more imaginative exploration of the themes classically raised in the *De Trinitate* of St. Augustine than Bonaventure's *Hexameron*.

There is an episode in the *Legenda Major* to which I have already alluded obliquely, a kind of theological and hagiographical witticism, which perhaps can serve to suggest in crude fashion the scope of Bonaventure's "trinitarian" thinking. The episode recalls the conversion of Francis' first friar, Bernard of Quintavalle. At the crucial moment in the process of his decision to "live a life of penance," Bernard (like Augustine before him) turned to biblical *sortes* for guidance, and with Francis, he entered the church of St. Nicholas to pray. Bonaventure describes Francis with the remarkable phrase *cultor Trinitatis Franciscus*, and he says that Francis opened the book three times in honor of the Trinity: "Cultor Trinitatis Franciscus ter Evangeliorum librum aperuit, trino exposcens a Deo testimonio."[53] This may strike a modern reader as empty or superstitious formalism, but Bonaventure considered the action a radical part of the moral episode pointing to a radical truth of Francis' life. Though the phrase has been often quoted, I am not sure that it has been noticed that Bonaventure places the episode in the third paragraph of his third chapter. That, too, is radical trinitarianism.

The trinitarian vision of Bonaventure's theology is not present in *San Francesco nel deserto* in obtrusive or schematic form, and it does not impose itself upon the casual experience of the painting except in a few trivial details: the three cut poles of the *sukkāh* trellis, for example, with their three corresponding horizontal members; the triplex scions of the grafted tree founded upon a rock. We see the deeper Trinity at the center—Moses, Elijah, Francis—only when we ourselves learn to look deeper. In this tableau of a Franciscan Transfiguration, we have also the mystery of salvation re-

[53] *Legenda Major*, III, 3; *Legenda*, p. 568. On the deeper meanings of this phrase, see W. Lampen, "Sanctus Franciscus cultor Trinitatis," *AFH* 21 (1928): 449-467; and Olegario Gonzalez [de Cardedal], *Misterio trinitario y existencia humana* (Madrid, 1965), pp. 6ff.

vealed in time: for in Bonaventure's scheme, the representative figures of the ages of nature, law, and grace, are Moses, Elijah, and Francis.[54] Yet this is an almost accidental truth, and to it Bellini has devoted no energetic development.

In subtler and markedly more interesting ways, however, *San Francesco nel deserto* is inescapably trinitarian, for its artistic composition and its intellectual apprehension are controlled by the spiritual sense of scriptural images. In the prologue to the *Breviloquium*, Bonaventure explains that all of theology is contained in understanding the breadth, the length, the height, and the depth of Scriptures. The breadth of Scripture encompasses all of time, its length the "ages of the world." The height of Scripture expounds ecclesiastical and angelic hierarchy, and its depth shows forth in the three spiritual senses founded in the unity of the letter. "It is entirely logical for Scripture to have a threefold sense in addition to the literal. . . . God is triune: one in essence and trine in the persons; hence, Scripture, proceeding from Him, has a threefold sense beneath the same literal text."[55]

There are many passages in Bonaventure's work in which the imposition of numerological congruence seems merely decorative if not actually contrived and strained; but this is not one of them, and any serious student of the *Breviloquium* or the *Hexameron* will here recognize a serious claim fundamental to all the master's thought. God, the creator of all things visible and invisible, the sacred author of Holy Scripture, reveals himself in it both in form and in content. Theology *is* the Bible; and the science of God is a science of reading the threefold mystery of divinity in the threefold mystical senses of the Bible.

We encounter throughout the *Divine Comedy* an authorial pretense that the supernatural journeys therein described literally oc-

[54] This is a typically Joachimist idea, for Joachim had pressed the novelty of interpreting the famous "two witnesses" (Apoc. 11) as Moses and Elijah —rather than Enoch and Elijah. See R. Manselli, *La "Lectura super Apocalipsim,"* p. 90.

[55] "Recte autem his triplex sensus debet esse in Scriptura praeter intelligentiam litteralem: . . . Deus autem est trinus er unus: in essentia unus et in personis trinus. Ideo Scriptura, quae est de ipso, habet in unitate litterae triformitatem intelligentiae." *Breviloquium*, prologue, 4; *Opera*, V, 205.

curred and that Dante is not their inventor but their reporter. "Quella materia ond' io son fatto scriba," he says of the voyage with Beatrice—"that matter of which I am made the scribe."[56] "The fiction of the *Divine Comedy* is that it is not a fiction." The ruse is an audacious attempt to usurp for his own *materia* something of the dignity of Scripture. The events of the *Comedy* like those of Scripture signify allegorical, moral, and anagogic truths founded in events that actually happened.

There is no ruse in Giovanni Bellini's mute claim to scriptural authority in *San Francesco nel deserto*. There is no image of his own invention in its whole broad expanse; he has merely been the faithful and technically brilliant scribe of the Holy Ghost. "Bellini's modification of the Stigmatization would probably have been facilitated by the fact that the painting, unlike his other large panels, was made for a private person," writes Meiss. "Messer Zuan, even if he did not welcome so personal a religious conception, would very probably have permitted the painter greater iconographic freedom than any official body."[57] I would argue that the only "personal religious conception" in the painting is that of the Third Person of the Trinity. When we speak of "personal opinions" expressed in a book, we refer to opinions of the writer, not of the printer.

When Bonaventure speaks of the outpouring of the Spirit in the seventh age, he does not speak of the promiscuous charisms of a busy and eternal Pentecost; the two words he uses are, quite literally, "peace" and "quiet." The reign of the Spirit will mean the fullness of scriptural revelation, that is, the plenary understanding of the *spiritual sense of the Bible*. Then will not be the hot labor of the field hand nor the fierce exertion of the warrior—the robust images of Christian life from the Scriptures and the hymns of the Church —but the contemplative quiet of the scholar's study and the hermit's cave.[58] "When he had opened the seventh seal, there was si-

[56] *Paradiso*, X, 27. [57] Meiss, p. 32.

[58] Bonaventure's insistence on the priority of the scholarly mastery of primary texts has pointed relevance to the study of all great Christian verbal and pictorial art and must be the last word in this book. *Collatio*, xix, 10 (*Opera*, V, 421-422): "Ad hanc autem intelligentiam non potest homo pervenire per se, nisi per illos quibus Deus revelavit, scilicet per *originalia Sanc-*

lence in heaven" (Apoc. 8:1). That is the silence of St. Francis in the desert, and the silence we also must seek if we are to gaze upon him with understanding as well as with wonder.

torum, ut Augustini Hieronymi et aliorum. Oportet ergo recurrere ad originalia Sanctorum; sed ista sunt difficilia; ideo necessariae sunt Summae magistrorum, in quibus elucidantur illae difficultates. Sed quia ista scripta adducunt philosophorum verba, necesse est, quod homo sciat vel supponat ipsa.—Est ergo periculum descendere ad *originalia*, quia pulcher sermo est originalium; Scriptura autem non habet sermonem ita pulchram. Unde Augustinus, si tu dimittas Scripturas et in libris suis studeas, pro bono non habet; sicut nec Paulus de illis qui in nomine Pauli baptizabantur. Sacra Scriptura in magna reverentia habenda est."

San Francesco nel deserto

As for this study, the rest—if not quite silence itself—is quiet recapitulation and distinctly muted speculation. One article of Panofsky's canon of common sense—to wit, that which enjoins the investigation of the extent to which "such symbolical interpretation is in keeping with the historical position and personal tendencies of the individual master"—can be but imperfectly honored in an examination of *San Francesco nel deserto*. The first impediment to its plenary application is the fact that the study of Bellini's iconography is an infant industry—sometimes speaking with an infant's uncertain voice. Bellini's "personal tendencies" with regard to allegorical imagery have been explored only in a few particular instances and often with only oblique purposefulness.[1] But there is a more daunting obstacle, and that is the unique-

[1] During the course of this book I have pursued the ecumenical intention of noticing, either by direct citation or clear allusion, every significant discussion of the iconography of *San Francesco nel deserto* known to me, beginning with Bernard Berenson's opinion that the religious subject of the painting was the mere pretext for a landscape ("European man had not yet made sufficient advance toward nature to compose a landscape without some pretext of a religious, legendary or at least romantic subject," *Venetian Painting in America* [New York, 1916], pp. 97-98). Though Berenson's view has been challenged by Meiss and others, Norbert Huse could still write vaguely of its iconographic "puzzles" within the last decade (*Studien zu Giovanni Bellini* [Berlin, 1972], p. 41). The conceivably relevant study proposed by Maurice Cope (see *The Frick Collection: An Annotated Catalogue* [New York, 1968], II, 208n) has perhaps not yet appeared. There is

ness of *San Francesco*. There is not another painting like it in Bellini's surviving oeuvre, and not another much like it in the whole vast corpus of Franciscan iconography generally. Bellini's post-biblical religious subjects are few in number and relatively simple in conception. One exception alone—his *Peter Martyr* in two extant versions—has something of the iconological density of his "Francis," but then only something.

It is not usual to speak, however capriciously, of Renaissance painters as scribes of the Holy Ghost, and if it is possible to speak thus of Giovanni Bellini, it is with regard to this one painting alone, which finds no rival for its density of scriptural imagery controlled by a specific and coherent theology of history. Although it is easy enough to connect the painting with Bellini's general intellectual affinities in other works, one is tempted to conclude that here his uniqueness of subject has brought with it its own uniqueness of treatment, a treatment that, based upon the principles of scriptural exegesis, everywhere transcends mere narration. It may be useful to summarize here the theological whole in which are subsumed the narrative parts treated in earlier chapters.

The painting presents us not with moments from the history of Francis, but with integrated emblems of the Francis of history, an altogether different subject. The Francis of Franciscan history is the incarnate fulfillment of promise in "the age of the prophetical voice, the time of clear doctrine." That promise is founded in the truest history of Christian hope, the comic plot of the Exodus, so that Francis is "inevitably" Moses *redivivus*, surrounded in his panel by allusions to Moses' vocation, his miraculous power, his mystical communion with the Godhead. Since he comes "in the power and spirit of Elijah," and since his stigmatization echoes the Transfigura-

no general essay on iconographic problems in Bellini known to me, and I have cited all of the important *specific* studies with the exception of those devoted to the *Sacred Allegory*, on which see Susan J. Delaney, "The Iconography of Giovanni Bellini's *Sacred Allegory*," *Art Bulletin* 59 (1977): 331-335, which summarizes earlier work and offers a new interpretation. The single deep study of an individual painting remains Edgar Wind's *Bellini's "Feast of the Gods": A Study in Venetian Humanism* (Cambridge, Mass., 1948), which, for a variety of reasons, does not in my opinion offer a safe model for approaching other paintings by Bellini.

tion of Christ, we find as well important Elian references. Francis'
inevitable arena, in the justest etymological sense of the word, is the
desert. Only in local and topographic terms—if then insistently—is
the desert La Verna. The Franciscan desert is the uncharted spiri-
tual wilderness of the Pentateuch and the Psalms, of Cassian and the
Carmelites, the desert of the religious life. Bellini's eremitic images,
and particularly his desert fauna, are commonplace emblems of the
monastic tradition.

The meaning of all this for the Francis of history is twofold. In
the first place the Christian ascetic life, what was usually called
simply *religio* in the medieval vocabulary, like all institutions of the
New Law, finds its clear and powerful type under the Old. That
Moses and Elijah are the two most famous "monks of the Old
Testament" is too elementary a truth even to be called an idea of
the medieval monastic tradition: it is more a simple lexical fact.
The central position of Francis of Assisi in this landscape means
that the Francis of history, the greatest religious founder of the
post-Lateran Middle Ages, is a special heir and, perhaps, a superoga-
tor of the "monastic" prophets. That is quite a lot to say, especially
in paint; but it is no more than could be said in other ways, indeed
had been said, of Anthony Abbot, Benedict of Nursia, Robert of
Solesmes, or Dominic Guzman.

The unique claims of the painting are those that are controlled by
the special theology of history, which, though it is clearly influ-
enced by Joachimism and the controversies of the poverty contest,
finds its classical expression in the authoritative pages of Bonaven-
ture. The claims of this theology are two. The first is that the Fran-
ciscan *ordo*—if not the Franciscan Order itself, its spiritual agenda
founded in poverty and penance—has an unparalleled role within
the Church. The ecclesiological significance of the Francis of history
is quite specific. The Franciscans have a special vocation of leader-
ship, renewal, and prophetic purification within the Church. They
are, so to speak, the institutional memory within the New Israel of
the deliverance of the Exodus. Hence the insistent, and initially sur-
prising, tabernacle—at once a statement *of* and *about* the Church.

The second claim, actually of logical priority to that just de-
scribed, is that Francis of Assisi is a saint different rather in kind
than in degree from all other saints. Francis' divine appointment

plays a crucial role in the history of Salvation at a crucial moment in God's calendar, near the end of man's Time. His is the special office of apocalyptic prophecy, of the final call to penance. He is the *tau*-writer appointed to save, with the seal of the mystical cross, those who sign and mourn for the abominations of Jerusalem. He is the Angel of the Sixth Seal.

Such claims, as extravagant as Bonaventure himself knew they might be perceived, were nonetheless definitively validated in his eyes by unimpeachable testimony more extravagant still: the testimony of the stigmata, the "sign of the living God" printed on Francis' very flesh. The Stigmatization on La Verna is not Bellini's narrative subject, but it is as emphatic a fact within his panel as it is within Bonaventure's Franciscan theology of history.

Such, then, is *San Francesco nel deserto*—Bonaventure's Francis and Bellini's. It seems to me unlikely that we shall ever find certain proof of the specific and local circumstances surrounding its commission, let alone a single "text" that has determined the painting's structure and organization. The painter's intellectual achievement is an impressive one, but it is not chiefly demonstrated by a mastery of difficult or arcane Franciscan ideas. In Venetian Franciscan circles of the 1480s, its ideas would be, in fact, rather commonplace, the appropriate and expected ideas for serious statements about Francis of Assisi. Most of them are to be found in *the* obvious book about Francis, the *Legenda Major*, and at that in its most famous chapter —the exordial prologue. Nonetheless, I do feel obliged to adduce two particular circumstances of conceivable relevance to the creation of *San Francesco nel deserto* in the 1480s.

The first circumstance is the canonization of Saint Bonaventure, after a more or less intensive campaign of nearly a decade's duration, on April 14, 1482. Its possible significance for the execution of the painting has already been suggested by Smart.[2] The only original observation I myself can offer is that Bonaventure is a good deal more relevant to the painting that I have described—a painting illustrative of Bonaventure's theology of history—than it is to the one Smart has described—the exemplification of a chapter in the

[2] Smart, p. 471, where the specific suggestion is that Bonaventure's special devotion to La Verna might be related to the painting.

Speculum Perfectionis, a book as far removed from Bonaventure's sympathies as Paris is from the Marches of Ancona. A second and more promising event, at least in terms of plausible specific influence, was the public appearance of the *Arbor vitae crucifixae* of Ubertino da Casale, in Venice, in 1485. The deep obscurity of its printer, Andrea da Bonetis, has stymied any attempt to forge a link with Bellini's circle, but if there is a single literary work closer in tone and intellectual texture to the painting than the *Collationes in Hexameron*, it is the *Arbor vitae*; the repeated citations I have made of it could have been multiplied, and relevantly, several times over. When we bear in mind that the current consensus dating the painting in the very early 1480s has no particular objective warrant, the potential interest of the book seems at the very least inviting.

Though any specific connection between *San Francesco nel deserto* and either Bonaventure's canonization or the publication of Ubertino's *Arbor vitae* must remain purely speculative for want of further evidence, there is one important respect in which both events address "the historical position . . . of the individual master" in their general relevance to the painting's mood and meaning. Both events speak of a certain resolution of partisan postures within the Franciscan Order. The extraordinary delay in the canonization of the greatest of the Franciscan doctors—a delay of more than two centuries—has been a perennial conundrum of late medieval religious history. Its most convincing explanation, surely, is that offered by Giuseppe Abate: namely, that Bonaventure's canonization was difficult if not impossible so long as he was the object of the hostile memory of the Spirituals and their heirs, who had looked upon him as a Minister General faulty in his loyalty to the founder's *altissima paupertas*.[3] That opposition, though not the rigorist tendencies with which it had been associated in the thirteenth and fourteenth centuries, had for the most part been silenced by the second half of the fifteenth century.

At the opposite end of the spectrum, the publication of the *Arbor vitae* suggests something like a public rehabilitation of Ubertino da Casale, who had died in bad odor and, in fact, forcibly separated

[3] "La Santità di S. Bonaventura secondo la storia," *Doctor Seraphicus* 3 (1956): 49.

from the order. He was inextricably implicated in the Spiritual cause repudiated under John XXII, and his reputation for Dante as a fractious extremist (*Paradiso* XII, 124) was perhaps the common judgment of the fourteenth century. We know, however, that the *Arbor vitae* was widely circulated and read, and not only among the Spirituals. It is among the conspicuous influences on Bernardino of Siena, the most famous Franciscan of the Italian *quattrocento*, and it was reverenced by numerous other irreproachable authorities as well.[4] It is of some significance that the Venetian edition of the work prints its fullest text, including the antipapal polemic bowdlerized, doubtless for politic reasons, from some manuscript versions. All this is to suggest that by the 1480s it may have been possible for Italian friars to view both Bonaventure and Ubertino within a single mainstream of their order's history. Retrospection can teach us that any such resolution was to be short-lived, though it finds a possible temporary expression in the majestic *pax* and *quies* of Giovanni Bellini's panel.

[4] See Frédègand Callaey, "L'Influence et la diffusion de l'Arbor Vitae d'Ubertin de Casale," *Revue d'Histoire Ecclesiastique* 17 (1921): 533-546.

Index

Aaron, 24; Francis and, 47ff.; and *tau*, 116-117

Abate, Giuseppe, 162

absurdity, as indicator of allegory, 94-95

Actus S. Francisci; see Fioretti

Aland, Kurt, 90n, 94n

Albani, J., 150n

Alber, Erasmus, 12

Alcoran des Cordeliers, 11

Altamura, Antonio, 126n

alter Christus, as Franciscan identification, 140ff.

Andrea da Bonetis, 162

Angel of the Sixth Seal, 28, 129-157; as "Oriens," 135; significance of "*alter* angelus," 139ff.

Angelico, Fra, 94

Angelo Clareno, 23-24, 141

Anselm, 153

Anthony Abbot, cult of, 35; *see also Vita Antonii*

Antoine de la Salle, 123, 125n

Arbor vitae crucifixae Jesu (Ubertino da Casale), 13, 19; *see also* Ubertino

army, metaphor of, 84ff.

ass; *see onager*

atramentarium; see inkhorn

Augustine: on the limits of ornithology, 42-43; on the pilgrim church, 84; on olive tree, 152; on Skenophegia, 81

Aurenhammer, Hans, 119n

Auspicus van Corstanje: "Christus-speler," 108n; on the *Testamentum*, 76

baldness: in Franciscan iconography, 137-138; spiritual significance of, 137ff.; *see also corona*

Barfusuer Muenche Eulenspiegel und Alkoran, 12

Bartelink, G.J.M., 34n

Barthelmy (Bartholomew, Bartolommeo) of Pisa, 14, 19, 29; *see also Liber Conformitatum*

Bauer, Johannes Baptista, "L'Exégèse patristique," 96; "Lepusculus Domini," 60n

Bauer, Viet Harold, 117n

bell, 86, *fig. 20*

Bellini, Giovanni (selected references); evidence of *vagare* in, 96; knowledge of the *chartula*, 105-106; knowledge of Judaica, 78-80; as a "learned painter," 6; Madonnas of, 7; as supposed maverick genius, 6; medievalism of, 7; at Pesaro, 137; *Sacred Allegory*, 158-159; *San Francesco nel deserto*, origin of name, 30; San Giobbe alterpiece, 137; as *scriba Dei*, 155-156; scriptural imagery in, 28; and the *Speculum Perfectionis*, 15ff., taking liberties with nature, 150; Transfigurations of, 8, 10

Bembo (agent of Isabella d'Este), 9; no match for Janson

Benz, Ernst, 85n

Berenson, Bernard, 58, 158

Berkeley, T., 35n, 84n

Bernard of Quintavalle, 154

Bernardino da Siena, 143n

Bible (specific citations or exegetical comments): GENESIS 13:11, 138; 25:27, 82; EXODUS 3:1-5, 49; 12:23, 116, 120; 17:6, 62; 24:18, 82; 33:11, 78; 33:18, 59; LEVITICUS 11:18, 42; 23:40, 80; 23:42, 77; NUMBERS 6:24-26 (*chartula*), 107ff.; ch. 13,

Bible (*cont.*)
8; 21:8-9, 116-117; I KINGS 17:3,
66; 19:9, 66; II KINGS 1:8, 66; ch. 2,
138; 19:9, 66; III KINGS ch. 19, 69-
70, 82, 97; IV KINGS 2:20, 70; 2:23,
138; 2:24, 130; 6:17, 64; NEHEMIAH
(II ESDRAS) 8:15, 80; JOB 30:29, 41;
39:5-8, 37; 40:15, 41; PSALMS 6:2,
37; 38:13, 27; 101:7-8, 37, 41, 42;
103:18, 44; ps. 114, 108; ps. 118,
90; PROVERBS 10:12, 66; 30:24, 44;
ECCLESIASTICUS 15:5, 143; ISAIAH
1:8, 89, 5:2, 89; 32:14-15, 40, 73;
32:18, 90; 55:13, 74; JEREMIAH
2:21, 89; LAMENTATIONS (THRENI)
3:27-28, 37; EZECHIEL ch. 9, 113ff.;
ZACHARIAH 2:9, 135; 6:12, 135;
MATTHEW 1:17, 130; 4:2, 82; 4:4,
92; 4:6, 136; 7:25, 60; 12:43, 33;
17:4, 92; 17:10, 64; 21:1, 30; 21:19,
46; 27:51, 32; MARK 4:4, 92; 6:8,
126; 6:9, 57; LUKE 1:17, 64; 1:78,
135; 8:29, 23; 9:3, 126; 9:33, 92;
10:4, 57; 13:6-9, 146; ch. 24, 26;
JOHN 3:14, 117; ch. 7, 81, 91-92,
98; 15:1, 89; ACTS 4:32, 36; ch. 7,
84-85, 89; 18:3, 83; ROMANS 1:1,
144; 11:7, 145; 11:26-28, 145, 150,
152; I CORINTHIANS ch. 10, 33, 62,
112; II TIMOTHY, 132; HEBREWS
11:38, 33, 37; ch. 13, 28; I PETER
2:11, 27; APOCALYPSE (REVELA-
TIONS) ch. 7, 139; 7:2, 115; 8:1,
157; 11:3, 130; 12:6, 130; 13:5, 130
Bigne, M. de la, 67n
Bihler, Johannes, 85n
bittern, 10, 34, 41ff., *fig. 3*
blindness, spiritual, 144ff.
Bochart, Samuel, 42n
Bonaventure (selected topics and
references): *Breviloquium*, 128,
155; his canonization, 19, 161-162;
Collationes in Hexaemeron, 142,
143, 152, 156; his conception of
Francis, 5; his historical schema,
142ff.; importance of Stigmatiza-
tion for, 102; *Itinerarium Mentis
in Deum*, 30-31;
 Legenda Major: composition of,
18; free of Joachimism, 133;
iconographic importance of, 16ff.;
specific citations: prologue, 114,
133-134; 13:3, 20; 7:31, 64;
11:9, 103;
 Legenda Minor, 48, 65; and
Parisian Joachimism, 133ff.;
senarium and *septenarius*, 122; on
the seraph of the Stigmatization,
13, 20; *Sermones*, 41, 98; his use in
this book, 19; *Vitis Mystica*, 89ff.
Bondatti, Guido, 25n
Bongi, S., 145n
Bonnard, Pierre, 33n
Bosch, Hieronymus, 126
Brieger, P., 59n
burning bush, laurel tree as, 51ff.;
figs. 8 and 10

Callaey, Frédègand, 163n
Cambier, J., 115n
Carith, the brook, means "charity,"
66
carmel; see charmel
Carmelite iconograph in Bellini,
66ff.
Cast, David, 7n
cave: gate of contemplation, 97;
of Moses, Elijah, and Francis,
96ff.; *fig. 18*
Celorum candor splenduit, 13
Chapter of Mats, 76-77
charmel, 73ff.; *fig. 15*
chartula, 100, 103ff.; *fig. 32*
Chitty, Derwas, 74n
Clareno, Angelo; *see* Angelo Clareno
Clasen, Sophronius, 47n
Columbus, Christopher, closet
Joachite, 145
Considerazioni sulle stimmate, 8, 20,
30, 33-34, 49, 63-64, 86, 103
Cope, Maurice E., 70n, 158n
Coppens, J., 96n

Cornelius à Lapide, 138n
Cornet, Bertrand, 119n
corona, as tonsorial term, 137ff.
cryptogram in *chartula*, 107
Cuttler, Charles D., 7n

Daniélou, Jean, 86n, 90
Dante Alighieri: Exodus theme, 108;
 on Francis, 102, 136; on Ubertino
 da Casale, 163
Dawson, Doyne, 85n
De Beer, Francis, 86n
Déaut, Roger le, 92n
Delaney, Susan J., 159n
Delorme, F. M., 138n
Denifle, H., 131n
Desbonnets, Théophile, 15n
description, difficulty of objectivity
 in, 100ff.
desert: Alverna as, 7ff., 32-74,
 108ff.; a city, 40; in title of
 Bellini's painting, 31
Dettloff, Werner, 153n
discalcement, 57ff.; *see also* shoes
dogmatic botany: author eschews,
 10; author succumbs: *see* burning
 bush, fig tree, grafted tree, juniper,
 vine, willow
Dölger, Franz Joseph, 113n, 135n,
 136n
Donin, Hayim Halevy, 80n
donkey; *see onager*
dove, from Noah's ark, signifies
 Franciscan Order, 25
Drury, Roger, W., 42n
Drury, Samuel S., 42n

Eisler, Colin, 58n
Elias of Cortona (Assisi), Minister
 General OFM, calls Francis
 "Aaron and Moses," 47, 102; *see
 also Epistola encyclica*
Elijah, 28; and Francis, 32-74, 82,
 159; and Bellini's *vas*, 69ff.
Elisha, and forty-two baldy-baiters

bitten by bears, 138
Emond, Cécile, 69n, 70n
Enoch, in Joachist thought, 155
*Epistola encyclica de transitu
 S. Francisci* (Elias of Cortona),
 13, 47
ergotism, 117
ericius, 41
erinacius; see ericius
eschatology: Franciscan, 115ff.,
 130ff.; Jewish, 90ff.; optimistic,
 141ff.
Esser, K.: *Angänge*, 86n; *Das Testa-
 ment*, 75n, 119n; editor of
 Opuscula, 104n, 105n, 106n
Este, Isabella d', 9
Evangelium Nicodemi, 119
Exodus: in *Proles de caelo*, 92ff.;
 in the *Testamentum*, 76-77; as
 theme, 28, 48ff., 75ff.; *see also*
 under Bible

Feast of Tabernacles, 77ff., 81ff.;
 Augustine on, 81; and date of
 Stigmatization, 98; *Proles de caelo
 prodiit*, 92-93; *see also* tabernacle
Felder, Hilarin, 26n
Feuillet, A., 62n, 73n
fig tree, 146ff.; *fig. 32*
Fioretti (*Actus*), 49, 51, 97, 103
Fleming, J. V., 12n, 15n, 25n, 57n,
 69n, 102n, 107n
Fletcher, J. M., 8, 9n, 10, 14, 49, 58n,
 95n, 100n
Flood, David, 57n
forty-two, symbolic number, 130-
 131
Four Masters, on the "shoe
 question," 57
Francastel, Pierre, 120n
Francesco da Meleto, 145
Francis of Assisi (selected refer-
 ences): as Aaron, 47; ascends
 Alverna, 63; autograph *chartula*,
 104ff.; and the Bellini painting,
 100; *Cantico de frate sole*, 15, 75;

Francis of Assisi (*cont.*)
 his death, 46; as a Desert Father,
 34ff.; and the Exodus, 75ff.; on
 humble houses, 85; and the man
 dressed in linen (Ezechiel 9),
 113; his pictorial imagination,
 75ff.; *Regula bullata*, 27, 57, 76,
 85; *Regula non bullata*, 85; rules
 of, 23; as second Moses, 47ff.;
 Testamentum, 23, 76, 85-86, 119;
 his theatricality, 25ff.; typology of
 biographical sources, 17ff.; *see
 also* Stigmatization
Francis of Meyronnes, on Stig-
 matization, 13
François de Sainte Marie, 67n, 98n

Gaiffier, B. de, 29n
garden, 15; as *charmel*, 67, 73ff.
gate: image of contemplation, 97;
 see also cave; *fig. 18*
Geary, Patrick J., 123n
Gemelli, Agostino, 8n, 33n, 82n,
 104n
Gerard de Borgo San Donnino,
 21-22; episode of the *Everlasting
 Gospel*, 131ff.
Gibbons, Felton, 9n
Giotto, and representations of
 Francis, 137
Goetz, Oswald, 146n
Goffen, Rona, 7n
Gonzales, Olegario, 154n
grafted tree, 150ff., *fig. 33*
Green, Rosalie B., 120n
grey heron; *see pelicanus
 solitudinis*
Grondijs, L. H., 109n
Guillaume de Saint-Amour, 132
Guillet, Jacques, 108n
Gunkel, H., 121n

Halton, Thomas, 83n
Hastings, James, 123n
Heinrich von Hesler, 119

Helm, K., 119n
herenicius; see ericius
heron; *see pelicanus solitudinis*
Hiller, Matthaeus, 150n
Hinnebusch, John F., 142n
Hirsch-Reich, Beatrice, 145n
Hollander, Robert B., 59
Holloway, Julia B., 26n
homo similis Aaron, 113ff., 121;
 fig. 29
Hugh of Digne, 21, 24
Huse, Norbert, 158n

icons and iconology, Meiss skeptical
 concerning, 4-6; *see also* individual
 images
Ilarino da Milano, 141n
inkhorn, 123ff.; and *chartula*, 126
Innocent III, 23; and *tau*, 115

Jacques de Vitry, 73-74
Jean de Meun, *Roman de la Rose*, 22
James of Milan, *Stimulus armoris*, 98
Jehan de Santré, 125n
Jews, conversion of, 143ff.; *see also*
 Judaica, *sukkāh*, Tabernacle,
Joachim of Fiore and Joachimism,
 21ff., 116, 130ff., 140ff.
John Chrysostom, 83
John of Parma, Minister General
 OFM, 24, 131, 141
Jordan of Giano, chronicler, on the
 Chapter of Mats, 76ff.
Judaica: Bede's knowledge of, 82ff.;
 Bonaventure and, 143ff.; Francis-
 can exegetes and, 98
jug; *see vas*
Julian of Speir, author of *Officium
 rhythmicum*, 18
juniper, 70ff.; *fig. 15*

Kerith; *see* Carith
Knowles, David, 73n
Knudson, Charles A., 125n
Koch, Robert A., 66n

Kraus, Hans-Joachim, 80n

Lambert, M. D., 23n-24n
Lampen, W., 154n
Lapsanski, Duane V., 85n
laurel tree, as burning bush, 51ff.;
 figs. 8, 10
Leclercq, Henri, 96
Leclercq, Jean, 44n
Lecoy, F., 22n
lectern, 86, *fig. 19*
Lee, Rensselaer W., 6, 10
Legenda Perusina, 16
Leo: and the *chartula*, 126; com-
 panion of Francis, 18; as figure in
 pictorial treatments of the
 Stigmatization, 13, 99ff.
Liber Conformitatum (*Liber de
 Conformitate . . .*), 11; Sabatier's
 judgement of, 12; on the signifi-
 cance of Alverna, 7-8; *see also*
 Barthelmy of Pisa
Lindeboom, J., 12n
Llanillo Garcia, F. A., 73n

MacRae, G. W., 80n
Madariaga, Salvador de, 145n
Manselli, Raoul, 131n, 141n, 155n
mat; *see* Chapter of Mats
medieval, a naughty word among
 art historians, 7
Meditatio pauperis in deserto, 138-
 139
Meier, Ludger, 153n
Meiss, Millard, 3-4, 8n, 9, 11-12, 20n,
 30n, 32, 34-35, 41n, 49, 51, 56, 59n,
 67n, 70, 95n, 99n, 100, 110-111,
 120n, 129, 146n, 148n; author's
 principal criticisms of, 11ff.
Melani, Gaudenzio, 8n
Michaelis, Wilhelm, 81n
Michiel, Marcantonio, 8
Michiele, Zuan, 8
Misrahi, Jean, 125n

Mollat, M., 24n
Montesquiou-Fézensac, Blaise de,
 120n
Moorman, John, 77n, 133n
Mosan crosses, 120ff.
Moses, 24, 32-74; Francis and, 47ff.;
 as rabbit, 60ff., 82, 159-160; as
 shepherd, 34, 48

Narbonne, Pentecost Chapter
 General at, 133
nettles, 74
nycticorax; see bittern

O oriens, 136
Octavianus à Rieden (Oktavian von
 Rieden), 96n, 102n
olive: used in building tabernacles,
 80; grafted, *see* grafted tree
Olivi, Peter of John, 24; on the
 "shoe question," 57
onager: and the Bible, 29ff.; 34ff.,
 66; Brother Ass, 5; Meiss on, 4
onocrotalus, two kinds, wet and dry, 42
Ordo Peregrinorum, 26
Oriens, name of Christ, Franciscan
 significance of, 135
orientale lumen, 36
Origen, 60
Os, H. W. van, 140
ostium; see gate
Ovid, *Fasti*, and *Feast of the Gods*,
 11

palm, in building tabernacles, 80
Panofsky, Erwin, 120n; his principle
 of common sense, 146
paper; *see chartula*, but do not see a
 patch
Passover, 120ff.
patch, as mistaken identification in
 painting, 100ff.
Pater, Walter, 96
Peeters, Ferd., 69n
pelicanus solitudinis, 10, 34, 42ff.;

pelicanus solitudinis (*cont.*)
Petrarch's drawing of, 44;
figs. 4, 5
Penco, Gregorio, 35n, 40n, 42n, 46n
Pépin, Jean, 94n
*De periculis novissimorum tem-
porum*, 132
Peter of Apuleia, 21
Peter of John Olivi; *see* Olivi
Peter Lombard, 153
Philobiblon, 125
Pichery, E., 36n
Pinto de Meneses, Miguel, 38n
pitcher; *see vas*
Places, E. de, 92n
Plagnieux, Jean, 65n
plum tree, scholarly phantom of,
146, 150
Portiuncula, as model of Franciscan
habitation, 86
potence, 126ff.
Proles de caelo prodiit, 92-94

rabbit, 49; *lepusculus Domini* and
Moses, 60ff.; and the Transfigura-
tion, 94; *figs. 7, 13*
Rahner, Hugo, 86n
Ratzinger, Joseph, 65n, 84n, 140n,
142n-143n, 145n
raven from Noah's ark, emblem of
Dominican Order, 25
Réau, L., 69n, 70n, 73n
Reeves, Marjorie, 21ff., 132n, 143n,
145n, 153n; *see also* Joachim
Richard de Bury, 125
Riesenfeld, Harold, 92
Robertson, D. W., 59
Robertson, Giles, 30n
rocks: of Alverna, 8, 15, 32, 60; rock
where Moses stood, 62ff.
Roman de la Rose, 22
Rousseau, Olivier, 62n
Russo, Francesco, 131n

Sabatier, Paul, 76n

Sacrum Commercium, 25, 69
Salimbene of Adam, 21
sandals, 15; and discalcement, 49ff.
Scalia, Guiseppe, 21n
scribe (of the *tau*), 113ff.; in
Bonaventure, 114; Francis as
scribed scribe, 135
scutella; see vas
Selbie, J. A., 123n
senarius and *septenarius*, 121
sheep, 34, 48, 129; *fig. 13*
shepherd, Moses as, 49ff., 129; *fig. 7*
shoes, and the "shoe question," 57
Singleton, Charles S., 59, 102n, 136n,
137n
Skenophegia; *see* Feast of Taber-
nacles
skull, 86; connection with *tau*, 109ff.
Smart, Alastair, 10, 14, 20n, 30n, 57n,
63n, 100n, 111, 126n, 148, 161n
sol justitiae, 135ff.
Speculum Perfectionis, 10, 14, 15-17,
63-64, 76-77, 97
Speculum Vitae S. Francisci, 15
spring of water, 15, 49
Stanislao da Compagnola, 139n
Steer, John, 129n
Steinmann, Jean, 65n
Stigmatization (selected topics):
and "active tree," 56; many
alluisions to, in painting, 90;
attempt to reconcile Bellini with
traditional iconography, 13ff.;
Bellini's subject in painting, as
traditionally identified, 4; not
Bellini's subject, 99; and Brother
Leo, 99ff.; and Feast of Taber-
nacles, 98; "by light," 4, 8; Meiss
on, 56ff.; seraph in, 13; theory of
the sawed-off seraph, 129; reality
of seraph, 20; and the Trans-
figuration, 19ff.; wounds as
writing, 12-13
Stimulus Amoris, 98
Stoevesandt, Heinrich, 143n

storium, 77; *see also* Chapter of
 Mats
Stuhlmacher, Peter, 150n
sukkāh; see tabernacle
Sukkoth; *see* Feast of Tabernacles
sun: image of *sol justitiae*, 135ff.;
 sunlight in painting, 129-130
synagogue, Augustinian interpreta-
 tion in Bonaventure, 143ff.

tabernacle, 77ff., 160; different
 meanings of, 78-79; and Jewish
 eschatology, 92ff.; *storium*, 77;
 sukkāh, 78ff., *fig. 18*; *umbraculum*,
 77; *see also* Feast of Tabernacles
Tabor, as site of Transfiguration, 91
tau, 99-128; and brazen serpent,
 116-117; Innocent III and, 115; in
 Francis' life, 112ff.; in Mosan
 art, 119ff.; and potence, 126;
 figs. 24, 25, 31
Thomas of Celano, 13, 16, 17, 18, 27-
 28, 97, 102, 103, and passim
Tocco, Felicé, 131n
Töpfer, B., 131n
Transfiguration, 65, 94ff.
tree; *see* fig tree, grafted tree,
 burning bush, olive tree
Trinity, 154ff.
Turner, A. Richard, 7n, 9

Ubertino da Casale, 13, 18, 19, 24, 57,
 161-162; *see also Arbor vitae*
umbraculum, 77

vas: as Elian attribute, 69ff.; and
 Transfiguration, 94
Verdier, Philippe, 119n
Vinck, J. de, 30n, 128n, 143n, and
 passim
vine, 86ff.; figure of the Church,
 fig. 18
vineyard: figure of the Church,
 86ff.; Bonaventure's and Bellini's,
 89ff.
Vita Antonii, as model of monastic
 hagiography, 34
Vitae Patrum, 35
Vorreux, Damien, 15n, 123n

walking stick; *see* potence
Weinstein, Donald, 25n
willow, 80, 92ff.; anaphrodisiac
 qualities of, 95ff.
Wind, E., 6, 159n
wicker-work (basket-making),
 Desert Fathers and, 77-78, 83
Wittkower, Rudolph, 42n
Wolff, Hans Walter, 150n
wounds, as writing, 12-13, 135
Wünsch, R., 113n

Young, K., 26n

Library of Congress Cataloging in Publication Data

Fleming, John V.
 From Bonaventure to Bellini.

 (Princeton essays on the arts)
 Bibliography: p.
 Includes index.
 1. Bellini, Giovanni, d. 1516. Saint Francis
in ecstasy. 2. Christian art and symbolism—
Medieval, 500-1500. I. Title. II. Series.
ND623.B39A73 1982 759.5 82-47593
ISBN 0-691-07270-1
ISBN 0-691-10143-4 (pbk.)